Peter L Folkes
1994.

That's
the way I
see it

FOLKES
61 ETHELBURT AVENUE
SWAYTHLING
SOUTHAMPTON SO2 3DF
TEL. 0703 556918

1 Untitled, 1987

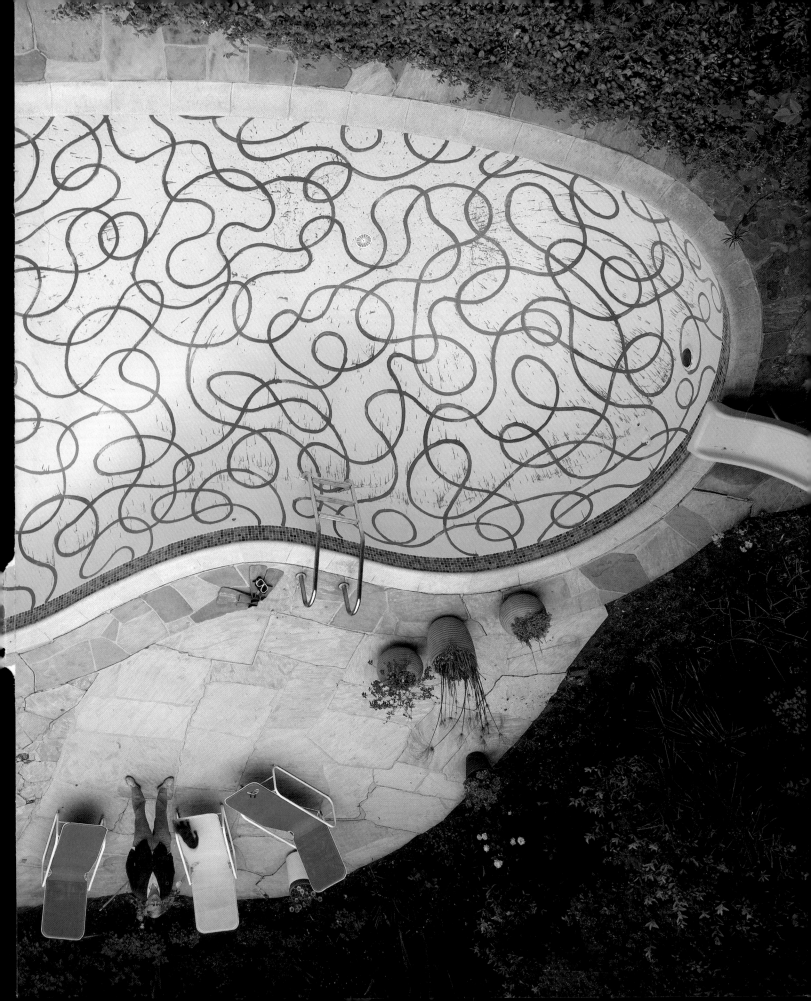

BCA

LONDON NEW YORK SYDNEY TORONTO

with 365 illustrations, 315 in colour

Edited by **Nikos Stangos**

That's the way I see it

David Hockney

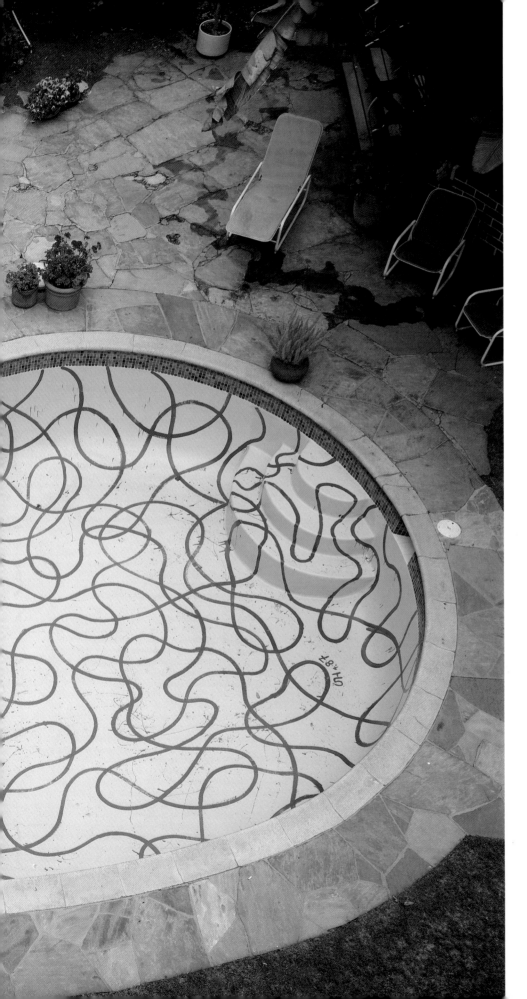

Title page: Untitled, 1987

Endpapers: front: production shot from
Turandot, 1991; *back:* production shot
from *Die Frau ohne Schatten*, 1992

Left: David Hockney's swimming pool,
painted by him, 1987

This edition published 1993
by BCA by arrangement with
Thames and Hudson Ltd

CN 1237

Typeset in 'Monophoto' Fournier
by Servis Filmsetting Ltd,
Manchester

Printed and bound in Japan by
Dai Nippon

Contents

PREFACE AND ACKNOWLEDGMENTS

The text of this book is based on extended recorded and unrecorded conversations between David Hockney and myself over a period of about five years.

By around 1978 Hockney felt increasingly constrained by and impatient with the limitations and wider adverse implications of naturalistic representation in art. Having always resisted the pat and foolish distinction between figurative and abstract art, he came to see that 'all art is abstract' in the sense that no representation is ever a duplication of the outside world and that all representation, regardless of stylistic variations, is based on perceptual and conceptual assumptions and conventions. At the same time, he resented being stereotyped as the painter of predictable Hockney images, despite their popularity. Furthermore, having challenged the falsely assumed veracity of the photograph (the fact that photography is mechanical recording does not stop it from being based on limiting presuppositions about spatial perception and does not empty it of meaning), he became interested in and excited by different ways of representing space and by the rich possibilities of 'reproduction' through new technological developments. And, to complement his unceasing curiosity and experiments in how space can be represented, space being the essence of all forms of representation, he also began to work with increasing regularity in stage design, an activity which, by definition, combines illusion and three-dimensionality.

Hockney, by temperament, is entirely undisturbed by any charge of naivety: as an artist, he believes that nothing can be taken for granted. He must explore everything himself. His investigations and experiments in spatial representation, its broader implications, the meaning of reproduction etc., are not a philosopher's questioning, but a working artist's and are characterized by the purity of the artist's childlike curiosity. He has no interest in the limited concerns, vagaries and changing fashions of the artworld and he goes his own way not because he wants to strike poses of originality, but because he is genuinely and passionately interested, always as an artist, in 'wider perspectives', the cosmos at large. So as well as chronicling his work, the text of this book chronicles the moral and intellectual tracings on his work, which are, of course, inseparable from it.

Gregory Evans was instrumental in the choice of illustrations which appear in this book – selected out of literally thousands of unpublished works Hockney has kept in his collection – and in providing overall guidance in the presentation of this material. His familiarity with the work and with Hockney has been of immeasurable help. Richard Schmidt, as Hockney's assistant, has provided enormous help, not only with photography, but also in answering the many demands on his and Hockney's time that this book entailed. Karen Kuhlman runs the Hockney Studio with exemplary curatorial and administrative efficiency, together with Lisa McPherson; they have provided all the illustrations used in this book as well as the documentation that goes with them, and have reviewed all the material used. Cavan Butler also provided his assistance with illustrations located in England. I am enormously grateful to all of them. Their help has made this book possible. David Hockney often works in a team with various people who help in many ways and he will never stint with credit where it is due. But, ultimately, it is his time, attention and energy which are crucial. I am of course most indebted to him for his generosity and support.

Nikos Stangos

1 Rehearsing the New

I have witnessed in my own time the massive growth of printing and it has shaped my awareness as an artist, as it did when I was a student. I can remember the first Skira art books arriving from Switzerland, the Impressionists and so on, with tipped-in colour plates. I can remember the Penguin Modern Painters series being published; they were very cheap and almost anyone could afford them. There were two American artists on the Penguin list, published I think in 1948, Ben Shahn and Edward Hopper, and it was because of those little books on their work that they became known in England. At that time most people outside America didn't know much about what was going on in American art. Even in the sixties very few exhibitions in London had a catalogue; the Marlborough Gallery tended to do them, but hardly anybody else, and even the Marlborough catalogues had very few colour reproductions and then only of the most expensive pictures.

Other than helping disseminate images, art reproduction has an effect on the art itself. When private museums are built, and built big, artists paint jumbo pictures to fit in them. When I bought a laser colour printer it led me into ordering a hundred canvases $16\frac{1}{2} \times 10\frac{1}{2}$ inches because that is the largest canvas that can go on a laser printer if I want to make my own colour reproductions of my paintings; it was the laser printer that led me to using canvases of that size. The printer also made me paint in a slightly different way. I quickly saw that the ability of the laser printer to pick up the transparencies of oil paint, the layering of it, was something I could use. The moment I saw how the machine reproduced the image, I deliberately began to paint in a certain way. Similarly, when making posters, I came to realize that when I made them myself they were often better, better laid out, better printed. I slowly realized that some people could print better than others and I began to use that. All artists, however humble they might be in other things, would like their work to be seen, and printing is a powerful way to reach a large audience. Though I do wonder what effect printed reproductions will have, in the long run, on the work of an artist, say, like Rothko, which is essentially unreproducible.

Picasso understood the power of printing, and Picasso is without doubt a very popular artist. I once had an argument with someone who tried to tell me that Andrew Wyeth was more popular than Picasso and I said this was absolutely not the case. One reason for Picasso's popularity might well be that his work has been widely reproduced. But of course it isn't just that; the art itself has a great power

and through reproduction more people can see it and respond to it. In the case of Rothko, because the paintings are so ungraphic, to experience them fully you have to stand in front of them. When I did 'The Artist's Eye' exhibition at the National Gallery in London, in 1981, my booklet on that exhibition was based on these ideas. Every artist I know sticks reproductions of paintings, printed images, on his or her wall – postcards, posters, anything. In that sense, for instance, I have a marvellous Picasso collection, the Zervos oeuvre catalogues in which you can study Picasso's work. I really believe that printing itself is a medium for artists, even the cheapest commercial printing.

93–105

In 'The Work of Art in the Age of Mechanical Reproduction', Walter Benjamin writes: 'In principle, a work of art has always been reproducible. Man-made artefacts could always be imitated by man. Replicas were made by pupils in practice of their craft, by masters for diffusing their works and, finally, by third parties in the pursuit of gain. Mechanical reproduction of a work of art, however, represents something new. Historically, it advanced intermittently and in leaps at long intervals but with accelerated intensity.' My disagreement here is that reproduction is not ever as *mechanical* as one might think. How come some people make better reproductions than others? First of all, there is no such thing as a perfect copy, because each copy is an interpretation, each a little bit different from the rest. There are printing revolutions going on at the moment that will have profound effects. Printing machines are more and more common – fax machines, for example, which are copiers, transmitters and receivers of images. Copiers get smaller, cheaper and more widely used. Even highly sophisticated copiers like my laser printer cost only $40,000. It may sound a lot of money, but before laser printers came along, if I had to have printing machinery doing the same job, it would have cost a few million dollars and would have taken up a vast amount of space. The laser printer is smaller than a table and its price, for an office or printing works, is not that much compared to what you'd pay for printing presses. Such means of reproduction will, no doubt, expand. What I want to emphasize, however, is that the technology of printing can be used, is being used, as an art medium.

What does copying do to the notion, and value, of the original artwork? The 'original artwork' is probably a modern Western idea. Certainly, in Chinese painting, what was an original was not considered that important; many copies were always made. With a copier you can develop an image in many ways. If you start with one picture you can then print it on the laser printer, then you can draw on the copy: so you now have two originals. What you are in fact doing is using printing as part of the technique of making a picture. I have used this technique more and more. All my instincts tell me to follow it wherever it goes. You might go off on tangents that don't go anywhere, but you have to explore it, follow it.

In this book, as we move through it, the reproductions nearer the end are going to be very different from the ones at the beginning, and tracing their difference will tell a story. By using the laser printer on paintings, it seems to me you get a new kind of reproduction that has taken away much of the distance between the viewer and the printed work; the laser printer has brought the reproduced image to the surface of the piece of paper you are looking at, because in laser printing the painting itself is placed in the printer, so no camera is involved – no transparency is made to use for reproduction. We thought we didn't perceive the distance between the reproduced image and the viewer before. Now it's becoming apparent that we do, or I do anyway. I'm beginning to think that the removal of this kind of distance in a reproduction is very important.

It seems to me that, in some ways, there are other parallels about removing distance: as we look into space, we now know that the further we look, the further back in time we are seeing, time and space becoming one dimension. If this is the case, our view of the universe will, little by little, change entirely. I think this process has begun and that at least a few people are aware of it. What is odd is that one might become aware of it through the reproduction of a picture. I never would have thought that a few years ago; now I do. This is bound to affect images profoundly. Our perception of space has incredible effects on us. Ultimately, it is about our identity: who we are and where we are, not a mere formal matter.

In the Renaissance, the invention of a new way of depicting space, using the vanishing point, seemed to make the depiction more real. The subject-matter artists used at that time was mostly religious because the Church commissoned the pictures and their printed copies to spread its message, as people couldn't read. It was very important that the pictures which carried the message of the Church could be 'read'. If a peasant couldn't 'read' them, what could he or she know about the pain of Jesus? Religious images had to be vivid, lifelike. With the invention of perspective, these pictures seemed still more lifelike. Most artists got very excited by the discovery of new ways of rendering space. Uccello's wife complained that he was married to perspective. I can understand that very great excitement, because they thought that they were getting perhaps nearer to the truth. Uccello was probably more excited by the new ways of rendering space than by the literal depiction of a religious subject. But the two are deeply connected because one gives the other power. Then a point was reached, perhaps in the nineteenth century, when the Renaissance depiction of space was seen as not all that real. Perceptive people began to realize that space could be rendered in a different way.

We are always fascinated by visual magic. When I was young I used to go to the cinema at least once a week – my father loved the cinema. We went to see whatever was on. And, somehow, there was an excitement on that screen. The screen, as if by magic, was opening up the wall to you, it showed you another world

even in the dingiest little cinema of suburban Bradford. I would always be sitting near the front row, looking up, looking at grainy pictures. But I have now got bored with the movie image. I think it is unspatial; there's something a little tedious about it; the visual magic has gone. Of course a movie can sometimes transcend this if it engages you emotionally, but when I was a child it hardly had to. The picture alone did it, and I think it did so for masses of people. The idea of a moving picture was so thrilling. It was the same with television, when it first started. We didn't have a television at home until I was about eighteen, so I'm probably the last generation brought up without it. I can remember during the War, we had a big Consul radio with medium and short waves, and as you flicked it from one wave to another they changed colour. Above the radio was a map of Europe; most people had a map up because they followed on the news what was going on as the armies moved into Germany and so on. I thought when the war ended there would be no more news. (I thought it wouldn't be necessary because everybody would be happy, and what would there be news for? I had learnt that the news is always about war.) Our Consul radio had a big loudspeaker at the front which was covered by a cloth. I was small and the Consul radio seemed very, very big, enormous. Sometimes I'd get close to the cloth-covered speaker and I always thought that this cloth could be replaced by a screen and then you would be able to see people and that would be fantastic! I thought somebody would come along one day, take out the cloth and put in a screen. And that is what actually did happen. Before that we all sat round the fire. I used to sit too close with my books and they used to curl up and when I'd tell my mother, It's all right, it's only a library book, she'd say, That's worse. And when television was still a novelty, people would eat at six o'clock and by six thirty, or a quarter to seven, they'd settle down in front of the television set — there was only one channel — and they would watch it all evening.

Visual magic tends to wear out when it is based on the photographic conception of space which immobilizes the viewer, distancing him from the view. I suspect that higher technology is bringing back the kind of intimacy we lack when we are separated from the world by visual perspective. And an intimate world seems to me more human. What an artist is trying to do for people is bring them closer to something, because of course art is about sharing: you wouldn't be an artist unless you wanted to share an experience, a thought. I am constantly preoccupied with how to remove distance so that we can all come closer together, so that we can all begin to sense we are the same, we are one. That is what I think removing distance on whatever level means, and that is why there are so many parallels, in science, in publishing, in printing, in communications generally.

So I became fascinated by, and started using, new media made possible by new technology which had not before been seen or used the way I used it. It is like the use of film and the movie camera to which I have referred. At first, in most early

films, the medium was treated as though it was merely recording a play. Early film versions were probably made by people who did not have the imagination to conceive of the real newness of the medium and they made melodramas: big gestures were made by the actors to show the emotions they felt. Then came along people who saw that you could do it all very differently, that the moving camera had possibilities itself, the way you used it. Chaplin made a marvellous statement: 'We use the camera like a brush,' meaning that he often began making his films with no clear idea at all and they grew into something. What those early people sensed was that film was not a mere recording instrument for drama and plays as conceived on the stage; it could do something else. In the very early days, film makers would point out that a film was actually shot on location, suggesting that this made the film highly realistic; you were there, you were taken to these streets, shown them. And I have no doubt that at the time such films would appear very vividly real, not stylized. Yet when you see them today, you of course see the stylization, partly because there is stylization in any kind of picture-making, including the photographically recorded image. It is all stylized; it has to be; it's not the reality. It is an arrested reality and therefore an interpretation of reality; therefore it is stylized. Every recorded image is seen to be stylized after a while; we begin to see the stylization even if we think it's not there at the moment when the image is made.

It is the same with printing which, after all, did not advance in Western Europe for a long time from the invention of movable type in the mid-fifteenth century. All printing was relief printing: something was cut away, ink was rolled on the top – a very simple device. And everything was printed that way: woodblocks, type and so on. A slight advance came when this process was reversed: you dug into the surface and the groove held the ink. This was engraving, etching and so on. These two types of printing were used for two hundred years. There then came another kind of printing made directly from a flat surface, based on the discovery of a certain kind of limestone that would accept grease and water, which did not mix. Lithography was thus invented, which opened up new possibilities, drawing direct onto the stone with different materials, mostly at first chalk and ink. Then it was further developed using different instruments. This technique was used throughout the nineteenth century. The invention of the half-tone process for printing photographs on cheap paper, rather than on chemically or light-sensitive paper, came at about the end of the nineteenth century. Photographs could now be reproduced in newspapers and of course in books. This also, therefore, opened up new ways of reproducing paintings; previously paintings could be reproduced only through engravings and that is how many people, including artists, knew them. Certain painters became famous in this way – such as Hogarth, who used engravers to copy his pictures. *The Rake's Progress* and *The Harlot's Progress* became very well known because they could be seen everywhere, not just in London. I think the

connection between painting and printing is very underestimated by artists in our time. Seurat never went to London, never really saw many Piero della Francesca paintings, but knew them from black-and-white engravings. And that is how people who lived in London eventually began to see paintings from Italy that they had never seen physically. They began to see reproductions of them made by artist-craftsmen, people who developed great skills in engraving, being able to copy what the painter's brush did.

In recent years we have had a new kind of printing that is basically electronic. And the development of the photocopying machine introduced yet another kind; and that led to the more recent laser printer. These new printing machines are also the processing machines of all the previous processes brought together. One machine now does the work previously done by four or five. As I said before, we can now make a reproduction directly from a painting without the camera being involved. And if no camera is involved, no lighting is even involved.

The urge behind the ever-growing means of reproducing images is to reach more people on a straightforward, simple level. But over and above that there's something still more important: the profound relationship between us and reproduction, how this affects our way of seeing the world, and how this, in turn, affects the way we depict the world. I used to think that pictorial space wasn't that important. Slowly I began to realize it is much more important than we think – than I had thought previously, anyway – because it makes the viewer begin to see the world in another way, perhaps a clearer way. We can't all be seeing the same thing; we are all seeing something a bit different. But the artist wants to share the vividness of his or her experience of actually looking at this physical world which we are finding is more and more elusive to define. It almost appears that there is nothing there at all when you get down to it. Matter appears to be trapped energy or even trapped light, scientists suggest now. Oddly enough, I think that we are moving out of what might later be regarded as a materialist age because of this perception of the elusive nature of matter. In the materialist age, the epitome of the picture is the photograph, which assures us that that is how the world is, that's how we see it, that's what things will look like. And to me, that disenchants the world. I love the phrase 'the re-enchantment of the world'. I love it because it means it is for everybody. I think the world is beautiful and that if we don't think it is, we are doomed as a species. I don't think there is a place in the natural world that we could think was ugly. It tends to be only man-made things that can be called ugly. I have never seen an ugly natural landscape. Some places are desolate, but they too have an awesome beauty. One might think that artists have forgotten about beauty but we now learn that scientists and mathematicians did not forget.

At the time of my 1988 retrospective in Los Angeles, London and New York, somebody asked me what effect did the book which had chronicled my life and

work up to 1975 have on me, when looking at my exhibition? Was it a surprise, did I see things I wasn't aware of before? The difference between my 1970 retrospective at the Whitechapel Gallery in London and the 1988 retrospective was that in 1970, in planning the exhibition, I did not have reproductions of my own work at my fingertips as I did in 1988. In 1970 I had not seen for a long time many of the works we were thinking of including. This was not true in 1988, because I could pick up my first book and flick through it and be reminded of the work.

There is a cumulative effect in looking at reproductions of your own work; it is like having it around your studio, like having a retrospective at any moment. Reproductions of one's own work, whether faithful or not, are very useful to an artist. They serve to remind one not only of the physical facts of a picture, but also of the precise circumstances in which it was painted. Many people, going round my 1988 retrospective, said to me that they were so surprised by the actual size of a picture they had known only from reproductions. Naturally, I am not surprised in this way because when I look at a reproduction I know exactly what size the picture is and it brings back to me the action of making it. If I look at a reproduction of, say, the painting of Ossie and Celia Clark, it brings back to me my crowded little studio in Powis Terrace in London where I painted it. That wouldn't happen to anyone else.

It occurred to me once, looking round the new wing of so-called primitive art at the Metropolitan Museum, that if you are an artist and you look at something, some sculpture of a figure, there is always something you would see that an art historian or critic could not. It's this: somebody made the piece with his hands and the person who made it had some similarities to yourself. That artist too had an urge to make something, to depict something, to represent some form of perceived reality, to represent and reproduce experience, even though he lived in a totally different era, a totally different society. This connection between an artist from the past and one in the present is always there. The art historian cannot connect back to a work of art in this way; his is a different profession: he is a documenter or a cataloguer, or an interpreter. The artist, however, shares with an artist from the past and from any culture the actual activity; they share the same urge: the urge to communicate a way of seeing things in the world. The earliest art we know of are the Lascaux cave drawings; we recognize the marks because they add up to the look of an animal, a bison. If the marks didn't look like anything, possibly we wouldn't even think of them as made by a human being. But when they do, there is no doubt in our minds that somebody a little bit like ourselves, no matter where or when, scratched these representations because we can recognize that that is what they are: a figure, an animal, a spear.

The urge to represent is very deep within us. Depictions occur at very early stages of civilization. And this urge is there because each individual person feels or

knows that he or she has a unique sort of experience. They come across something, get excited by it and want to communicate it, because other people will not perceive it unless it is pointed out to them. For instance, many people have told me that without my commentary on the film we made in 1987 of an eighteenth-century Chinese scroll, *A Day on the Grand Canal with the Emperor of China*, directed by Philip Haas, they wouldn't have grasped and actually seen the things I was talking about in it. When I first saw that scroll, in about 1984, I got incredibly excited: it was one of the most memorable days of my life. I loved it and I wanted to pass on the excitement of what I saw in it to other people.

That is why the film was made. What I perceived in that Chinese scroll, I was *ready* to see. I recognized something in it, just as sometimes you are ready to read a book. This happened to me with Linda Henderson's *Fourth Dimension and Non Euclidean Geometry in Modern Art*. I know perfectly well that this is a title that would put most people off and I am sure not many people would read it no matter what I say. When I came across it, however, I was ready to read it. A few years before, I might not have done; in fact, I'm sure I wouldn't have. But at a certain moment, you are receptive to ideas that have been developing vaguely in your head; you are therefore responsive when you encounter these ideas articulated by someone else. My ideas about photography, for instance, had prepared me for the Chinese scroll and led me into seeing what was so special about it: photography and my gradual understanding of its nature and its shortcomings had led me to it. And all these ideas revolved and still revolve around the ways in which images and experiences are represented and the fact too that there is little difference between representation and reproduction.

PARIS 1973–75

From 1973 to 1975 I lived mostly in Paris. I lived alone, although Gregory Evans, a friend from America, was around the corner in the rue du Dragon. I rented an apartment from a friend. I have always liked Paris: it is a wonderful city. It is the only Continental city I have lived in for any length of time. I simply locked up Powis Terrace in London and went off. I was in a state of confusion and I felt I had to get away from London. That period – 1973 – was very disturbing for me; I had been struggling with the paintings, like the one of *George Lawson and Wayne Sleep*, which I eventually abandoned. There was something wrong in what I was doing, which I have elsewhere described as the trap of naturalism, and I had to find out what it was and I needed peace and quiet. It was always hard to get peace and quiet in London. There were always people asking, would you do this, would you talk on that, would you do a television programme, would you do the other? I am probably too amiable a person to say no. My way of getting out of it was to go off to

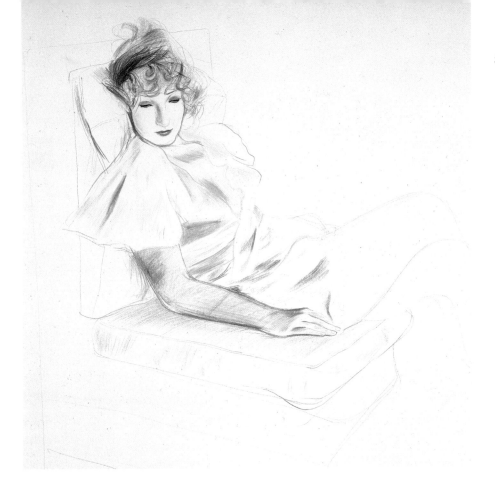

Paris. Not many people knew I had gone; just some friends who would come over to visit. I lived near the Odéon Metro stop on the boulevard St Germain in a very pretty little courtyard. I didn't quite know what to do; I was at a crossroads. I was thinking about many things and about certain attitudes to painting I felt were dead. I was trying to break out of something, break out of what I called obsessive naturalism. It took me a long time, when I think about it. In Paris I spent a lot of time doing quite big portrait drawings. I did them slowly. I would spend two or three days drawing the person slowly, rather academically, sort of 'accurately' in an ordinary sense. I did a number of drawings of Celia, which I still own; I drew friends who would sit; and I had a show of these drawings at the Claude Bernard Gallery in 1974. What I was doing was looking back, reading and looking at pictures. I spent a lot of time in the Louvre and got to know it quite well. My place was only a fifteen-minute walk away, a very pleasant walk, and I would go at least once a week for a good few hours. There are lots of little back places in the Louvre where, of course, the less interesting pictures are, and I loved exploring them.

I lived quietly in Paris, drawing friends, sitting in cafés. I went out to eat breakfast, lunch, dinner. My living-room was my studio – never a good combination for me. If ever people rang me up and wanted to see me, I never invited them there, I would meet them in cafés. I would get up in the morning and

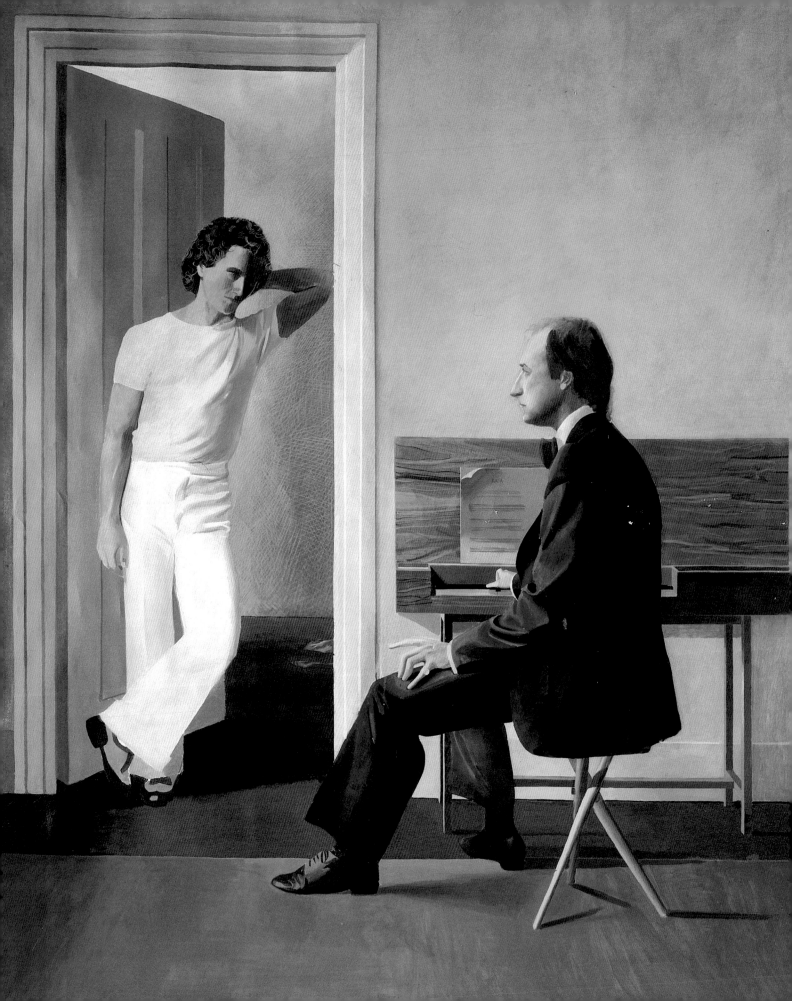

go and sit and read the English newspapers sitting in a café at the top of the street, and drink tea and eat that delicious bread and butter for my breakfast and then work. I would work all day until maybe 5 or 5.30 and then walk up to the Café Flore where I always met people I knew. There was always somebody there. In England you couldn't do that.

I also used to go to the Musée d'Art Moderne a great deal. I spent many hours in Brancusi's studio. I loved that room, with the dust on it, the pieces in it and that marvellous atmosphere. Next door was that other terrific room with the González sculptures, which have always affected me. He was a wonderful sculptor. So I was, in a way, looking at art of the long past, and at early modern art, which of course was made in Paris, anyway. Contemporary art I felt quite removed from. The rise of conceptualism had made it all rather arid to me, utterly unsensual and alien.

5 *Opposite: George Lawson and Wayne Sleep* (unfinished), 1972–75 (detail)

I never completed this painting, though I worked on it for years, altering it and repainting it. I saw later that my struggle with it had been about naturalism. I couldn't find a solution to the problems naturalism raised.

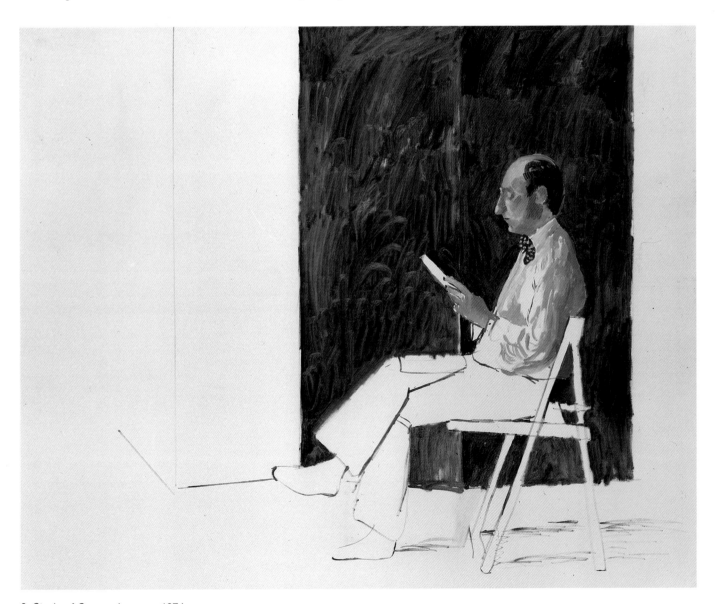

6 *Study of George Lawson*, 1974

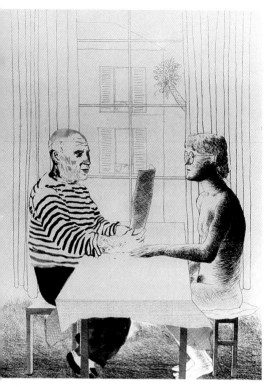

7 *Artist and Model*, 1974

This etching is drawn from a
photograph of Picasso. I would love to
have met him, even just once.

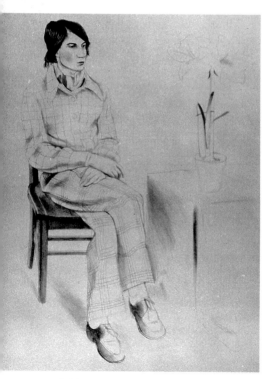

8 *Yves Marie*, 1974

My friend Ron Kitaj often came to Paris and we would have a few days together and enjoy the city, look at exhibitions, eat and talk about art. We could not quite understand why the figure had disappeared from art, or seemed to have – of course it never did, if you looked at it another way, not at all. It was only a certain branch of the art world that said it had. One forgets how small an art world is, or how many art worlds there are.

That was a period, I think, when Kitaj also felt restless. He had only just bought a house in London. He too was trying to work things out, not quite knowing what to do. Usually when I get into that state I have to do something, so I just sit and draw in some way or other. At that time I felt almost as though I should go back to drawing skeletons, as I did when I was a student at the Royal College of Art, thinking, what shall I do?: I'll make a study of the skeleton; what should I do?: I'll make some drawings of my friends; I'll make them slowly, accurately, have them sit down and pose for hours, and so on. I tend to do that at times when I feel a little lost, searching around. I also read a lot. My French wasn't very good – schoolboy stuff. Most of the people I knew in Paris were either Americans or were French people who liked me to speak English because they said I spoke slowly and clearly and they could improve their English; and their desire to do that was stronger than mine to improve my French.

And then, of course, there was constantly the thought of Picasso. Picasso, to me, was still a massive force and I did not know how to deal with it. Like other people at that time, I too believed that what he had done was so idiosyncratic nobody else could use it. I do not believe that now, but I did then.

THE RAKE'S PROGRESS
BREAKING THE RULES OF PERSPECTIVE

In the spring of 1974, I had a letter from the opera director John Cox asking me if I would design Stravinsky's *The Rake's Progress* for the Glyndebourne Opera. Although I had seen a production of it years before, I had completely forgotten it. John Cox suggested that I go to see him next time I was in England, and I went in the summer of that year.

I had met in Paris a young man called Yves Marie Hervé. He was a charming person whom I enjoyed very much and he was very keen to learn English; we became great friends. So Yves Marie came to Glyndebourne with me. He, Gregory Evans and I went together and we saw Richard Strauss's *Intermezzo* in a very nice production. That was only the second time I had been to Glyndebourne; the first had been in the sixties, to see a production of *Werther*. I said to John Cox, I'm interested in the theatre and I love the musical theatre and I love Stravinsky – I don't know the music, but I will listen to it.

I had been to see many operas and I knew that opera was lavish theatre, extravagant theatre in a way that commercial theatre could not be. But I also felt I didn't know enough technically – the only thing I had ever designed for the stage before was Alfred Jarry's *Ubu Roi*. The people at Gyndebourne said, Artists are very adaptable people, perhaps you don't need to know as much as you think you do. And I immediately thought, of course, they were right; I knew what it was: sometimes professionals use technical jargon to keep others out. And I thought, of course artists are adaptable. So my reply was, All right, I will do it, but I must tell you that I do not mind if I fail. It's something new to me and I will do my best for you, but I'm not afraid of failure. And they said, All right.

I guess one reason I was asked to design *The Rake's Progress* was because I had done my own *Rake's Progress* in 1961–63, a series of sixteen etchings in which I had updated the story and placed it in New York. John Cox didn't want to impose his own schemes on me, unlike the traditional director of an opera who tends to choose a designer who will carry out whatever scheme the director has in mind. Many opera directors do that: choose what you'd call a professional designer, who is prepared, in a sense, to take orders. Well, I don't have a personality quite like that. I'm willing to collaborate with people, but I'm not interested in illustrating someone else's ideas.

First I read the libretto and I loved that straight away. It was by W.H. Auden and Chester Kallman – a wonderful, witty, very literate libretto – which not all operas have. I started listening to the opera. To begin with, the music seemed very difficult; I listened and there was probably very little I got, maybe the Chatterbox aria when she sings 'Snuffboxes came from Paris'; it's wonderful music, that Chatterbox. But slowly the music came to me. The more I listened, the more beautiful it became, and I saw how exciting it was. I talked a lot with John Cox and then I made this suggestion: since *The Rake's Progress* was from Hogarth, could we not stylize the designs with crosshatching, like Hogarth's engravings?

John Cox and I had long talks and discussions. I was getting more and more into the music and kept thinking of ways in which I could use the crosshatching technique. The music seemed to me very linear and spiky and yet the strong thing about it was that it had an element in it of eighteenth-century pastiche, while it was also totally Stravinsky. So I felt you couldn't ignore the eighteenth century, this was quite an important aspect of it. I started work in October 1974 and it had to be finished by December for the opera to be performed in the summer of 1975.

At about the same time in 1974, an exhibition of my work took place in Paris, at the Musée des Arts Décoratifs, in the Louvre, organized by the British Council. It was a retrospective; a very nicely organized exhibition. Many people came over from England to see it, so I thought I'd better get away.

I began my own *Rake's Progress*, a series of 16 prints, in 1961, after my trip to New York. They set the story there, and updated it. It was partly because of this series that John Cox asked me in 1974 to design Stravinsky's *Rake's Progress*.

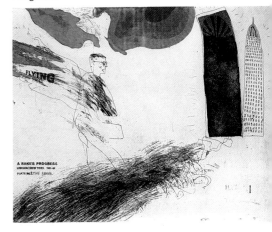

9 *The Arrival*, from *A Rake's Progress*, 1961–63

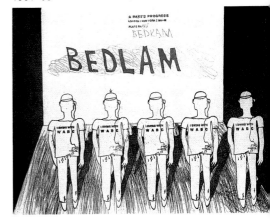

10 *Bedlam*, from *A Rake's Progress*, 1961–63

I went to Hollywood for three weeks and brought along Mo McDermott, who had worked for a theatre designer in London – I think it was Ralph Koltai – as an assistant. It was Mo who advised me straight away to make models because, he said, if you only make a drawing, somebody else then translates it into the space. The moment he said that I thought, I don't want anybody else to do that, I want to do that myself. So I thought, I will make scale models. I wanted pictorialism, I wanted to bring my own attitude to sets.

I had seen many operas and I liked Zeffirelli's verisimilitude which I thought was always interesting, at least it never let you down, there was something to look at. But a lot of set designs seemed to me to have become too abstract. This was a period when theatre design was dominated by ideas that derived originally, way back, from Adolphe Appia and had spread under the influence of Wieland Wagner. I had never seen any of Wieland Wagner's productions. I'm sure when they were first done they must have been very exciting theatre, yet he had a very bad influence. His productions at Bayreuth, starting in the fifties, used the ideas of Appia – great simplifications of form, light, colour and so on. The first productions he did, of which I have seen photographs, look very exciting because they've got beautiful, simple spaces which he made. I don't know what the colour was like, because the photographs were black and white, but I'm sure that at the time it was very exciting theatre. By the mid-sixties that influence had spread everywhere, partly because it made sets cheaper. The abstractions, instead of being genuine abstractions, that evoked something, had become too simple. So instead of seeing that a great big block represented a castle, you thought, what's that man sitting on that big block for? It had become merely a big block, it had lost its power to evoke

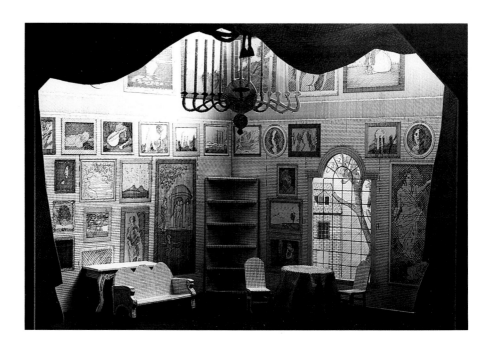

11 Model for *The Rake's Progress*, the morning-room of Rakewell's house in London, Act II, scene i, 1974–75

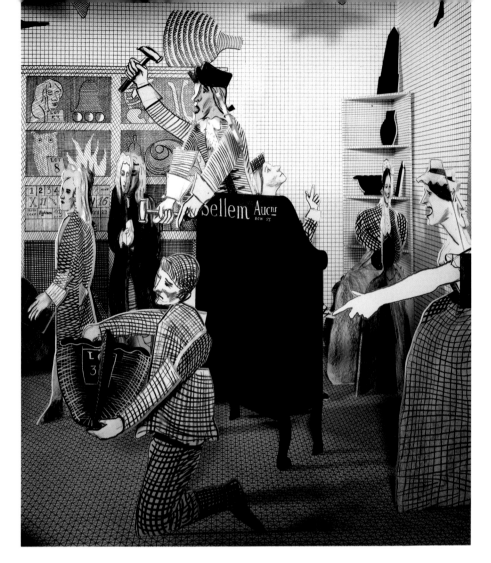

12 Set design for the auction scene from *The Rake's Progress* (detail), recreated for the theatre exhibition 'Hockney Paints the Stage', at the Walker Art Center, Minneapolis, 1983

I took the crosshatching effect directly from Hogarth's engravings. All the sets and costumes consist of a white ground crosshatched with black, red, blue or green lines – the colours of 18th-century printer's inks.

something. It was time to change because, in a way, the abstract had become literal. So I thought, here was an opportunity to introduce the pictorial element again.

With Hogarth, of course, you've got a rich area of visual references. I got all the big Hogarth books on engravings and I came to Hollywood with Mo. We rented a little apartment at the Chateau Marmont for three weeks. I borrowed a record player from a friend to play the opera and we got to work rather quickly. Once I had had the idea of doing crosshatching for costumes and sets, I had even gone down to Glyndebourne to decide what scale the crosshatching should be for the theatre. If it was too small you wouldn't see it, if too big it would be a dominating pattern – it had to be a certain scale. When we got to Hollywood I realized, of course, that the opera itself had been written in Hollywood.

We got half of it done in three weeks. Then I went back to London to see John Cox. I still hadn't done the last scene – the Bedlam scene. When I showed what I had done to the people at Glyndebourne, they were amazed that I had made models.

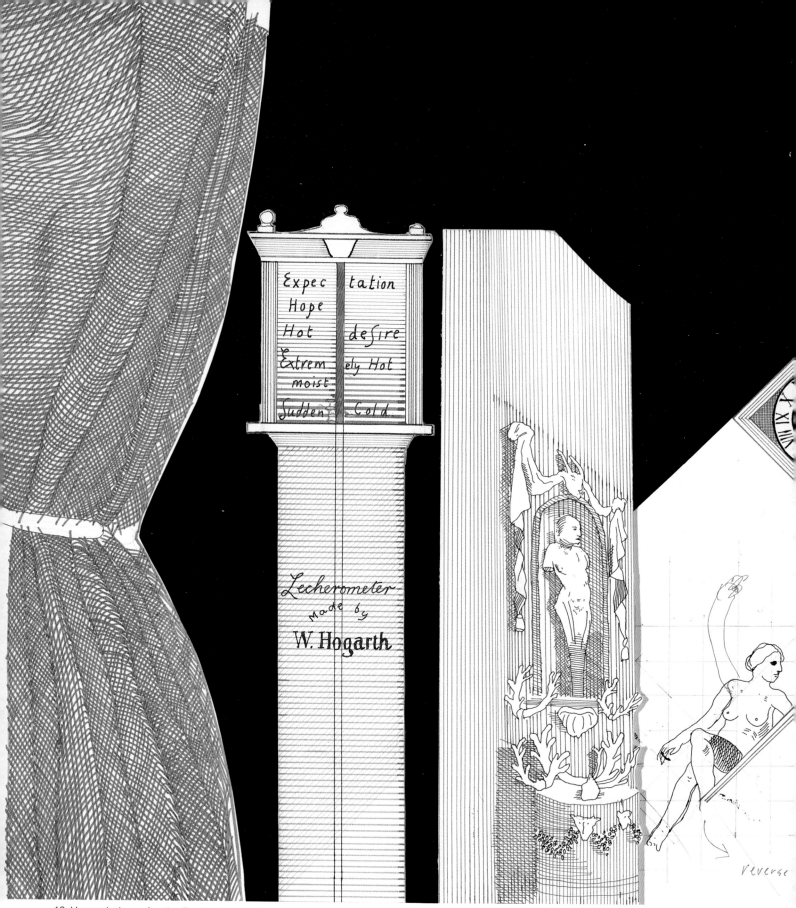

13 Unused pieces for the Brothel scene, from *The Rake's Progress*, 1975

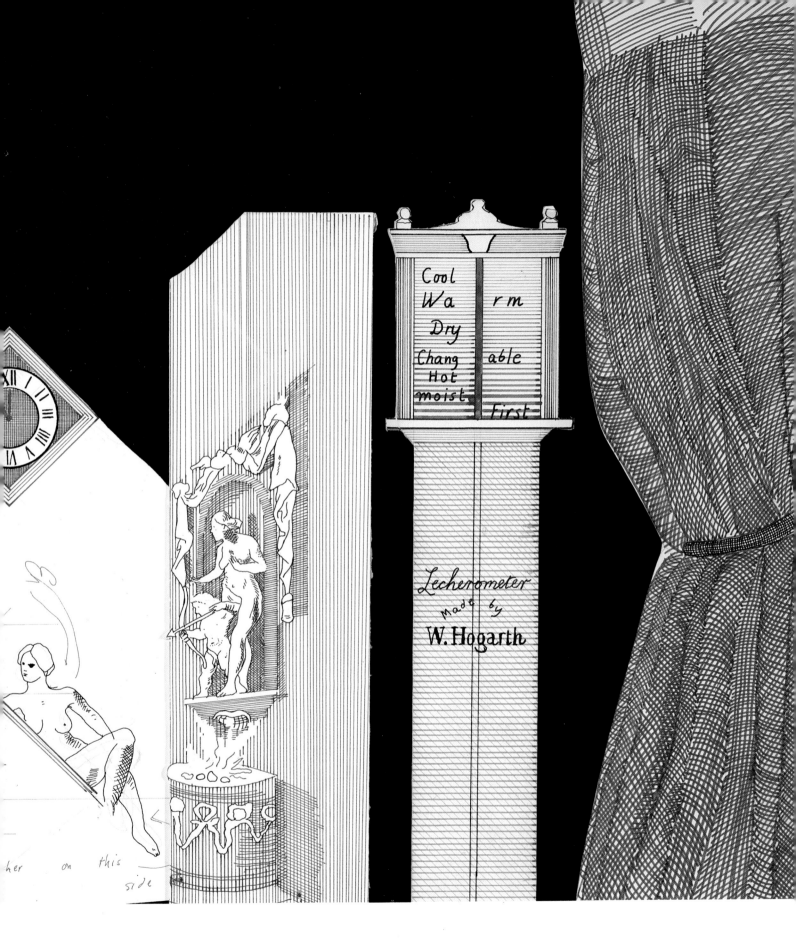

Cool Wa rm
Dry
Chang able
Hot
moist First

Lecherometer
made by
W. Hogarth

her on this side

They had expected me to do just a few drawings. What I didn't know at the time was that some of the people thought what I was doing wouldn't work at all, but they did not say so. I'm glad of that because I think if they had they would probably have put me off; I would have believed them, thinking they knew more about the theatre than I did.

When it opened in the summer of 1975, the restaurateur Peter Langan organized a party on the lawn, a picnic, for the long Glyndebourne interval. I think it cost me more than they'd paid me to design the opera but it was a splendid picnic. I'd done a drawing of Peter with a wine merchant in Paris and this was on the cover of the menu, and he'd written at the top in his kind of mad Irish handwriting, 'An evening of excess', and I must say it was, a wonderful one. It was Midsummer Day. Peter Langan had realized that as he was bringing 120 bottles of champagne for about 30 people it would be no good driving back to London. So he'd organized a bus for people to go back in. For the picnic he'd set up tables on the lawn. The food was marvellous and there was so much of it I invited the orchestra and chorus, after the performance. The performance ended at about 9.30, and because it was Midsummer Day we came out, back to the food, and there was this wonderful, glorious sunset over the Sussex Downs, absolutely beautiful. And as the sun set, the moon came up and it was so bright that it cast shadows on the lawn. It was very, very pretty and I'll never forget it; most of the people who were there said they too would never forget it, the whole thing was marvellous. It *was* an evening of excess, and I like that, no matter what it cost. I thought, why not, that's what we should do every now and again, be excessive.

The opera turned out to be quite a success. The audience loved it. There was only one reviewer who thought it was dreadful, someone called Rodney Milnes, who wrote in the *Spectator*. It was quite funny, his piece. I think he said something like, this production was so dreadful, so awful, that he wouldn't comment; and he wrote instead about the party on the lawn. It was a funny bit of writing, I must admit. But some readers who'd seen it wrote to Mr Milnes saying, If you think it's terrible you must say why, don't waste our time. So Mr Milnes had to write another review to say why; I think it was all a bit silly. But I thought the design worked; it was wonderful with the music; it seemed vibrant and lively to me and the audience appeared to think the same. I thought what John Cox had done was marvellous. And at that opening night he asked me if I'd do *The Magic Flute* and I immediately said yes. I love *The Magic Flute*, it's a wonderful work to design. I knew one could do it many different ways. It was for 1978 so there was plenty of time, I didn't have to begin straight away.

The Rake's Progress had taken a considerable time. I had put a lot of effort into it and had thoroughly enjoyed it; I had enjoyed collaborating with other people. Glyndebourne was a great place to work. The people were wonderful and the stage

16 *Peter and Friend*, 1975

This drawing appeared on the cover of the menu for our Glyndebourne picnic, an unforgettable feast that Peter Langan produced for us on the opening night of *The Rake's Progress*, 21 June 1975.

14–15 *Preceding pages:* Large-scale painting with separate elements based on the design for Bedlam, for *The Rake's Progress* (detail). *Inset:* Set design for *The Rake's Progress*. Both recreated for the theatre exhibition 'Hockney Paints the Stage', at the Walker Art Center, Minneapolis, 1983

shops there were terrific. Tony Ledell, who made the costumes, understood immediately what I wanted. Suddenly, I realized I'd found a way to move into another area. In a sense I'd broken my previous attitudes about space and naturalism, which had been bogging me down. I'd found areas to step into which were fascinating: the space of the theatre. It also helped that it was a success, both critically and with the audiences. People would stop me and say how much they had enjoyed it as a piece of theatre. I then went back to Paris and started painting.

Kerby (After Hogarth) Useful Knowledge was painted in 1975 and it came out of *The Rake's Progress* sets; it is the only painting that actually came out of the opera. In designing the opera, I had made only models and some drawings, mainly for costumes. Later on I was to do more and more paintings which derived from my work in the theatre, but from *The Rake's Progress*, *Kerby* was the only one. I came across the Hogarth picture in doing the research and it caught my eye, probably because of its rather whimsical feeling. You could see what it was about, how Hogarth meant it: if you did not know the rules of perspective, ghastly errors like

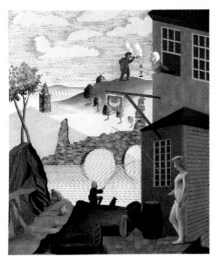

17 *Kerby (After Hogarth) Useful Knowledge*, 1975

Kerby (After Hogarth) Useful Knowledge (*above*) is the result of the research I did on Hogarth for *The Rake's Progress*. I got the idea from a satirical frontispiece Hogarth created for an 18th-century treatise on perspective (*left*). The treatise was published and popularized by Hogarth's friend Joshua Kirby, whose name I misremembered when I did my picture.

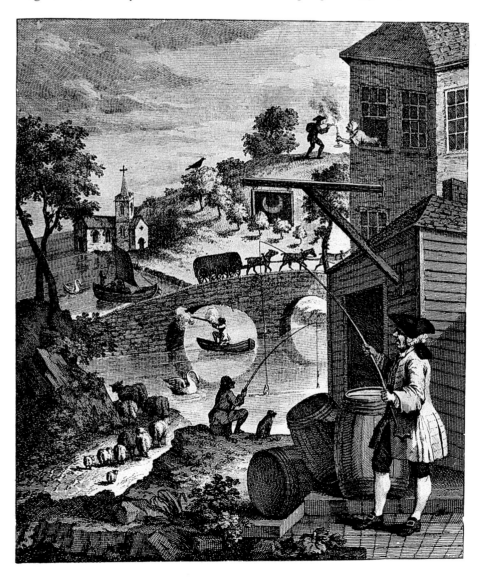

18 William Hogarth, frontispiece to *Dr Brook Taylor's Methods of Perspective*, published by Joshua Kirby, 1754

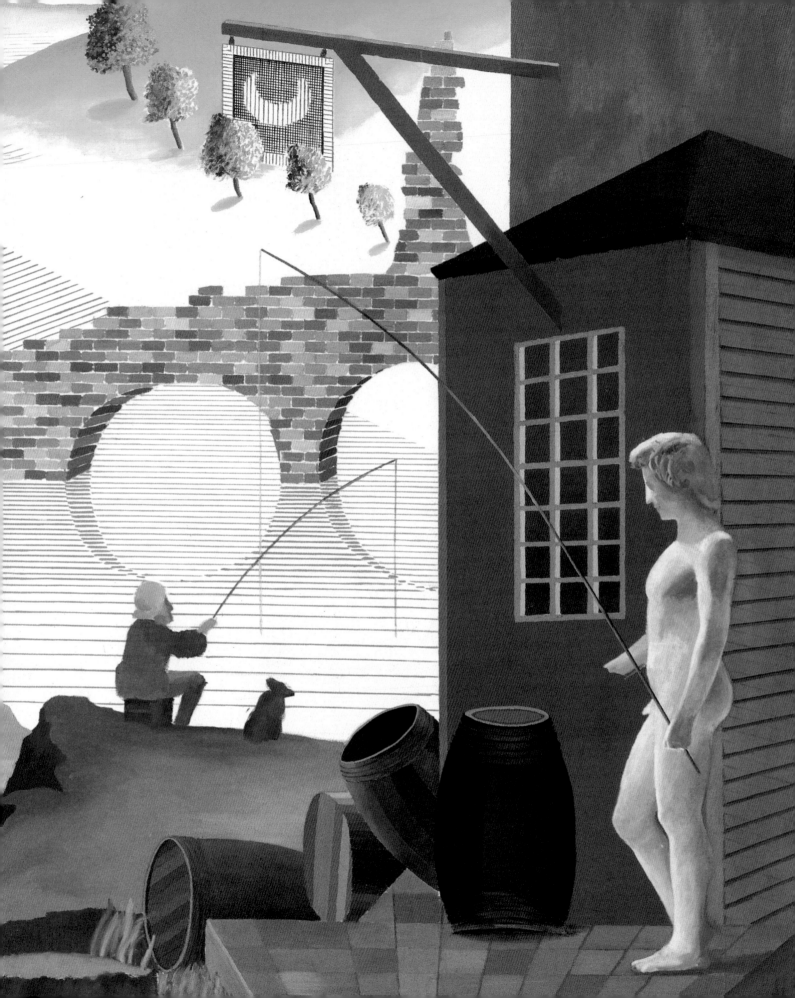

this would occur. But I was attracted to what Hogarth thought were the ghastly errors and I thought I also saw that they created space just as well, if not better, than the correct perspective he was praising.

It took me a long time to realize fully what the implications of that Hogarth picture were. My intuition alone had attracted me to his little engraving. When I painted *Kerby*, I didn't altogether understand how or why certain attitudes were working out in my head. Just before Kerby I also painted *Invented Man Revealing Still Life*. These were the first paintings done for quite a while in which I did not cover the whole of the canvas. I started leaving unpainted areas again, as I had done years earlier. Both of those paintings were about space, using it, or making it, depicting pictorial space in different ways, breaking the rules of literalism in depicting space.

After that summer of 1975 I got going painting. But many people now knew where I lived; also that movie on me, *A Bigger Splash*, had been showing in Paris. The French loved it; I suppose it was a kind of French-style film. And so people would come up to me on the street and they'd come round to my place. They started coming earlier and earlier, we'd go out to lunch, and I couldn't work in the afternoons. At night I always went out to a restaurant, sometimes with six or seven people. I was always at the Coupole – I made some drawings there of Sacha Rubinstein, the little man who used to draw portraits there. But I couldn't work in Paris any longer.

I decided to move back to London and within four days I was back. Gregory came with me. He was still going back and forth to Paris a bit, but mostly he was with me in London. I set myself up there in late 1975.

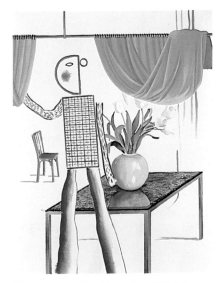

20 *Invented Man Revealing Still Life*, 1975

Invented Man Revealing Still Life was painted before *Kerby*. The figure is invented, but the still life is real. I had used a similar figure in *Showing Maurice the Sugar Lift* (1974). The curtain the man is holding is lifted straight from Fra Angelico's *Dream of the Deacon Justinian*. A similar invented figure appears in the sketch below. These pictures, and *Kerby*, were for me a release from naturalism.

THE BREAK WITH NATURALISM

In the summer of 1975 my friend Henry Geldzahler, the exhibitions organizer and critic, had come over to see *The Rake's Progress* and when he went back to New York he invited me to go with him to Fire Island, just outside New York. I went for a month to The Pines, on Fire Island, which was a kind of mad, gay resort. I had a lovely month.

On Fire Island I read Wallace Stevens, whose poems I didn't really know. The only poem of his I'd ever come across, one that is in a lot of English anthologies, was 'The Emperor of Ice Cream'; the title alone had always attracted me. Now I came across 'The Man with the Blue Guitar'. I wasn't sure what it was about; it seemed to me to be about the imagination in some way. But I was thrilled with it. The second time I read it, I read it out loud to a friend, which made it much clearer. It is also about Picasso, about the imagination transforming things, the way you see. I began some drawings inspired by this poem. I later did the series of twenty

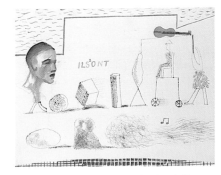

21 *Ils² Ont*, inscribed on the back 'La vie commence à quarante ans', 1976

This is a sketch I made on Fire Island after reading Wallace Stevens's *The Man with the Blue Guitar*, rehearsing ideas for the etchings.

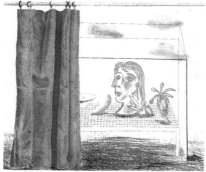

22 *Top:* 'I Say They Are', from *The Blue Guitar*, 1976–77

23 *Above:* 'What Is This Picasso?', from *The Blue Guitar*, 1976–77

The Blue Guitar etchings, of which there were twenty, were inspired by a poem by Wallace Stevens, which was itself inspired by Picasso's *The Blue Guitarist*. They were done in 1976 and 1977. Here, too, I was breaking out of naturalism. It was while I was still working on these, in early 1977, that I started *Self-Portrait with Blue Guitar* (*right*), my first self-portrait on canvas, which appears in *Model with Unfinished Self-Portrait* (*opposite top*). In the latter painting, the figure on the bed is Gregory, who was visiting at the time.

etchings on 'The Blue Guitar', using a technique devised for Picasso by Aldo Crommelynck. I began these etchings, 'The Man with the Blue Guitar', in the autumn of 1976 and they were published in 1977.

The ideas for these etchings quickly started developing and moving about, and I got excited and realized I was breaking out of naturalism. Oddly enough, after working in the theatre, which is a box, I abandoned in some ways the idea of the painting as space in a box.

My first painting which resulted from these insights was *Self-Portrait with Blue Guitar*, then *Model with Unfinished Self-Portrait*. Both were painted in Pembroke Studios in London in 1977. When I'd finished the etchings on 'The Blue Guitar' I decided to visit California – I hadn't been since 1974. The printer Maurice Payne came with me. We flew to Denver, where we rented a car and drove to L.A. It was a wonderful two-day drive over the Rockies and through the canyons.

When I got back to London I settled at Pembroke Studios, which I liked at first. Not too many people knew I was there. Each time you move back you have a nice period when it's quiet, the 'phone doesn't ring much, you can get on with work and see only a few friends. Despite what some people may think, I tend to live in a rather intimate world of a few people, close friends who are very respectful of my time, and if I want to work they let me. I started feeling much better, I felt that the work was going somewhere again. I had sold my apartment at Powis Terrace and with the money I bought the top of the same house and converted it into a studio. I moved back to the new studio in Powis Terrace in the summer of 1977 and I let Peter Schlesinger stay in Pembroke Studios. But I did not really want to stay in London and one morning I suddenly thought, I've only just built this studio, but I don't want to spend the rest of my life here. I couldn't face that – it all seemed so fixed.

24 *Self-Portrait with Blue Guitar*, 1977

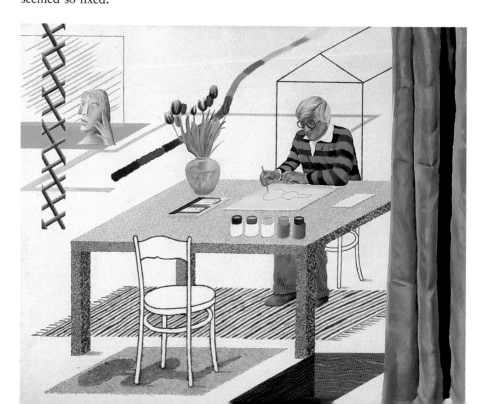

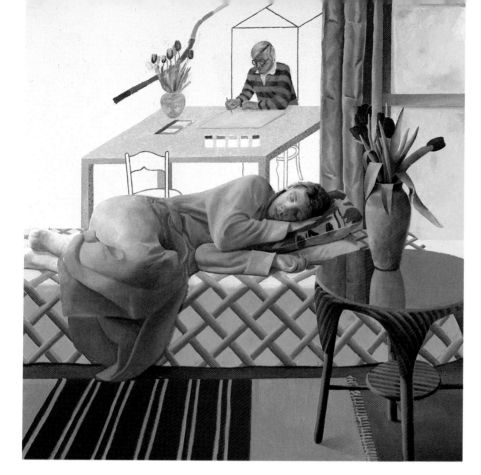

25 *Model with Unfinished Self-Portrait*, 1977

At this point I decided to go to New York to design *The Magic Flute* for the 1978 season at Glyndebourne, after I'd done research on it. Someone lent me an apartment for three months, the longest I had ever stayed there. I wanted peace and quiet without interruption; I had found it very hard again working in London. I came back to London at Christmas 1977 with the models and then finished the work in the new studio at Powis Terrace. I hated that studio, I hated being back in that house. Ever since Peter Schlesinger had left me in 1971 I hadn't wanted to live there; that is why I had gone off to Paris and started doing a lot of travelling again. When I moved to the new studio upstairs in Powis Terrace in 1977 Gregory visited often when he came over from Spain where he'd been living. I painted and drew him a lot. But I really didn't like going back to Powis Terrace. It was quite a beautiful studio, but I felt cut off. In my old apartment downstairs my studio had looked out over Powis Terrace so that if I was sitting at the table drawing I could see what was going on in the street. I could see the people walking up and down, ladies gossiping in the dry cleaners; I had known everything that was going on, and I missed that. In the new studio up at the top of the house I felt a bit like the baron in his castle, cut off, with the peasants below, which was not my idea of myself at all. I couldn't bear the thought of spending the rest of my life there. The only paintings I made there were *My Parents* and *Looking at Pictures on a Screen*, both in 1977.

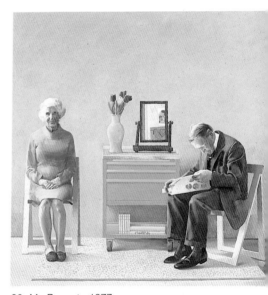

26 *My Parents*, 1977

26,93

27 *In a Chiaroscuro*, 1977

34

I had been living with Gregory Evans on and off. I spent a lot of time with him and made some paintings of him in 1976 and 1977, including *Model with Unfinished Self-Portrait* (1977). Pembroke Studios had not been adequate either. It was fairly small, and the studio had to be the living room as well. I might not go out much but I like people around, coming to visit, and when you start working a lot the room gets messy, especially if you're not a very tidy painter.

28 *Abuo Shakra Restaurant, Cairo,*
1978

29 Joe MacDonald, 1978

Peter Schlesinger and Joe MacDonald, who went with me on the trip to Egypt in the spring of 1978.

TIME IN EGYPT

In the spring of 1978 I went to Egypt. I'd finished designing *The Magic Flute* and I decided it would be nice to visit Egypt again. I went with an American friend called Joe MacDonald and with Peter Schlesinger, the three of us. We went on a Bale's tour, which was quite amusing. When I went to the travel agent to see about getting three tickets they said you can go for £200, two weeks including the hotels and everything thrown in as a tour. So the three of us went on that.

There were about twenty-five people in the group – quite a few Americans and an Englishman who was, we were told, a pyramidologist. I knew nothing about pyramidology; it seemed to be a kind of pseudo-science to do with numbers and measurement of the pyramids, the Great Pyramid. Some of the Americans in the group also turned out to be pyramidologists; they were from Tennessee. Joe and Peter were a little snobbish about them; they thought they were hick Americans and that I shouldn't spend my time talking to them. But I told them, they're more interesting than you think. I was amused, actually, by all this pyramidology, although I could see it was perhaps rather silly. The Englishman in charge seemed to be a marvellous kind of man; there was something fascinating about him. So I listened sometimes, when we went off on little tours, to what he said. And then sometimes he'd stop speaking if I went over, perhaps because I had all these intimidating guide books I'd taken with me. I always read guide books and I even had with me an old Baedeker from 1910 which gives very extensive coverage of some of the monuments.

I would read up about them every evening before we went to look at them. You get very interested in Egyptian history when you are there; and, looking back, I realize it was a rather wonderful holiday. Egypt is one of the most thrilling countries I've ever been to in the sense that these monuments are the oldest known buildings anywhere. After all, when Cleopatra showed Julius Caesar the pyramids they were already two thousand years old and more. It is quite awe-inspiring; not even in China are there things older, and I think you feel connected with them, whoever you are. You feel that civilization as we know it comes from this area. I would often go and sit on the banks of the Nile. In Luxor, where there are lovely sunsets, I'd sometimes sit and watch the river. Perhaps the pyramidologists had had

25

some kind of effect on me, but it does make you think. It took two thousand years to build the temple at Karnak; they worshipped in it for two thousand years and it's been a ruin for two thousand years – and the state it's in now is very impressive. What was it like with the golden gates and the painted pillars?

Sitting on the banks of the Nile, alone, I was thinking that perhaps we live in a very arrogant age that thinks it knows a great deal. In Egypt they had three thousand years of civilization, keeping records, and they learned about the Nile and the floods at certain times, and they used what they knew for irrigation, so it did occur to me that they might well have observed bigger cycles of events that we, in our arrogance, have not observed. We have had two thousand years of Christianity, and supposing every seven or eight hundred years there was a certain cycle of human affairs, that would only be three cycles in the whole era of Christendom. We have probably not recorded enough over a long enough period to notice changes and cycles as the Egyptians did.

You start thinking of things like this in Egypt because of the very long historical periods involved. I always find this stimulating to my imagination. I drew all the time I was there. I like even modern Egypt, the people; my impression of them is that they are rather gentle. I do not speak Arabic, so no doubt I miss things I can't understand, but I like the place. I made drawings of modern Egypt and when I came back I painted a picture of a café in Luxor which I then forgot about. It turned up in a sale in New York last year; somebody had paid a lot of money for it! I saw it reproduced in the catalogue and I must admit it looked a lot better than I imagined.

30

It was only a two-week trip to Egypt, but every day of it is vivid to me. There are times in your life when you travel, or are in one particular place, and you can remember almost everything about a day. I remember in Cairo going to visit the oldest mosque – built about 800–810 – a very simple, beautiful place. It's like a cloister with a simple tower in the middle; I hadn't seen it the previous time I was in Egypt. I loved all that Islamic side of Cairo. Islamic decorative art is very beautiful. It is a rich experience: you've got the marvellous, ancient world that you feel even to this day, and then the Islamic world that is interesting, especially the older mosques. It makes you wonder that one never hears about Islamic art being made today. I don't know whether there are artists any more, but you think if they're going back to fundamentalism they might go back to making wonderful art as well, or encourage it. It seems to me a contradiction that they should have television, but that there should be a law saying they shouldn't have images of humans. If they're really fundamental they shouldn't have any images at all. Perhaps they should go further and make a marvellous art again.

As a child in Bradford I used to cycle over to York Minster and climb up the steps to the top of the tower. York Minster, which is five or six hundred years old,

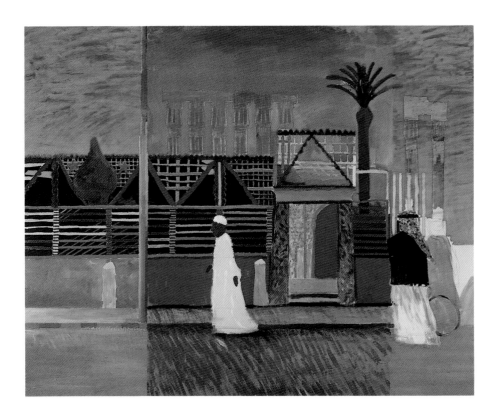

seemed old. But when you're sitting in the temple at Luxor, six hundred years seems practically modern. And so it does affect you, this thing about time. Also, when you're sitting on the banks of the Nile, you watch the sunset, you're looking at this space, at the sky, you're thinking of the river flowing past you, how long it's been flowing there. This river has been observed for five thousand years. Five thousand years ago, who was on the Thames?

If you've never been to Egypt and you start reading about different dynasties it all seems a little boring; it doesn't seem alive, there's something missing. But the moment you're there it becomes vivid: Ramses II seems vivid, the Pharaohs come alive and you get carried away.

At the end even Joe and Peter said it was marvellous, and agreed that all the people on the tour had been interesting. I said, Look, the kind of people who come on these tours aren't the kind of people who go to the Costa Brava for two weeks. There were two ladies from Edinburgh in their late seventies: they didn't miss a thing, they went everywhere. There were couples, middle-aged couples, and you could tell it was the wife who had really said they should go to Egypt, and the husband, the rather loving husband, had dutifully gone along and was somewhat less interested. I remember two couples: the wives were very keen and they too had guidebooks and would talk about things and would see me reading and so talk about them with me, and the husbands were always slightly behind, a bit like the couple in *Monsieur Hulot's Holiday*.

When we got back to London I got to work again on *The Magic Flute* and went straight to Glyndebourne. I had shown the models of the *The Magic Flute* to Robert Bryan, the lighting man at Glyndebourne. When you show models to people who are going to make them for the stage it's different from showing them to friends. People who are not going to have to do anything come to look and say, Ooh, aah yeah, that's beautiful, that. But practical people at the theatre don't do that: they think, how are we going to make this, how are we going to do that? I remember Robert Bryan pondering over the models and then saying to me, It will be very difficult to light.

Lighting was something I'd never paid much attention to. When I did *The Rake's Progress* I didn't think about it at all and it wasn't well lit. My designs for *The Magic Flute* were made up of about thirty-five drops just going up and down, painted, each with an allusion on it. I realized in talking to the lighting man that nobody had done theatre like this for quite a long time. It was a rather old-fashioned technique and the lighting people were not used to it any longer. Many designers for the theatre had been architects and in their designs they were putting objects in space. Lighting objects in space is quite different from lighting a flat surface. You get shadows when you light objects. The objects cast the shadows from the lights in a three-dimensional way. But if you are lighting flat surfaces, you have got to paint the shadows. When we got my painted drops to the theatre it did turn out that they were difficult to light. What also turned out was that they had made a mistake; they'd told me I could use all the drops which would normally be

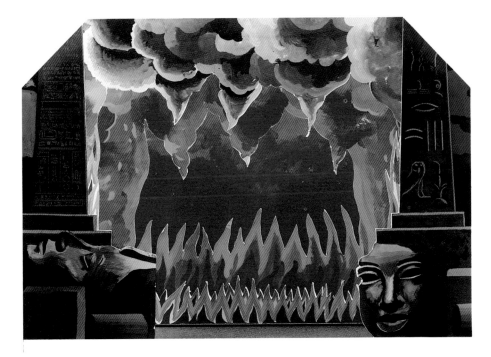

31 *Trial by Fire*, model for *The Magic Flute*, 1977

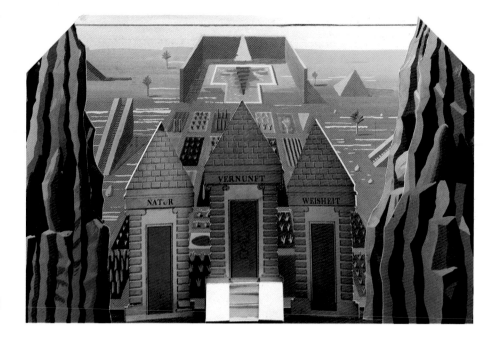

People often assume that my trip to
Egypt influenced the designs for *The
Magic Flute*, but in fact I had finished all
the models before we went.

33, 34 *Opposite: An Avenue of Palms*,
model for *The Magic Flute*, 1977

available at Glyndebourne, but we couldn't, and everything got squashed up a bit,
which I didn't like. We couldn't fly in the little boys in Act 1, Scene 3, because there
wasn't enough room, so they were wheeled in. I was disturbed by all that and
disappointed. I thought it was very important that these little boys should fly.
Nevertheless, theatre is compromise, collaboration also means compromise, and
you do compromise and it usually works.

In the fire and water scenes the curtain never came down for scene changes. If
you were backstage you saw people running around with lights, moving them by
hand, quickly. They were running around putting lights in terribly awkward places
and sometimes somebody would just hold for a minute, because those scenes are
very short, and then he'd have to move and put the lights somewhere else.
Nowadays in the theatre they don't like this sort of thing. They want everything to
be organized and programmed so you don't have to have a man holding something
in an awkward position. Anyway, they did a very good job, but I realized that in
future I must consider the lighting properly. My disappointment in the
Glyndebourne production was that the sense of space was lost. Nevertheless, the
audiences enjoyed it and some people thought it was better than *The Rake's
Progress*. *The Magic Flute* is a more immediately enjoyable opera: Mozart's music
is sheer delight, ranging from the marvellously comic to the sublime.

I read a great deal about *The Magic Flute* before doing it and I'd seen many
productions. Some critics have written that the plot was changed halfway through
and that it didn't make sense. I never understood that. It made sense to me, if you
looked at it a certain way. The criticism was that the Queen of the Night is seen first
as a bereaved woman and Sarastro as wicked; then it changes and it is Sarastro who

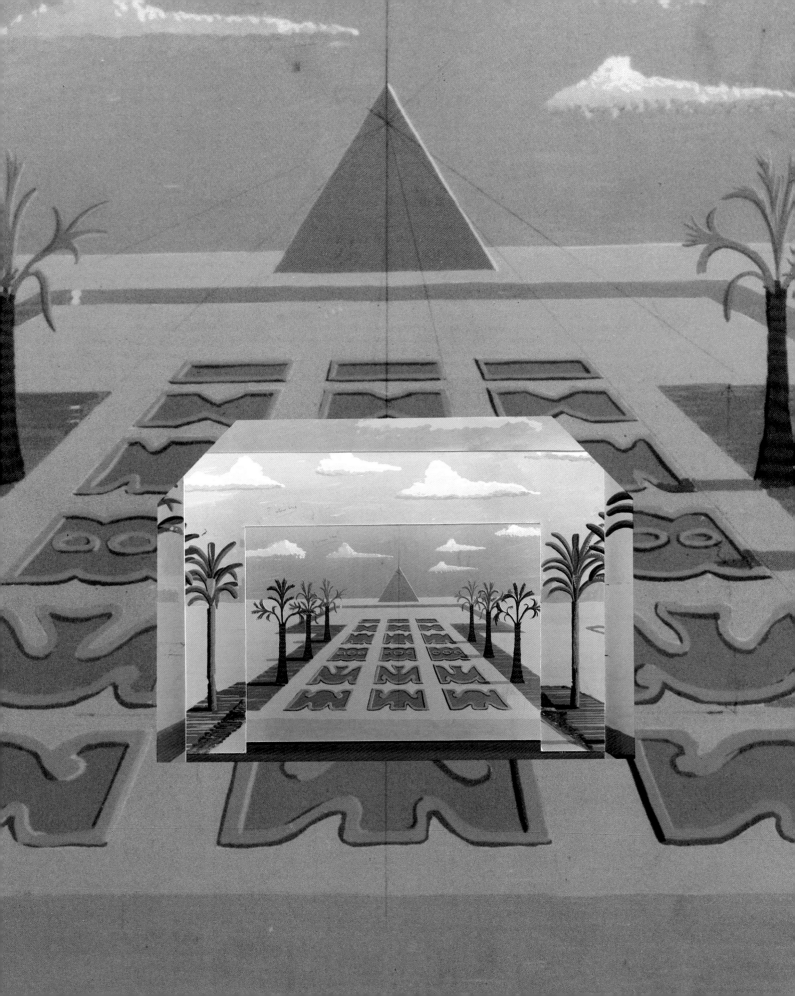

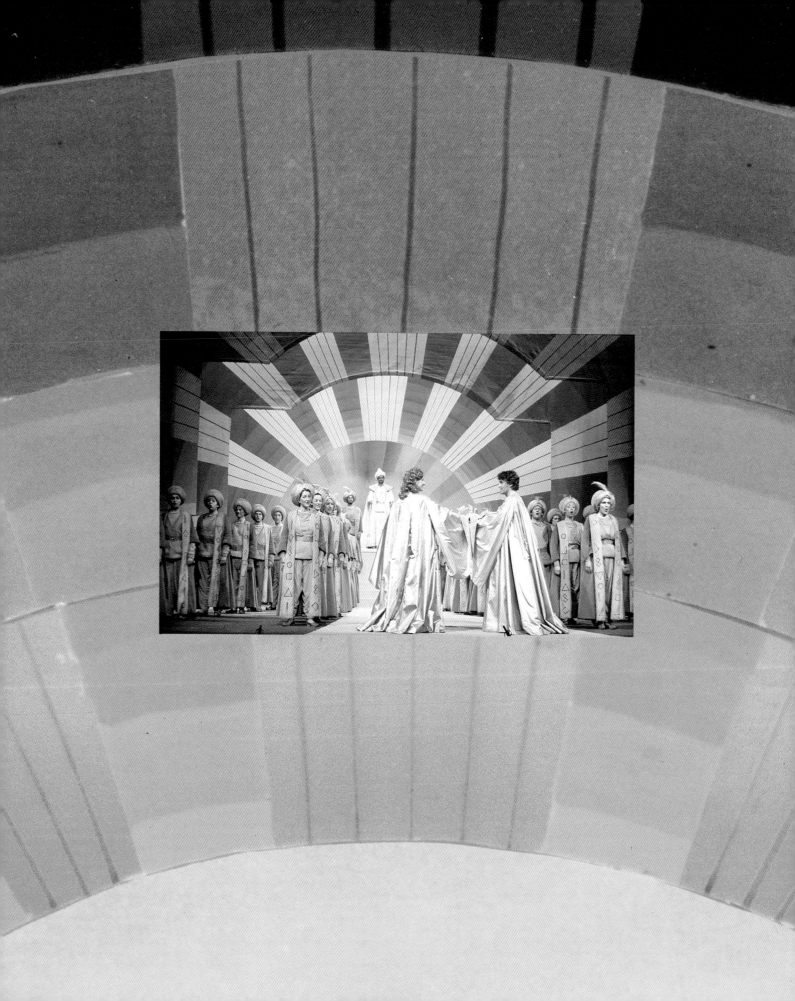

is good and the Queen wicked. But seen in a different way it seems to me that *is* how you would begin: if the Queen is deceitful, of course she's going to say she's been wronged at the start. It seemed quite clear to me. And I think we told the story in a clear way; I wanted to do that. The music's clarity is perfect. And it has a lot of depth, everything to do with Sarastro has, especially just before the trial. And everything about it, the separation and union of characters, the trial, all add up to a marvellous, profound work. To my surprise, it is not the most popular of Mozart's operas; *Don Giovanni* is always considered the greatest. Some musicians at Glyndebourne told me that when they saw it on television they realized they'd never quite understood *The Magic Flute* and this production clarified it for them.

When we did it at La Scala in Milan, in 1983, it was better. At first, when they asked me to do it at La Scala, I thought it would probably not work there, as it had originally been designed for a small theatre. But at La Scala they re-made it all on a big scale, using the models. I must admit, it turned out to be terrific. The three little boys, too, were wonderful. That little quartet when the three boys and Pamina sing together, so you get four soprano voices, three of them boys and one a girl, was just beautiful. Little boys' voices have an innocence that, in a sense, a woman's can't have; and that is in the music.

I had explained to them it wasn't easy to do the lighting. At Glyndebourne we had succeeded and Robert Bryan had done a good job, but it was not easy. I assumed it would be simpler in a bigger theatre because you have more space between the drops. And as it turned out, the lighting was stunning; the lighting man was fantastic. He sat in the theatre with a telephone – to communicate with the technicians on the stage – and a notebook; none of those computer boards with a little TV set with millions of numbers on buttons, which they have even at Glyndebourne. He just had this telephone and a notebook and I sat next to him with an interpreter.

This was the second time I had worked at La Scala – they had also done *The Rake's Progress* – and I'd always got on with their stagehands and staff, even though I know hardly any Italian and they knew hardly any English. The Italians think language is only one way of communicating and that there are others: you can sing or you can smile, for instance. They were always amused by something or other I was wearing and we could even talk. I would explain to the man who was doing the lighting what I wanted with the lights and he'd just nod. I think he thoroughly enjoyed it. He was obviously very visual and could see what one was doing and how beautiful it could be. He put a lot into it. The only trouble is they're always having strikes. In the end I only saw one full performance because of strikes, but I did enjoy it. Right at the end of the opera, with the rising sun – the night has stricken out the day, the sun has stricken out the night – as that last scene lit up, we lit up all the boxes in the theatre and it was beautiful!

35 *The Triumph of Light*, model for *The Magic Flute*, 1977 (detail)

36 *Inset:* The finale of *The Magic Flute*, showing the union of Pamina and Tamino, 1977

In the summer of 1977 I had already started toying with the idea of moving to California. I didn't discuss it with many people, but I was becoming very firm in my mind that I wanted to leave London and go to California. I thought, that's really where I should be, it's where my heart is, it's where I want to go: so I made up my mind. I did say it to John Cox when we were in Bayreuth in the summer of 1978 after the opening of *The Magic Flute* at Glyndebourne. We were staying about half an hour from Bayreuth in a hotel in the countryside. I told him I felt a bit unhappy in England. I said, I think I'd rather go back to California. I would have stayed there from the sixties onwards if it hadn't been for Peter Schlesinger who wanted to be in London, and frankly I didn't mind where I was at that time. But I really felt more at home in California. I said to John Cox, I think that's what I'm going to do. We went to *The Ring* that year, which was in July, and it was then that I made up my mind to go.

I love Wagner and I love *The Ring*. The first time I saw it, in 1974, I was staying with two friends at an inn in the centre of Bayreuth. When you are there you know you have gone to have a unique experience: this one work of art which takes a week. You never forget why you're there because Bayreuth is not a very big town. Everywhere you looked there were pictures of Wagner and Herbert von Karajan. It's quite different from, say, seeing a *Ring* in London, even if they were to take a week doing it. The moment you have left Covent Garden you are back in London where there is so much else going on. When you are in a town as small as Bayreuth you always know why you're there.

I spent the days reading the librettos. I prepared myself each day, as I think most people do. It takes you a week and it is this one massive work. I remember in 1974, the first time I'd been, walking back to the inn after *Götterdämmerung*; we didn't speak. The 1978 production was by Patrice Chéreau, conducted by Pierre Boulez. Some parts of it were stunning theatre, other parts didn't quite work; unfortunately the end didn't, I thought. It was one way of doing it. I think you can do a *Ring* in many other ways. There was one particular scene in which I thought they had missed something which I have always thought was profoundly true in *The Ring*. There is a scene in *Siegfried* in which Fafner has changed himself into a dragon guarding the gold in a cave. The cave is in a forest, which is described beautifully in the music. The dragon sits with his back to the gold, blocking the cave and looking out to the forest. This image is wonderfully true of what happens to all of us when we are taken up with material things. If the dragon didn't have the gold he could enjoy the forest, he would have been frolicking in the greenery, he would have been more himself. The contrast between luscious, lovely, green nature and this ridiculous gold is to me a very powerful image, clearly evoked by wonderful music. It is an extremely complex work that has many levels to it. One

day I'd like to work on it. If I spent a whole year on *Tristan and Isolde* (1986–87) (see p.171), it would take me two years at least to do *The Ring*. I assume one day I will do it somewhere if they'll have me, but I can't rush it, I will take my time and think about it. It could be one of the most marvellous pieces of theatre. In fact it should be one of the most wonderful, biggest pieces of theatre ever done.

2 Staging the New

PAPER POOLS

I left England for California in the summer of 1978. At that time Maurice Payne was working for me and I sent him off to California ahead of me to find a space to work in and a house. He found a house on Miller Drive, just above Sunset Boulevard, and a studio on Santa Monica Boulevard. So I went off. When I walked out of Powis Terrace and pulled the door to, I said to myself, I never want to come back again while I own it. When I got to New York I called up my brother and said, Sell Powis Terrace, I do not really want to live there any more, I think I'll stay in California for good, I'll find a place to buy here. I always felt kind of impotent in England; I never felt I was in control of things myself. There are aspects of English life that have always irritated me greatly. People never seemed to get anything done. And I felt not quite at home in London. After all, I'm not a Londoner. I was eighteen when I first went to London on a visit, somebody born two hundred miles to the north.

On my way to California I stopped off with Ken Tyler at Bedford Village, in upstate New York, and made all the *Paper Pools*. I had misplaced my driving licence and the replacement hadn't arrived, and in Los Angeles you can't get around unless you can drive. I'd had a California licence before but then when I'd lived in England it had run out and I'd had to get an English driving licence. In fact, I had to take the test twice, because the first time I went down with my California licence to the back streets of Wimbledon they failed me even though I'd driven the previous year about fifty thousand miles in the United States. I said I could drive but they said, Ah yes, but we don't teach you how to drive, we teach you how to pass the driving test. You have to do all that looking in the mirror very consciously. You can't just glance in the mirror, you have to turn your head and look at the mirror long enough to make sure the man who's giving the test sees you doing it. So I was going to wait for the replacement licence at Ken Tyler's.

37 *Ken Tyler*, 1978

By the time my driving licence came I was so involved in the work on *Paper Pools* I stayed on until October. Gregory came and helped in making the *Paper Pools*, together with Ken and Lindsay Green. We were making unique objects, not prints, and it was thrilling work. We worked long hours but we liked it. Ken is incredibly energetic and inventive. In using this paper pulp technique, you had to be bold. It is the exact opposite of an etching needle. An etching needle has a fine point, you put it on this lovely wax surface and you are drawing with a line. Here line meant nothing. It couldn't be line; it had to be mass, it had to be colour.

One other reason why I became so absorbed in *Paper Pools* was because I started using what I thought at the time were much bolder colours. Whenever I left England, colours got stronger in the pictures. That was true in the sixties, for instance. I think this is partly because of the way a place affects you.

38,39 *Opposite* (detail) and *inset. Le Plongeur* (*Paper Pool 18*), 1978

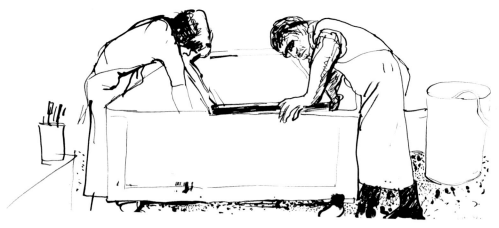

40 Untitled, 1978

Lindsay Green (*left*) and Ken (*right*) at the outdoor platform, laying down the metal moulds for a *Paper Pool*.

It was at Ken Tyler's graphic workshop in Bedford Village, just north of New York City, that all the *Paper Pools* were made. Ken and Lindsay Green made the pulp paper which contains the images – they are not made up on the surface. Sometimes, when there wasn't a lot for me to do, I drew them, using a big reed pen.

When we finished with the *Paper Pools* Gregory went to Spain for a while (he was living with a friend there) and then to Paris. And in October 1978 I came to California. Maurice Payne and I lived in Miller Drive, and I had the studio in Santa Monica Boulevard to start work in. When I got back there I finally started painting.

CHANGING STYLES

The first picture I painted, which I later called *Canyon Painting*, was only meant to be a way of testing some new acrylic paints which allowed you to use very bold colours, but I put it aside. I painted *Canyon Painting* with big brushes loaded with paint. California always affected me with colour. Because of the light you see more colour, people wear more colourful clothes, you notice it, it doesn't look garish: there is more colour in life here. I did a few other pictures that I abandoned – like a great big picture of Santa Monica Boulevard which I never got anywhere with. I worked on that for about six months – a massive picture twenty feet long – but I

45

48

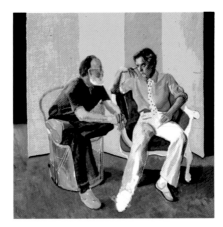

41 *The Conversation*, 1980

42 *Celia Elegant*, 1979

43 *Ann Combing Her Hair*, 1979

never got it together. I was still trying to work myself out of naturalistic depiction and conventional illusionistic space and that picture kept pulling me back. In fact, that was one of the reasons that made me deal with photography eventually. I painted other pictures: the portrait of Divine, *Kas Reading 'Professor Seagull'*, *The Conversation*, and I also did a series of lithographs of Celia and Ann.

I picked up a reed pen and started doing big drawings. These pens do not have a fine point and they make you draw a different way. Whatever your medium is you have to respond to it. I have always enjoyed swapping mediums about. I usually follow it, don't go against it. I like using different techniques. If you are given a stubby brush you draw in a different way. That's what I do often: I deliberately pick a medium which forces me to change direction.

I felt lost with *Santa Monica Blvd.* and I started painting other things, smaller pictures. I wasn't in a rush to do anything. After *Paper Pools* I just wanted to be quiet. I began to realize slowly that the little experiment, *Canyon Painting*, was perhaps a way of painting Los Angeles again, a different view of it – this was my first painting of Los Angeles for quite a long time, probably since the sixties, or very early seventies.

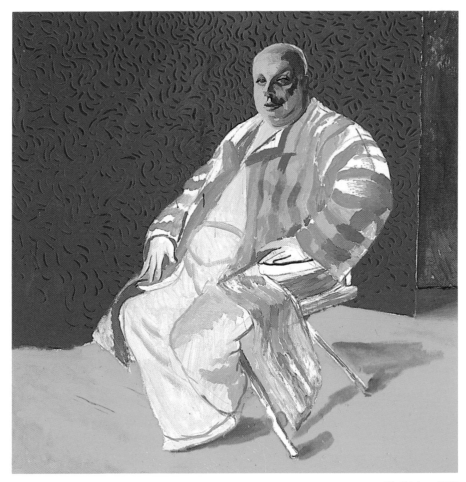

44 *Divine*, 1979

45 *Canyon Painting*, 1978

46 Untitled, 1979

I started *Canyon Painting* (*overleaf*) as a technical experiment, a way of testing new acrylic paints and trying out new colour combinations. I didn't take it seriously until I'd actually finished it. In *Santa Monica Blvd.* I used the same acrylic paints. In this painting I wanted to show the street life of Los Angeles and I began by taking a lot of photographs using a miniature Pentax Auto 110 camera so that people didn't know I was photographing them. Los Angeles streets are not like European streets: in Europe the buildings are created with pedestrians in mind; in Los Angeles everything is built to be looked at from a slow-moving car.

The painting was on a huge scale – twenty foot wide – and I spent six months working on it, only to abandon it eventually. At the time it seemed too static to me and I didn't think it worked. In a way it was the end of one phase and the beginning of another.

47 Untitled, 1979

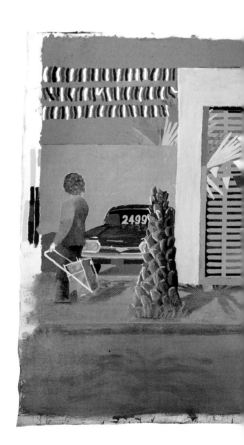

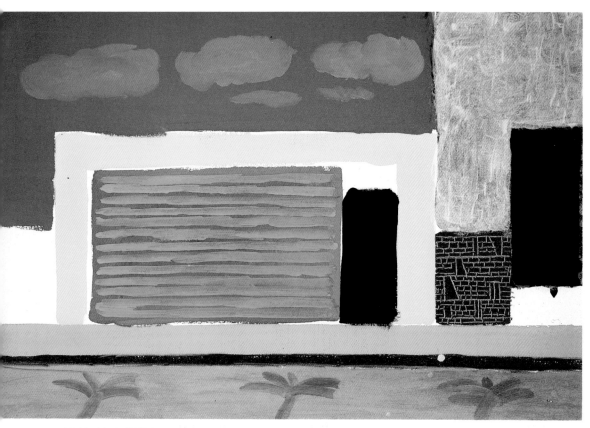

49 Untitled, 1979

48 *Santa Monica Blvd.*, 1979

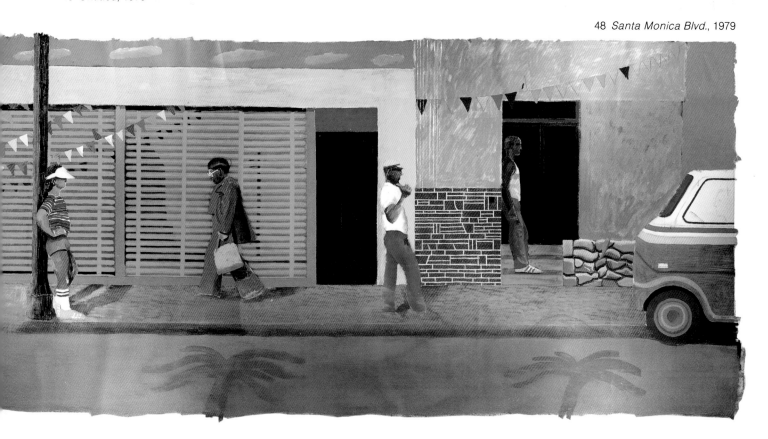

gesso

light + matte varnish

light + gloss polymer medium.

Hyplar matte medium + varnish

Hyplar gloss medium + varnish

48

70

The Santa Monica Boulevard painting I had blocked in quite quickly and I then kept struggling with it and altering it. I realized finally that I had probably painted about ten pictures on that canvas and I had kept taking them out. The picture had a horizontal format but the eye didn't move enough across it and the painting was too static. I wanted to get away from doing pictures in which the static element had become dominant. Later I was to use the same format in *Mulholland Drive: The Road to the Studio* (1980) and in *A Visit with Christopher and Don, Santa Monica Canyon* (1984), both of which have exactly the same shape. *Santa Monica Blvd.* had too many horizontals in it which were emphasized in a canvas of this size, which was itself a horizontal shape. The two later paintings hardly have any horizontals in them. I thought I shouldn't do this again, work over and over again on one picture, but simply do another. And so I did start painting much more quickly and broadly. I realized that's what one should do. Spending too long on one picture can easily make it ponderous and overworked. When I started working fast it all started getting fresh. And I also began using acrylic paints again. Now I alternate, sometimes I paint in oils, sometimes not.

I had leased the house for a year and the lease was up, so I decided to look for another. I found the house where I live now and at first I rented it. The studio was not where it is now, the house was a lot plainer, but it was nice and I liked the space of it. Gregory came from Paris and he and I moved in on 1st August 1979.

I was quite in love with Gregory. We got on very well together for a long time. It wasn't quite the same as it had been with Peter Schlesinger because Gregory had other friends and would sometimes go off. He had a friend who'd come to live in New York, a Spanish boy, so it wasn't quite the same. I think I wanted to make sure

it wasn't, because I'd been deeply unhappy after the relationship with Peter had ended and you guard against it happening again. I realized that I might be doing that. It can't really happen twice the same way. Gregory was always a terrific help. He was the only assistant I had on *Parade*.

THE FIRST TRIPLE BILL

In 1979 John Dexter, the British director who was then working at the Metropolian Opera House, approached me about designing a triple bill for the Metropolitan Opera, which was to be done in February 1981. I loved his idea; it was a fresh approach to do a triple bill: Eric Satie's ballet, *Parade*, which provided the title for the whole programme, and two short operas, Francis Poulenc's *Les Mamelles de Tirésias* and Maurice Ravel's *L'Enfant et les sortilèges*. I had heard the Poulenc piece on records, and *Parade*, but I did not know the Ravel opera and when I listened to it and read the story it greatly appealed to me. John Dexter pointed out that triple bills had a notorious failure rate at the Opera; they were not liked, not like ballets, where you *can* do three together. Of course I knew Picasso had done *Parade*.

The first drawings I made for the triple bill, and I did a lot of them, I called 'French Marks' because, listening to that French music by Satie, Poulenc and Ravel, I thought the one thing the French were marvellous at, the great French painters, was making beautiful marks: Picasso can't make a bad mark, Dufy makes beautiful marks, Matisse makes beautiful marks. So I did a number of drawings using brushes, letting my arm flow free, exploring ways of bringing together French painting and music.

52–54

51 Bar and Sea, from *Les Mamelles de Tirésias*, 1980

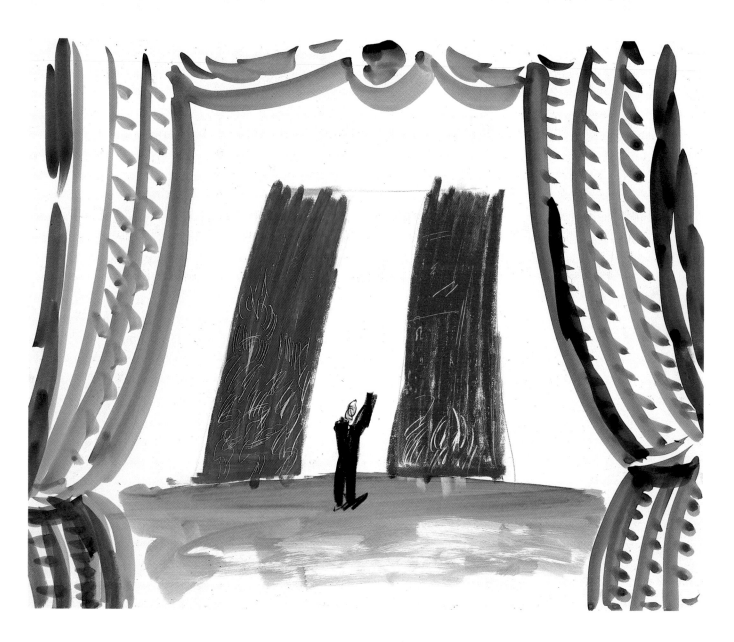

52 The Orchestra as a French Flag, from *Les Mamelles de Tirésias*, 1980

I had been looking at early 20th-century French painting for inspiration for the triple bill and I made a series of watercolours which I called 'French Marks', in homage to Picasso, Dufy and Matisse, none of whom ever made a bad mark.

53 French Marks Curtains with Airy Garden, from *L'Enfant et les sortilèges*, 1980

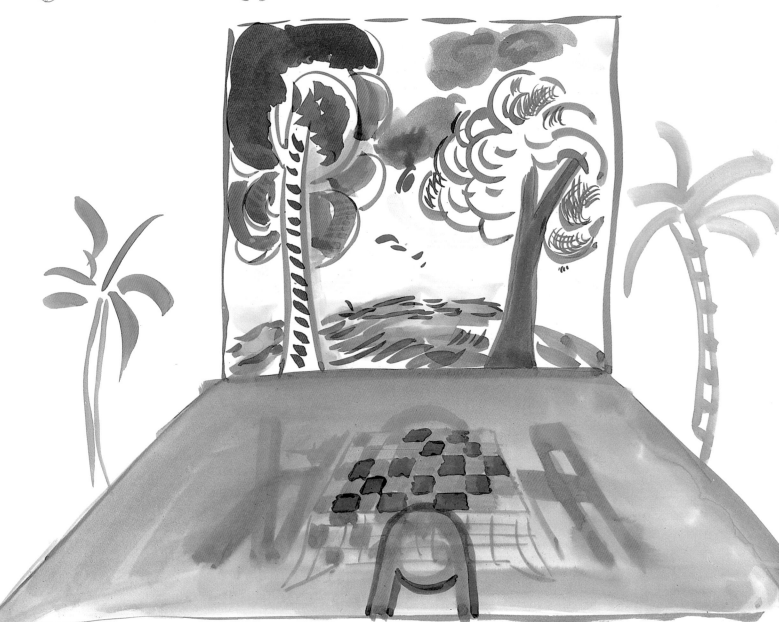

54 Painted Floor with Garden and French Marks, from *L'Enfant et les sortilèges*, 1980

John Dexter came out a few times and we did a lot of work on *Parade*. Whenever he came for three or four days we did an amazing amount of work; we'd work twelve hours a day. I got on very well with him. Our collaboration was enriching for me. It was his idea to put these three works together. The problem with a short opera is that you have to put it on together with something else and that always makes it difficult. But this idea of John's to link these three works together was brilliant, I could see how they fitted. Moreover, he was very visual, he had a keen eye, and so we worked well together. I knew John was good; I had never worked with him before, but I had seen things he'd done on the stage, and we saw eye to eye. Occasionally we might disagree over some tiny detail, but it was never anything important, it was never the basic concepts. In the end, John was rightly proud of the production as a piece of theatre using an ensemble, not stars.

We began in September and by Christmas we had finished designing the operas. The ballet was always a problem because Rudolf Nureyev was supposed to be doing the choreography and I found it very hard to work with him. I would do a lot of drawings, come up with a lot of ideas, but he didn't seem to respond, didn't seem to care what the other two pieces of the triple bill were like, while I, of course,

realized that what was most important was to make an evening of unity, that we had to give it a unity if it were to make sense. That was what John Dexter and I wanted. Nureyev was the wrong person to ask. But he was a star and I think the Metropolitan Opera felt they needed a star in the ballet and on the programme because there were no star singers. And it was the first piece of theatre I had done in New York so people would not necessarily know my work. Dexter was known but Nureyev was the only star name. In the end he backed out and they got another choreographer. The ballet turned out to be the hardest thing to do, though I had supposed it would be the easiest. You cannot clutter up the stage for a ballet; it has to be pretty empty, in contrast to an opera where the singers can walk around the sets. I swore I would never do a ballet again.

For the Ravel *L'Enfant et les sortilèges* I decided to start by looking in toyshops. I went to one on Hollywood Boulevard and, on a hunch, I bought a set of children's letter blocks, some little dolls and a little clockwork plastic squirrel. I put the building blocks on the model stage to spell 'Ravel'. I didn't quite know what to do but I thought that there was perhaps an idea there.

I asked John Dexter to come to L.A. again. It was a rainy day and our roof had leaked onto the model. But I was very keen to get started and I went to pick John up at breakfast time at the Beverly Hills Hotel. He was a bit annoyed with me because he hadn't planned on coming up to my house until later in the day. But I brought him up and showed him the two models for the Poulenc *Les Mamelles de Tirésias* and he chose one. He said, This is the one, this is how we can do it, the one with the

56 Untitled, 1980

I bought the building blocks from a toyshop on a hunch, thinking there might be the germ of an idea there for staging *L'Enfant et les sortilèges*. It's a difficult opera to stage and, as it turned out, the blocks were perfect. The fact that they were six-sided meant that we could turn them over to represent many different things.

58 *Opposite above:* Untitled, *Parade*, 1980

59 *Opposite below: Zanzibar with Postcard and Kiosk*, from *Les Mamelles de Tirésias*, 1980

Les Mamelles de Tirésias takes place in Zanzibar, an imaginary resort on the French Riviera, in about 1910. For the sets I drew inspiration from Dufy's harbour paintings.

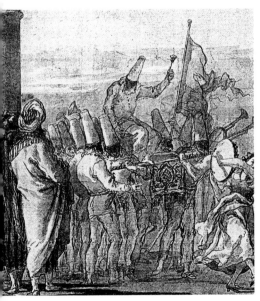

57 Giovanni Domenico Tiepolo (1727–1804), *The Triumph of Punchinello* (detail)

It was this drawing by Tiepolo, which John Dexter spotted in a review in the *New York Times*, that gave us the solution to the problem of the chorus in *L'Enfant et les sortilèges.*

three drops. Then he said, What about the Ravel? After we'd talked about it for a while I said, I'm just getting going but I'll show you what I'm thinking, and I put the name 'Ravel' on the blocks on the stage and a little French cut-out book behind them of a lady in a kitchen. He looked at it and his eyes lit up when he saw the blocks. He said, Can we spell 'Maurice' with them? We didn't have quite enough letters so I asked Gregory to rush down to the toyshop to buy another box. Then we got the twelve letters of 'Maurice Ravel' spelled out, and then John said, Of course we can use this; they've all got six sides and we can flick them over and represent with different sides of the blocks things like the furniture, etc. That afternoon we blocked the whole thing out. I crudely painted the sides of the blocks, making a fireplace, furniture, books and so on, to show how they could be transformed. At the end of that afternoon we knew we'd found a good solution. The Ravel is a difficult opera to stage: there are chairs, a teapot, cups and saucers and flames leaping out of the fireplace, and they all sing. Very few productions have ever succeeded well; it has a history of failed productions. But John was very turned on and so was I.

In the Ravel there is a chorus of sixty people. The conductor, Manuel Rosenthal, had said that the best place to put them to get the right sound was bang in the middle of the stage. Well, there goes your picture, I thought. How are we going to make a picture? But he insisted it was the best place. So I accepted the challenge and thought that maybe we could make it look as though they disappeared. The solution to this problem was to be found later.

It took me quite a while to do the drops. And I had to do many versions of the room – with the window cut in, so that the characters could be outside the window in a later scene – before I got the perspectives. And I did start playing with the lighting, the red and the blue, especially for the tree. I realized you could make the tree speak by altering its colours with the lights. I kept going back and forth to New York. Every two weeks or so I went to New York for a few days to see John Dexter and discuss things.

We still had to figure out what the chorus would look like. I said, If you're putting them in the middle, which is what the conductor wants, they should look neutral, we might perhaps dress them in black tie. I had been looking at the *commedia dell'arte* figures for ideas when John Dexter rang me up and said, There's a picture in the *New York Times* today that I think is a solution for the chorus; just look at it. He didn't even say what the picture was. I put the 'phone down and went to get a copy. I looked through and there was a review by Hilton Kramer of a show of the drawings of Giovanni Domenico Tiepolo (at Stanford University Museum of Art), illustrated with a drawing showing Punchinello being carried by his friends. It was the Punchinello! I rang John back and said, It *is* the Punchinello drawing, isn't it? And he said, Yes, it's in a marvellous exhibition. And I said I'd go

Quelle Chance

Roman

61 *Gregory's Painting*, 1980

to New York right away to see it. I flew to New York the next day just to see that exhibition, which I thought was just wonderful! You had to spend a long time with every single drawing to scrutinize it. Eighteenth-century drawings can be pretty boring, but these were marvellous. The skill of the drawing was superb. I sent many people who would never otherwise have thought of going.

I had only ever come across one or two of the Tiepolo drawings before, in books. What I noticed was that although all the Punchinellos looked alike they weren't actually uniform; there were variations in them. So when we came to using them for the Ravel chorus — because John and I had decided immediately that using Punchinellos for the chorus was a perfect solution — I chose to have them dressed in green and I pointed out to the Met costume people that this was not to be a rigid costume for everyone, that there should be variations; so we used the Tiepolo drawings to make them. Punchinello is a kind of Everyman. The titles of the drawings are marvellous: 'Baby Punchinello Being Entertained by a Caged Bird', 'Punchinellos Picking Fruit and Quarrelling', etc. One day in New York, when I was with John Dexter in a taxi, we started inventing Punchinello names. We just looked along the street: Punchinello selling hot dogs; Punchinello being arrested; Punchinello as a policeman. When the production eventually took place, stagehands came onto the stage to move things, so they too had to be dressed as Punchinellos. But because of the Stagehands' Union, or something, they could only be dressed up in the costumes for performances, not even for the dress rehearsal. When they finally got dressed, it was marvellous. Each one looked like a different character. One of them had a slouch and a beer belly and didn't like wearing the costume, but the way he walked out on the stage he looked like Punchinello as a weary stagehand. It was a brilliant idea because everything fitted. It was as though a troupe of actors had come to do the whole evening.

PAINTING AFTER *PARADE*

In the summer of 1980, Gregory and I went to London and stayed there for about six weeks to work on the Covent Garden performance of *Parade*, working on the designs, adapting them. John Dexter was there all that summer and I needed to work on it with him.

Before I went, I saw the great Picasso retrospective exhibition at the Museum of Modern Art in New York, and it made me want just to paint. I still had to do things for *Parade*, but the exhibition affected me so much I thought, God, if you want to paint, just paint. I thought, if Picasso was here and he had to work on *Parade*, what he would do would be to make paintings of the sets instead of doing them as gouaches — so that's what I did. In London I filled Pembroke Studios.

62 *Punchinello with Block*, from *L'Enfant et les sortilèges*, 1980

63 Untitled, 1980

64 *Horse for Parade I*, 1980

In the summer of 1980 I went to the Museum of Modern Art in New York to see the Picasso retrospective. I was deeply affected by the exhibition and it made me want just to paint. I was still working on *Parade*, but I said to myself, if Picasso were in your shoes he would *paint* the sets. So I did – I painted sixteen paintings in two months.

65 *Small Punchinello*, 1980

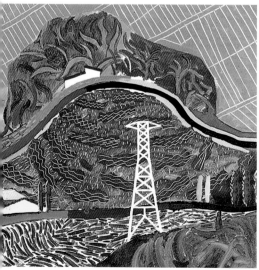

I painted sixteen paintings in two months. They were the paintings of *Les Mamelles de Tirésias*, *Ravel's Garden* and so on; they were all painted there. I put them up on the walls and by the end of the summer I had filled the studio.

I had with me the little models we had made for *Les Mamelles* and *L'Enfant* and we started doing the lighting effects. Up to now we had been using very crude lights to light the models. Then my friend David Graves, who was working for me, produced this boffin friend of his who built a lighting machine which allowed me to change the lights by pressing buttons. So I would play the music and match the lighting to the music; that was the first time I fully realized I must take an interest in the lighting as well, especially since I was using very strong colours. I then started playing versions of the opera a bit differently, from beginning to end because the operas were short – Ravel's is only forty-five minutes, so I could play it three or four times a night and practice the lighting with it.

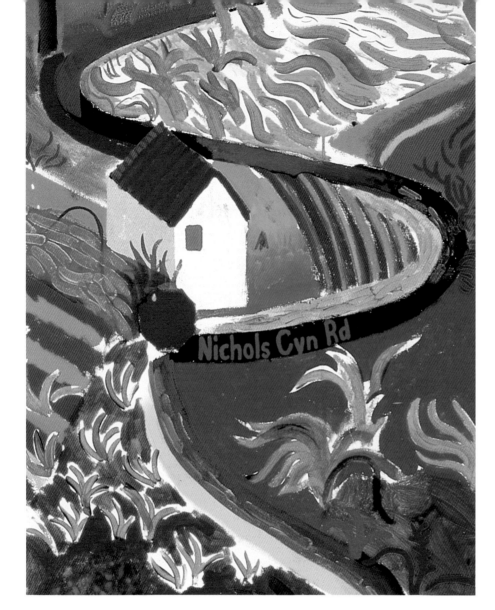

66, 67 *Opposite: Mulholland Drive: The Road to the Studio* (details), 1980

When I started living up in the Hollywood Hills, I drove every day down to my studio. I became fascinated by all these wiggly lines and they began to enter the paintings. From the hills, Los Angeles is a completely different experience. In fact, these pictures are more realistic than you might think. When you look at *Mulholland Drive* (*opposite*) – and *Drive* is not the name of the road, but the act of driving – your eye moves around the painting at about the same speed as a car drives along the road.

68 *Left: Nichols Canyon* (detail), 1980

69 *Nichols Canyon*, 1980

68,69

We went back to California in the autumn of 1980. I was anxious to continue painting. I started on *Nichols Canyon* and *Mulholland Drive: The Road to the Studio*. My house is in the Hollywood Hills. I had never lived up here before, I had never even been up here much. I didn't know many people who lived up in the Hills and if you don't know people in this area you don't come up because it's easy to get lost. The roads aren't straight and you don't know which one goes down the hill and which doesn't, so people tend to avoid the Hills. But the moment you live up here, you get a different view of Los Angeles. First of all, these wiggly lines seem to enter your life, and they entered the paintings. I began *Nichols Canyon*. I took a large canvas and drew a wiggly line down the middle which is what the roads seemed to be. I was living up in the hills and painting in my studio down the hills, so I was travelling back and forth every day, often two, three, four times a day. I actually *felt* those wiggly lines. This was a new perception for me of Los Angeles, a

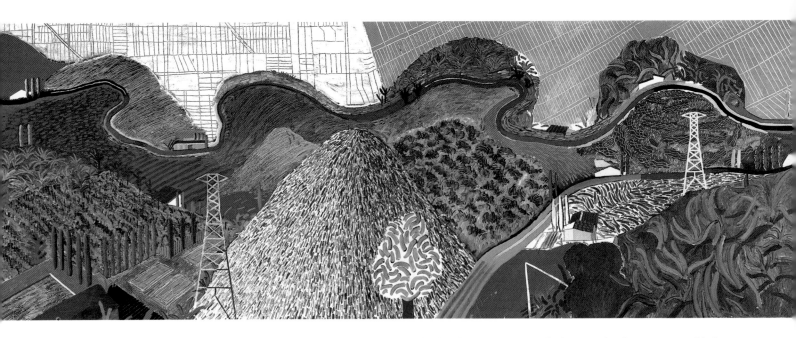

68,69

new experience of a city which is laid out in straight lines and cubes. You could also see the San Fernando Valley as a map from up here; you look down on it, even at night you can see all the streets, it's very clear. So I painted *Nichols Canyon* and *Mulholland Drive*, pictures which, if you live here, are more realistic than one may think. Colour too was getting bolder; I simply felt it again.

Then the Met cancelled their season. The orchestra had gone on strike in September and the people at the Met said they would cancel the season. That totally depressed me. I had put in an awful lot of effort and I knew it would work in the theatre; I was confident it would be really good. Having already done two operas, I knew well enough how the models would translate on the stage and I was convinced it would work as exciting theatre. I kept going to New York. The costume department carried on, but I kept asking, Are they really going to cancel it? I got so depressed; I thought, all that I've done will be wasted; they are not going to do it. They hadn't been too keen on it, anyway; it was the only new production they had ever done that was planned for only one season, not two.

Norman Rosenthal came to see me at that time from the Royal Academy. He was preparing a show in London, for January 1981, 'The New Spirit in Painting' – New Spirit sounded to me like a new kind of turpentine. I wasn't that interested in it, and Rosenthal was trying to get me to finish the *Mulholland Drive* painting. But my real heart was in *Parade* – that is what I really wanted to do. And I was feeling down because of the strike at the Met. Ken Tyler suggested I have a check-up and, I don't know why, I took his advice; I tend to avoid doctors usually. So I went for this check-up and they thought there was something wrong with my heart. For about three weeks, while I was painting *Mulholland Drive*, I heard every single heartbeat. I had more tests at UCLA and the man said, Have you had a heart attack?

70

I said, No, I haven't. He said, I don't know what you're doing here then, everything seems fine to me. I never went back and, frankly, I'm sure my heart was affected because of the strike at the Met.

Nichols Canyon and *Mulholland Drive* were painted in September and October 1980 when the strike was on at the Met. And I had at least also got the *Parade* paintings to show for it. The colour in those had become much bolder; I was taking that colour from Matisse for Ravel's *L'Enfant*.

69,70

Suddenly the strike at the Met was over and they decided they would be able to do *Parade* on schedule, in February 1981. I was excited. Nevertheless, there was the hard work of actually getting it onto the stage. Gregory and I stayed in New York for a month putting *Parade* together at the Met. At the dress rehearsal it all worked very well, I thought, and the Met people were pleased. They said to me afterwards that they thought it was wonderful, but that they wondered what the critics would think. And I said, Frankly I don't care; it's what I think that counts, and as far as I'm concerned it works wonderfully as theatre, so that's it. If the critics don't like it, too bad for them. I didn't think they would dislike it; it worked.

And they didn't dislike it. In fact it was a great success. Until the opening night not many tickets had been sold; there was not much publicity about it because we had deliberately been very secretive and hadn't let much out. What I didn't know was that rumours were circulating in New York that it wouldn't be any good. But the day after the opening they sold 5,000 tickets, I was told, without even a review. It was people going home, saying to their friends, you must go and see it, which is the best publicity, frankly – more convincing than any other kind. I too am like that. If a friend tells me to see something, I don't care what the review says, I tend to believe my friends more.

Parade's success was due to John Dexter's ideas of theatre using children, the children's choir, children as singers, children as actors, as Punchinellos, and no star singers because, anyway, there are no star roles. Poulenc's *Les Mamelles* has perhaps the biggest role for a singer. That too is an excellent and very enjoyable piece of theatre with a message, like the Ravel. I think John Dexter believed in that Ravel opera as I did, believed in its message as well: kindness is our only hope. And I think Manuel Rosenthal, the conductor, did too. He told me afterwards, Ravel would have loved it. And I said, From everything I read about Ravel, I would have loved the man; he sounded marvellous to me, as an artist. Manuel said he'd conducted it many times and he knew it was difficult to make a production work: most of them had not worked, but this was for him very exciting. He told me how, when John had asked him to come and do it in New York, he'd had doubts because, as they don't do that many French pieces at the Met, he was frightened he might fail and then ruin French music in New York. He felt very strongly about this as a promoter of French music. He is a wonderful musician and a modest, wonderful

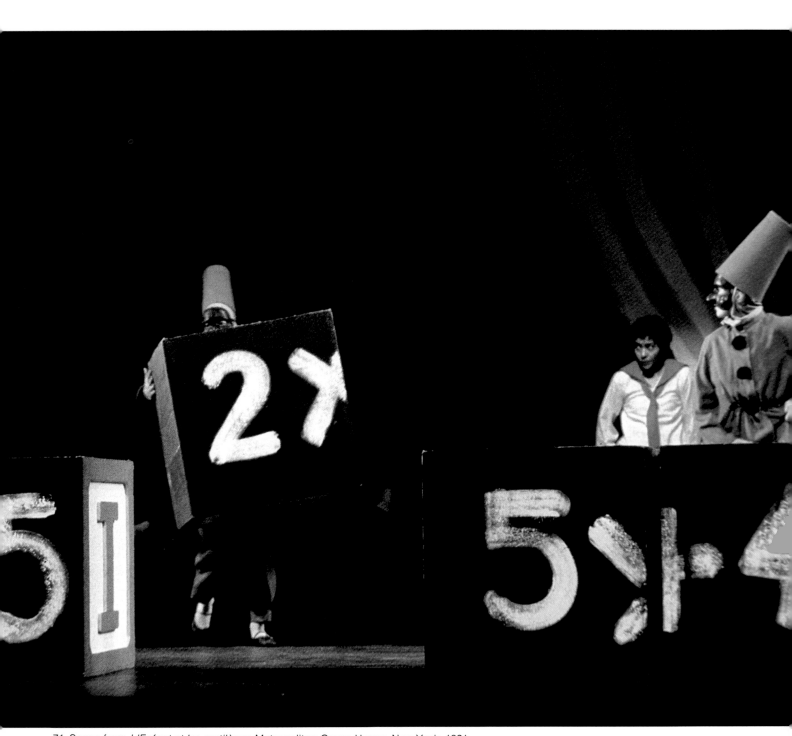

71 Scene from *L'Enfant et les sortilèges*, Metropolitan Opera House, New York, 1981

human being, and I thought that was another reason why it had worked. I remember listening to some of the rehearsals. The Ravel music is so beautiful, I wanted to find out how that marvellous sound was made and I would watch the orchestra playing. One time they were rehearsing the Poulenc piece, which is a lot of fun, but it is not as good as the Ravel, which moves you genuinely. I heard Manuel rehearsing the orchestra, saying, no, they were making it a little bit too heavy. He said, This isn't Wagner's Hans Sachs in the *Meistersinger* coming out singing about philosophy for an hour; I want it more like the town band. And after a while I heard it more like that, livelier.

As for Satie's ballet *Parade*, John Dexter's idea was that it should be an overture introducing all the characters who were going to appear in the other works. Originally it was going to be sandwiched between the two. After Rudolf Nureyev had dropped out, the problem was that they did not get another choreographer until October. Some people were critical of the ballet: the critic Clive Barnes said it was as though we'd put mindless graffiti on the tomb of Eric Satie. When I bumped into him about a year later I said, You know, the problem is that artists don't have tombs; they're either alive or, frankly, they're dead and forgotten; it's their work that lives. If Satie's tomb had had graffiti on it he'd have loved it. Surely, he wouldn't have liked a big, dead marble tomb for himself. Play the music; that's what he would have liked. Artists, even when they're dead, are alive in their work. I felt Ravel was alive.

THE SECOND TRIPLE BILL

All the work I have done in the theatre has been useful to me and I have never regretted any of the time spent on it. What is most important is using real space. You begin to think spatially much more. Immediately after the success of *Parade* I was asked to do another triple bill at the Metropolitan Opera which was planned for December 1981, the same year as *Parade*, consisting of three Stravinsky pieces: *Le Sacre du printemps*, *Le Rossignol* and *Oedipus Rex*. I went straight into it, even though many people tried to put me off. Henry Geldzahler said, Don't do it; you had a success with *Parade*, but you won't do it again. And I thought to myself, you shouldn't be frightened off, it's another wonderful idea to have the three Stravinsky pieces linked together in one programme.

Most of 1981 I was working on this project. It was the quickest, most spontaneous piece of theatre I had done. I began in February or March and it was performed in December. This was very quick, especially for a large opera house like the Met. In the middle of that period, just when I'd finished the design for *Rossignol*, in late May, Stephen Spender, Gregory and I went to China for three

The second triple bill, at the Metropolitan Opera, consisted of three pieces by Stravinsky: *Le Sacre du printemps*, *Le Rossignol* and *Oedipus Rex*. I spent most of 1981 working on them and the triple bill premiered at the Met on the 3rd of December.

72 Poster for the Stravinsky Triple Bill, 1981

74 *Study for Drop Curtain*, 1981, from the Stravinsky Triple Bill

73 *10 Dancers*, from Stravinsky's *Le Sacre du printemps*, 1981

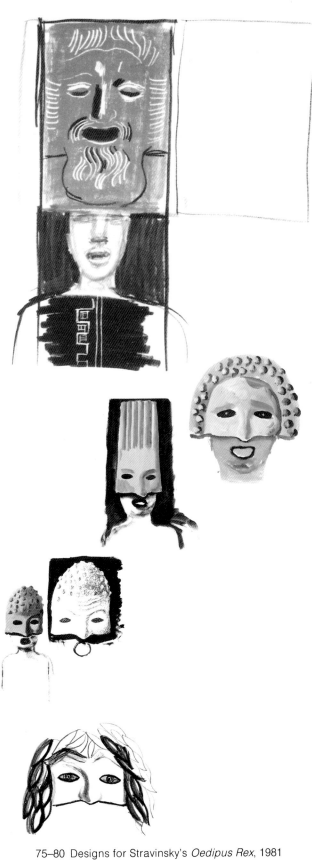

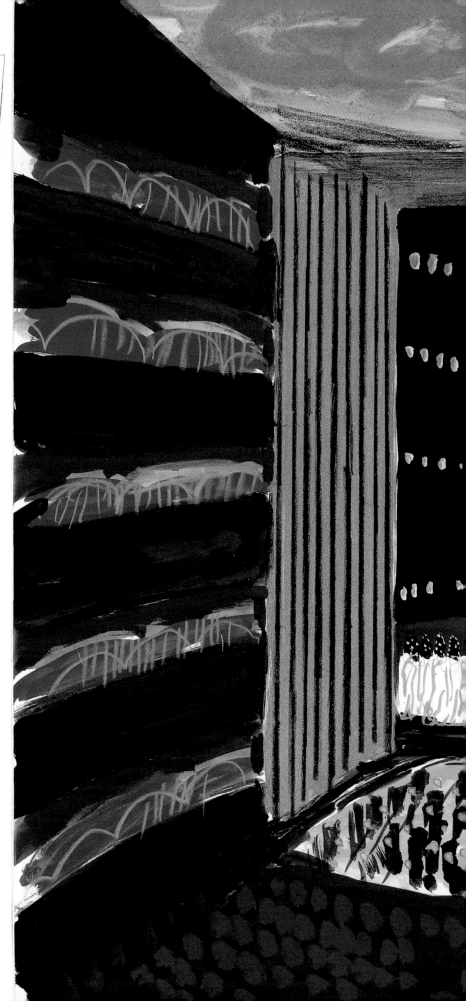

75–80 Designs for Stravinsky's *Oedipus Rex*, 1981

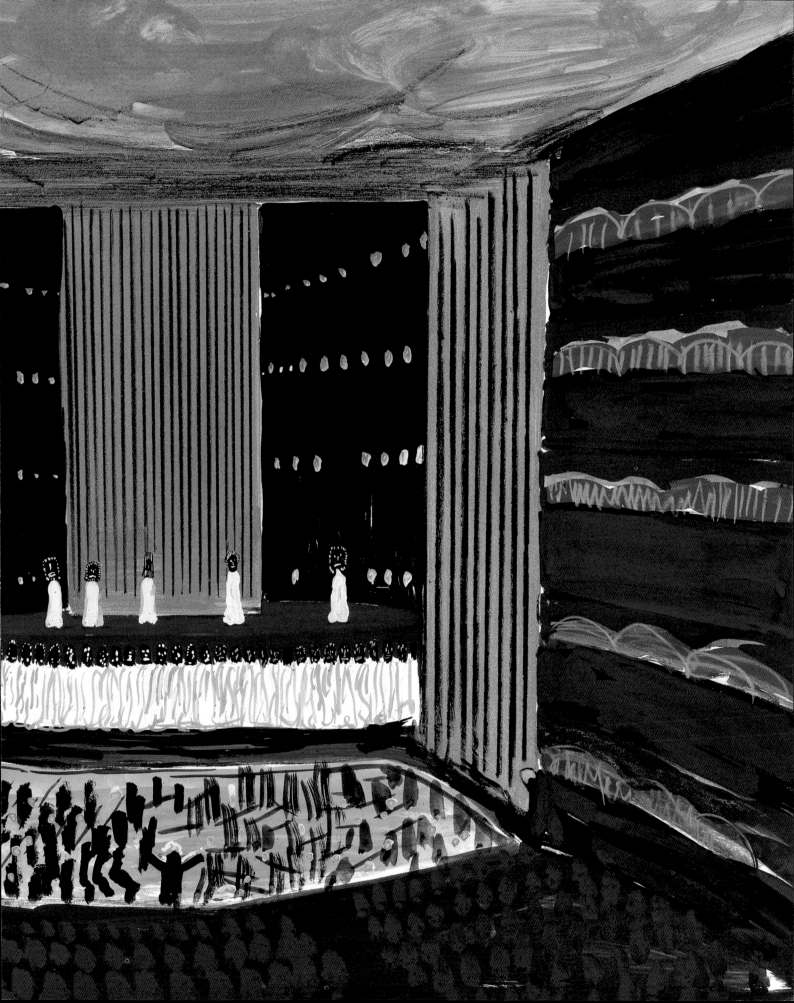

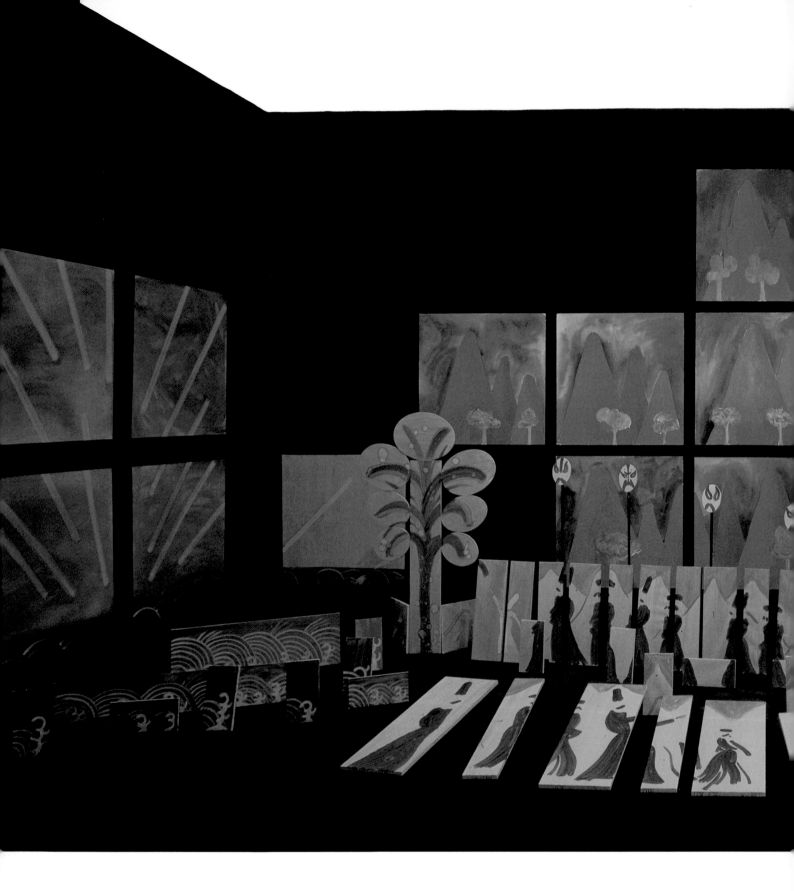

81 Large-scale painting with separate elements based on designs for Stravinsky's *Le Rossignol*, recreated for the theatre exhibition 'Hockney Paints the Stage', 1983, shown at the Rufino Tamayo Museum, Mexico City, 1984

weeks. We had been commissioned to do a collaborative book, *China Diary*. I kept listening to *Rossignol* on my Sony Walkman while we were travelling. But China had no influence on my designs for *Le Rossignol*, even though the opera is set there, because I had finished my work on it before we went. Nor did Egypt have an influence on *The Magic Flute*. I just happened to go to both places immediately before they were performed in the theatre. I returned to New York in November, to stage the Stravinsky triple bill.

IN CHINA

It was a marvellous three weeks in China. I'd like to go again. When I went I knew very little about Chinese art. I discussed it a little with Stephen Spender, who was saying, Isn't it all a bit the same? And I said, It seems to be. These are the words of the ignorant, frankly. Chinese art is too subtle for a lot of people. But the trip was marvellous. I remember Christopher Isherwood warning me about travelling with Stephen, saying, He'll be wanting to go to the British Ambassador's and Consulate's and stuff like that. And I said, Oh, thank you for that tip, because I wasn't too keen to do that, I thought we were going to see China. We did go and have tea at the British Embassy, but just tea. I didn't want to go halfway round the world and spend my time in English houses in Peking – though they were nice, actually.

I knew I would have to take everything – film, paper, ink, watercolours – with me because I didn't know what you could buy in China and I couldn't risk not having materials. I noticed in China that as time went on my drawings got more and more Chinese: I started using brushes and flicking ink. I used all kinds of media. I had only taken a small camera, a half-frame camera; originally I hadn't wanted to take as many photographs as I did.

The one problem was that the trip was organized so we were always moving. There was hardly a time when you had half an hour to sit around; so I realized I had to devise a method of drawing quickly or from memory. I started drawing from memory more and more. I remember arriving in Kweilin [Guilin]. I had no idea it was such a magical, beautiful place. We saw an extraordinary landscape from the plane and we were thrilled. Our hotel – actually a big house – had lovely rooms; I think the King of Belgium had been in them the week before. Immediately, I got out brown ink and paper and made some big blobs that were the mountains I'd just seen.

On the trip down the river – it's all day on the boat – you float through the most magical, beautiful landscape. It is as though children had drawn the mountains. I absolutely loved it. You're taken back to Kweilin by road: the boats go back too, but at night; they chug upstream without the passengers for twelve

The landscape in China is extraordinary. On the drive back from Yang Shuo to Kweilin, I took a number of photographs of trees – cypresses, Chinese poplars and others – which stood up very distinctly in the flat fields.

82 Tree, Kweilin, China, 1981

83 Plants, Trees, Fields and Mountains, Kweilin, China, 1981

hours, although it takes maybe only six hours to go down the river. So you just drive back, in one hour. On the way back I wanted to keep stopping, and I took some photographs. At first I thought there was nothing there, that everything was on the river, but there's something everywhere. The guide in Kweilin was a young man who spoke incredibly good English. If he'd told me he'd been born and brought up in San Francisco I'd have believed him. Mr Lin, our main guide, also spoke excellent English; he was a nice cultivated man who liked music and to whom I gave the tapes I had of Stravinsky and Ravel. But the young man had a wonderful mind and I spent a lot of time talking to him. He had never left Kweilin. He said, People come here and say it's beautiful, but it's just my town to me; and I said, It's ravishing. I know what he meant: if you're born and brought up there you just accept it, that's what the world is like. I discussed all kinds of things with him about China, its politics. What the Chinese I encountered wanted to know, their main question, was always, why was the West rich and China poor? I think that's what intelligent young people ask. I pointed out that in the West they value nonconformity, and that might be the reason. I said, Both the United States and England value nonconformity and therefore people can be inventive. In places that do not value it, where everything has to be orthodox, people ultimately become less inventive, because sometimes you need a nut in whom nobody believes to come out with an idea which turns out to be right or interesting. That's often the history of Western ideas, isn't it?

I found the Chinese were very interesting, rather pragmatic people; the country was just beginning to change then. Later on I came to see why they valued Mao; he had obviously given them back their identity. I think eventually they came to see that some of the political and economic ideas he was imposing were not very good at all, in fact weren't Chinese, but yet again derived from Europe. I pointed that out to them, that they were inflicting on themselves another European idea – Marxism. I have not been to what was the Soviet Union, but it seemed again to value orthodoxy, as it had in the past: the Tsars valued it and that led to its collapse.

One night we had dinner in the hotel. The meal we were served was one of the greatest meals I've ever had, very memorable, delicious, carefully prepared and, I'm sure, not your usual tourist fare. I remember photographing the chicken dish: the chicken had been sliced and rearranged on the plate and the shape they had given it was beautiful. Everything looked marvellous! Chinese cuisine is regarded as one of the great cuisines of the world and here there were obviously some experts wanting to show off their skill, and they did. They certainly impressed us with both the look and the taste.

When we left Kweilin for Canton [Guangzhou], Mr Lin, who didn't like Canton (he was from Peking [Beijing]) said, Oh you have to be careful in Canton, there will be pickpockets and thieves, probably thinking he was putting us off. I

thought, ah, that sounds more like a real city, we might enjoy it. Actually Canton was amazing. Suddenly all the Mao outfits had gone, they were wearing jeans and t-shirts. It was hot and the city seemed quite alive and throbbing. I asked Mr Lin, What do people do in the evening? We've seen a lot of other things but I'd love to know that. In the West, in America, people watch sports and have other kinds of entertainment. In a big city like Canton there must be something people do in the evenings. Mr Lin said, Yes, there's the cultural park, and I thought, isn't there something which people really want to see? I thought an official cultural park might be a bit of a bore. But we decided to go, anyway. Stephen didn't come. It was marvellous! It turned out it was like a fun park: there were roller-skaters, helter-skelters, and it was terrific. At last you saw the Chinese enjoying themselves. We watched basketball and roller-skating – the roller-skates were the old kind that made a noise the way they used to do at the roller arena in Bradford; and so there was so much noise there was hardly any point in playing music, you could barely hear it over this incredible din on the wooden floor. There were plays, little plays, little theatres and all of the stages looked quite old, I mean forty years old, made of wood – which naturally gave it a great charm for us. Mr Lin didn't quite approve, and then you realized, of course, that he was an official: it would be a bit like somebody from the British Council, an official in New York or London, taking somebody from China to Coney Island, or to Blackpool on August Bank Holiday weekend. I was glad we saw that: it humanized things. You felt that people need something to enjoy, something pretty and full of coloured lights, like that cultural park, and it was nice to know the Cantonese were just like human beings anywhere else.

Another wonderful place we were taken to was a little children's park. I saw it and asked what it was. It was being swept by children. It was a really delightful place. There was a very little girl who started showing off on the swings when she saw us with our cameras. What was nice was that children would talk to you. Of course, they talk in Chinese and you don't know what they're saying, but you do in a way. I could tell the little girl wanted to show us things and have us meet her friends: she was very warm, very nice. Gregory and I loved it. Stephen missed that too, but I told him about it; I thought it was a pity he hadn't come; it was things like that which were so charming in China, like when we were taken to a collective farm with pretty little cottages and fields around. We knew that not all the collective farms were like that, that what we were being shown was a model place. Mr Lin admitted this, and I was touched that he did; there was a certain sadness to the way he said it; he didn't like saying it. We felt he was being honest and even showing some feeling about it. That model collective farm was like some crazy little idyllic society. You thought, God, there are millions of people in the world who would love to live like this: little streams, little thatched cottages, working the fields,

growing vegetables; in America people would love to live like that. But we weren't fooled and neither was Mr Lin.

In Peking we went to an art school but all the art there was Western, they even had a kind of photo-realism. We did not see much old Chinese art; we did not know where to look for it. In Kweilin we went to see a little boy artist; the guide had said, We're taking you to see an artist aged eight! I thought, my God, what is this? Anyway, it turned out to be a wonderful morning. We were taken to a private house, the only time this happened while we were in China. The boy's father was a kind of hack artist. Kweilin was full of hack artists just as any beauty spot in Europe would be, artists selling their pictures to tourists. But the son, who had obviously watched his father working, had a stunning virtuoso talent. At first he wouldn't draw for us and they said, Oh he's very tired. I thought, no he's not very tired; he's sick to death of them bringing people like us here; he just doesn't want to do it.

I still had a lot of equipment left: a big box of crayons, the ones you can put water with as well, and paper – different kinds of paper – and I thought, we've only a few more days left; I'm not going to need all this; I'll give it to the boy, give it to an artist. So when he wouldn't do anything, I said, I've got these things, and I got out this equipment and to demonstrate the crayons I drew a picture of his bicycle, using every technique I could think of. The moment I began drawing he grabbed my hand. He realized I was an artist as well, who had come to see him, not just a tourist.

He was dying to get his hands on the crayons and Mr Lin told him I was going to give them to him. I was speaking in English about what you could do with these crayons and he just kept nodding, meaning, whatever you're saying, I understand

what you're doing. An artist that young and that good had obviously observed other people drawing – his father, now me. His face had lit up. And then he drew pictures for us, cats, done in the Chinese manner with brushes, which were stunning. Watching him do them was something: the way they were placed on the paper, everything about them was terrific; he was like a little Picasso, I thought; he was marvellous!

When we were leaving, he walked down to the car and he wouldn't let go of my hand. It was very touching. I felt we had communicated without the interpreter, that I had been talking to him even though he didn't know a word of English and I didn't know a word of Chinese. Any artist who watched him would have been thrilled, anybody who liked painting or brushwork. Mr Lin said, What should we do with him? I said, You must nourish his talent, you must value him, but perhaps you shouldn't take too many people to look at him; he has to be a little boy as well. Afterwards, I sent him a lot of books on Western art: I got a Dufy book because I thought they would like Dufy; there's something Oriental about his use of the brush and the brushmarks. I also sent him books on Picasso, Matisse, Van Gogh – because Van Gogh had copied the Japanese.

The boy's work made me realize all the beautiful things one could do with the brush, what the brush does; it was his work that made me look at Chinese things with new eyes. Of course, once you've been in China you take an interest in Chinese things. After we got back I read quite a few books on China. I'd read some before I went, but afterwards I read much more about China – the people and the history. I am now ready to go back; there are many other things I'd like to see – for instance, more scrolls. Now we know where they are: not in a museum in Peking, but in an archive which normally they wouldn't dream of opening or showing to anyone. I suspect the Chinese still don't think it's quite an art; they keep these scrolls as a record in an archive. But, oddly enough, I came to understand and appreciate Chinese painting more fully through photography.

85 Man Walking, China, 1981

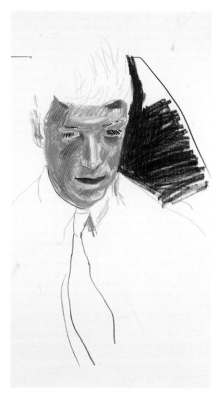

86 *Portrait of Ian,* 1981

I met Ian in 1980 in New York, where he was studying art history. He came to live with me in California in January 1982. Soon after he arrived I had the outside of the house painted in very bright colours. I was inspired to do this partly from having seen the De Stijl exhibition at the Walker Art Center and partly by the memory of the yellow Monet used on the outside of his Giverny house.

THINKING ABOUT PHOTOGRAPHY

Shortly before going to China I had been told to leave the house I was renting in California because the owners wanted to sell it. I decided to buy it. I had recently sold my house in London and with that money I bought the house in California – it cost about the same, I think. Once I had bought it, I decided I would stay there permanently. It was the first property I'd owned in America – I'd always lived in rented places. The first thing I did to the house I now owned was to start painting it. I had it painted red and blue, the colours of my designs for the Ravel *L'Enfant et les sortilèges* – and the green was the green of nature outside the house.

In 1980, in New York, I had met Ian Falconer. He was about nineteen or twenty when we met, and we became friends. When we were doing *Parade* in 1981 he was around and I showed him the Met, the theatre and everything. He had been studying art history in New York but kept drawing a bit. He then asked if he could come to California, and would I teach him things, and I said, Yes, after I got back from England where I was going to spend Christmas with my family and have a week in London. In London, for some reason, I started painting. I painted a picture of the house in California from memory. I just painted it to cheer myself up in grey London; I happened to have three canvases, and the picture was a kind of triptych. I shipped it unfinished back to California and finished it there.

Ian came to live with me in January 1982 when I got back from London. It was then that I had the outside of the house painted. You can't see it from the road.

87

87 *Hollywood Hills House,* 1981–82

88 *Terrace Hollywood Hills House with Banana Tree*, 1982

89 *Gregory Sleeping*, 1984

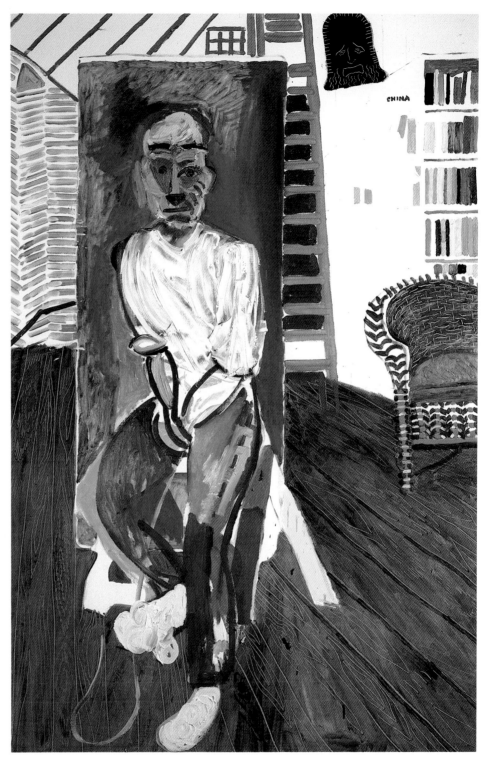

90 Untitled portrait of Ian, 1983 (study for ill. 106)

91 *David Graves, Pembroke Studios, London, Tuesday 27th April 1982* (detail)

92 *Gregory, Los Angeles, March 31st 1982*

If it could be seen from the road I wouldn't have had it painted like that. Ian, Gregory and I lived together in the house for quite a long time. We all got on. There was Ian and me upstairs and Gregory downstairs. Ian was studying at the Otis Parsons and he would go off to school while I was supposed to be painting. I did do some paintings; I started some big gouaches.

Then somebody came to visit me from the Centre Pompidou [Beaubourg] in Paris to organize a show of my photographs. They had asked me before but I'd never been that interested. Then they insisted so much I said to Alain Sayag, who was organizing the show, Why don't you come here and look through my albums? There are hundreds of them, thousands; I think you should choose them; I don't think I could; I don't know what difference there is between them. So he came for a week and every night we discussed photography, theoretical aspects of photography: I'd tell him what I thought, he'd tell me what he thought. I had all my prints in order, but I hadn't got all the negatives in order, I had just stuck them in boxes; I didn't even know where they were. He was rather horrified that I'd been that slack with them. He decided he needed a record of the pictures he'd chosen from the albums, so I bought a whole carton of Polaroid film, and made two sets of each of the pictures from the albums, one for Alain and one for me.

David Graves, who then worked for Petersburg Press in London, also spent a lot of time working in California with me. (He had assisted us, too, on the Stravinsky triple bill in New York.) David sorted out the negatives of the pictures the Beaubourg were interested in. After Alain Sayag went back to Paris, I started some paintings, but there was all this Polaroid film lying around.

In the summer of 1981 I had done the show 'The Artist's Eye' for the National Gallery, London. The catalogue essay, which I wrote, had a lot to do with photography. So I had been thinking about photography·for some time, and now I started to play with the Polaroid camera and began making collages. Within a week, very quickly, I made them quite complex. This intrigued me and I became obsessed with it. I made about 150 collages with Polaroids. I went on until I felt I had exhausted the idea, which was in about May. We showed them in New York in June in an exhibition we called 'Drawing with a Camera'. This very strongly rekindled my interest in Cubism, and in Picasso's ideas, so that in a sense it was photography that got me into thinking again about the Cubist ways of seeing.

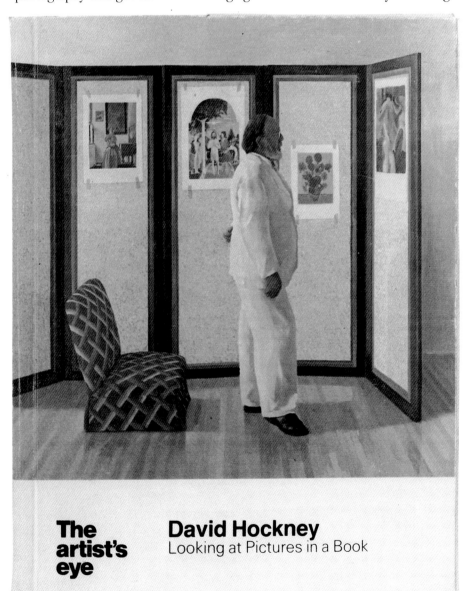

The artist's eye

David Hockney
Looking at Pictures in a Book

93 *Looking at Pictures on a Screen*, 1977, cover of 'The Artist's Eye' exhibition catalogue, *Looking at Pictures in a Book*, 1981

94–105 *Overleaf and following pages:* From 'The Artist's Eye' exhibition catalogue

Poster of *The Artist's Eye* exhibition, 1981

The artist's eye

David Hockney
Looking at Pictures in a Book
at the
NATIONAL GALLERY

1 July – 31 August 1981

Foreword

This exhibition is the last planned in the present series, and the National Gallery is greatly indebted to David Hockney for having agreed to organise it for us. Knowing the many demands on him, we were all the more grateful for his warm response, from the first, and for the time and thought he has generously given to the whole project.

In discussion of his choice, and the emphasis he has given the exhibition, he touches on a fundamental point about the reproduction of great paintings—something over which there still tends perhaps to be too much high-minded shrinking from the inadequacy of the reproduction when compared with the original. Yet most of us—if we are honest—will recall how stimulating even a poor reproduction of a painting can be, whether or not we know it in the original. As David Hockney so rightly emphasises, 'it's giving off pleasure in strange ways that go on and on'. And pleasure of the eye is the reason we look at paintings.

We are very grateful to Mr & Mrs Miles Q. Fiterman for generously lending the painting, *Looking at Pictures on a Screen,* by David Hockney, and to Mr Martin Friedman of the Walker Art Center, Minneapolis, for his kind co-operation. We are also grateful to Mr Peter Schlesinger for the loan of his chair and to Mr Paul Cornwall-Jones for lending the screen and for his help and interest over many aspects of the exhibition. As on previous occasions, I am deeply indebted to my colleague, Alistair Smith, co-ordinator of the exhibition, and to Robin Cole-Hamilton, the Gallery's own designer.

Michael Levey
Director

Looking at Pictures
by David Hockney

At first I thought there was an arbitrariness about my selection of pictures. I have not been in the National Gallery very much in the last few years; I've not been in England very much. And I must confess—this choice, if I tell you how it was made, would at first seem arbitrary.

When I was first asked to select, the point was that the artist puts in a picture of his own, to suggest that the pictures of the past somehow relate to him. Well, I had made a picture of a friend of mine, Henry Geldzahler, looking at some other pictures. It was about the pleasure of looking. And the pictures he was looking at were reproductions I had purchased at the National Gallery. True, because I liked them. But if all the pictures in the National Gallery were reproduced rather big I might have chosen others. I made a selection from what was there, and chose four pictures that gave me enormous pleasure. I then pinned them up on a wall at home. They'd been many places. I'd even moved about with them a bit. They were pinned on a screen eventually, and I painted a picture of Henry, who loves pictures, looking at them. I called the painting "Looking at Pictures on a Screen," because I thought the title then would make you realize in another way from the picture, that you could identify with him and his pleasure, because you were doing exactly the same, looking at it.

Now of course if you don't like the picture then you're not getting pleasure. But if there's something you can like about it, you're forced to identify with him in some way, in a very simple way.

So I decided, Well, these pictures were all from the National Gallery; why not put in this picture of mine which has all the others painted in them, smaller? And then here were the real ones, the real objects that were the source of the pleasure. So we put them up in the room with the screen, with the reproductions, and with my painting.

Then I thought, What would that signify? What would you get from it? And then I thought, Well, one thing that can come across quite clearly is if a painting is really wonderful, even in a reproduced form, even a *cheap* reproduced form, it can still give off a lot of its magic. You can't quite define what it is—magic is a good term, it seems to me. And I've even noticed this magic sometimes in postcards of paintings.

I was once in Albi at the Toulouse-Lautrec Museum where they have a small painting by Vuillard, of Lautrec. And they have a very beautiful postcard. I think the post-card is stunning. I saw it and I thought, My God, the postcard is even giving off real vibrations like the painting, of the sheer delight. I thought the painting was delightful, it was unbelievably simple and fresh. Vuillard must have just looked and watched Lautrec, probably almost out of the corner of his eye, and sketched it in very quickly, this feeling of looking at Monsieur Lautrec at work. And it had all the freshness and delight that his mind must have had as he looked up and saw Lautrec—wearing yellow trousers and a red shirt.

I purchased all the stock of these postcards and sent them to friends. And I must admit that most of the friends told me later that the morning they got the postcard and looked at it how thrilling it was—even a postcard, the very object they were holding. And I thought Well it's true, this, you can get the magic to come, even off reproductions.

Panchromatic photograph of coloured postcard.
Edouard Vuillard: *Portrait of Toulouse-Lautrec* (Albi, Musée Toulouse-Lautrec)

Now people will say, It's not the same thing. Of course the picture is the thing, that's where you get the real pleasure. The picture has to exist, otherwise the postcard cannot exist. The postcard can exist because a method of making pictures was invented in the 19th century that people mistook for something else. And it's called photography.

Now I think the best use for photography, the *best* use for it, is photographing other pictures. It is the only time it can be true to its medium, in the sense that it's real. This is the only way that you can take a photograph that could be described as having a strong illusion of reality. Because on the flat surface of the photograph is simply reproduced another flat surface—a painting. In any other photograph it's not reproducing a flat surface. So I suddenly realized this, when I went off photography—sometimes I go hot and cold—I think it's an interesting way to make pictures, and then I think, No, it's got unbelievably severe limita-tions that make it a minor technique, really. So at the moment I'm off, and I suddenly realize the *best* thing it can do, and its true thing, is this.

Now that means a great number of people who never come to the National Gallery can have rather good repro-ductions of the paintings. The reproduction, for instance, of the Piero della Francesca, that I had on my wall, we have here on the screen. Of course, in this room where you can see the real painting, the original, and you see this cheap photographic copy, and you can compare the two, of course you're not going to take much notice of the cheap photographic reproduction. Why should you? But you *can* take the cheap photographic copy home. You can pin it up next to your bed. You can have a look at it at night. You can wake up and have a look at it in the morning. And it's giving off pleasure in strange ways that go on and on.

Panchromatic photograph of old sepia photograph.
Piero della Francesca: *The Baptism* (The National Gallery)

Sometimes the more you look at it you notice different things.

Piero, it struck me the other day when I was looking at it, the reproduction that is, here in New York on the wall, I suddenly thought, one of the marvellous things about this picture, how beautiful it is (there are so many things about it), is that there are hints. For instance, the bird that is hovering over the head of Christ seems not to be moving. Now you say, Ah well, nothing is moving in the still picture. But there are marvellous suggestions of movement elsewhere in the picture. Just below, the water being poured doesn't seem still; it's an action that's going on, you *feel* it going on. Therefore, contrasting the bird with these things makes it hover, as though it's still.

All this seems to me as just some of the things artists do to have an effect. It's the skill of making the picture—part of the skill of making the picture. Ah, you might say these are all easy tricks. Well it's true, there are many many things people who construct pictures and make them employ to create a certain effect, to make something dramatic. These effects people used to study, rather academically. They were treated as parts of things that were useful for the artist in depicting his experience of the visible world—of the things outside him that are part of him.

As you pick up a reproduction, or as you picked up this piece of paper you are reading from, you look at a surface. Some suggestions in modern art have been that everything you see is on the surface. And therefore to be true to it you could eliminate certain things—to be even more 'truer.' Just as I am suggesting that the photograph, to be true to itself, should only photograph other flat surfaces, because that's what it can do.

Enlarged image of type from this page, paragraph 3, line 2, word "surface".

Yet surfaces can be broken in many ways. The surface of this paper, as you are looking at it, has got type on it that you are now reading, and the type forms patterns that have meaning, and thus you get the ideas. Or at least the words I am saying come into your head.

Now that is caused, people will say, by these patterns simply being on the surface, and there's nothing more. But what there is more of then, is the meaning of the words and ideas that have come into your head. Well, in the same way you can break surfaces. If we go back to George Herbert's lines:

"A man that looks on glasse
on it may stay his eye
Or if he pleaseth, through it pass
and then the heav'n espie"

George Herbert: *The Elixer*

—a simple idea of how you can choose where to look. As a metaphor it opens up incredible ways of looking, or suggestion. And it uses the surface idea, that there is something the surface can stop. Or, that you can go through it. Even with a sheet of glass, your imagination comes to work more, perhaps, when you've gone through the glass, because the glass disappears. You've made that surface disappear. A painting of course always has a surface. It cannot disappear. But in your imagination it can. And that is part of the magic of pictures.

There's a painting in the National Gallery, in Scotland, by Raeburn, of a man skating. It's called *The Rev. Robert Walker skating on Duddingston Loch.* A beautiful picture. It could be subtitled *Confidence.* It's got great elegance, in the balance of the picture. It's very harmonious and pleasing. There is something *right* about it, deeply. And in the painting, he's skating on ice. And Raeburn

Infra-red photograph.
Vincent van Gogh: *Sunflowers* (The National Gallery)

has depicted, on the painting, cracks in the ice, and the marks where the skates have gone around. Then, a few years later, cracks appeared in the painting of the cracks. And then the painting was photographed, i.e. the photograph took a painting of another flat surface, including the cracks that had occurred in the paint. Then they made a reproduction of it, and I purchased one in Edinburgh. And they said We will send it to you in California. They put it in a tube and it got a bit crushed along the way. So when it finally got to me, the paper surface had been cracked. And at first I thought—ruined. Then I pinned it up on the wall, and one evening I was looking at it—and you're forced to always come back to the surface of even what you're looking at—the piece of paper. And I suddenly saw all the levels of cracking. And it amused me, actually. It delighted me. And I thought, No, it's not been ruined. There's something else that's been added. So there we had the painted, depicted cracks, on the ice. We then had the cracks in the painting that had been made flat on the new surface of the paper. And then we had the cracks in the paper, on top of the other cracks. Different focusing. It's different focusing of the eye, moving in, getting it.

So then I'm looking at this and I thought—some lines came to me suddenly. I remembered the lines of T. S. Eliot, evoking this marvellously:

> "A painter of the Umbrian school
> Designed upon a gesso ground
> The nimbus of the Baptized God.
> The wilderness is cracked and browned"

Mr Eliot's Sunday Morning Service, copyright Faber & Faber

It's the sudden change of the focus, back to the surface. What it does mean, it seems to me, is that not everything

Detail of cracked reproduction. Sir Henry Raeburn: *The Rev. Robert Walker skating on Duddingston Loch* (Scottish National Gallery, Edinburgh)

you see on the surface is all there. It seems perfectly clear to me. The amusing side of this was then made by Magritte, who once made a picture of a pipe, and it says underneath, "This is not a pipe." A perfectly true statement. It is a *picture* of a pipe. And of course there's a vast difference. You cannot smoke the picture of a pipe, like a pipe. It has different qualities. He's simply pointing them out, and thinking that perhaps it needed pointing out. Well, it does, at times. Again, it's bringing us back to the surface.

So I'm going on and on about the surface, because when you're looking at the real painting, the surface of the painting is also a delight. There are times when you can look at these pictures (and I think all of these pictures can be looked at with great pleasure for, I would suggest, half an hour for each), and although nothing might happen for a while, you might think, Is it possible to look at these pictures for half an hour? But the longer you look, the richer they get. And of course it makes it difficult to look at them for half an hour if there's just these four pictures. You have to come to the National Gallery. And if you do, of course, pleasure is deepest. Because you're looking at the original thing that the artist did, that whatever the other reproductions have, could not have been made without the original painting. For in the real one, you can see more.

But the moment you begin to break the surface of the painting, what you begin to get is also what you can begin to get from the reproduction. The delight in the use of shapes, of its colours, of its relation to the subject matter— how they relate, how important it all is, when you go back to the still bird over Christ; how you realize it's still.

How does he make it still? What am I saying?—It's still. Of course it's still, nothing moves in the picture. Nothing moves in an ordinary way. Yet you can believe this. And of

Early "Medici" photograph. Johannes Vermeer: *A Young Woman standing at a Virginal* (The National Gallery)

course if photography gets better (if I suggest that its best use is in doing this), eventually we will have almost replicas of this painting, that you can have in your house. They will be almost like the real thing. And everybody will suggest that the machinery to do this is a wonderful invention. It's true, it will be. But without the original paintings, what would it do? What would this machinery do? It can only reproduce. But to reproduce means there must be something to begin with. So we must have this idea of making pictures that can tell us more than photographs can tell us.

Photographing the real world out there is, I think, a lot more stylized than we think, or believe at the moment. In time, they will begin to appear strangely stylized.

When I bought one of those stereo tape machines that play on your head, somebody said, Oh, you just like gadgets, David. I said, Well, it's not a real gadget, it's to bring music into your life. It helps music, this little machine, if you want music to tell you something and make it all more interesting. That's the purpose of this gadget and it seems to me a noble purpose. There's a lot of music you can listen to—you can listen on the bus, you can listen in the National Gallery—nobody hears it. So you could have a lot more time to listen to music if that is what you want to do. So all the ideas that went into the machinery have improved where and how you listen to music. Of course, they don't *improve* the music, that's another kind of thing. Technological advance is quite different from artistic advance—which I think there's really no such thing.

So I have suggested to the National Gallery that it would be interesting, for example, to see the reproductions as well, assuming at the moment that I think these reproductions are not obviously 'true.' It's not a replica of the

The exhibition poster proofed on a lithographic press.

painting, it's not the same size. But it can still give you—or me anyway—immense pleasure. So it does do something, this piece of paper, that Piero della Francesca—decorated. And even if you say it misses out too much, I'm not sure it always does. I think the pleasure is still great enough to welcome the idea.

When I put the reproductions up on my wall, one time, somebody said, Oh this is a terrible thing to do because reproductions are terrible, and what was best was an artist's original work, i.e. an original print, where an artist thought about the print medium to conceive a work in the true spirit of the medium. The reproduction does not do this, this is true. But the reproduction uses the skills of the craftsmen who devise these machines to do it, and they're skilful. They were made by skilful and inventive people. But *craftsmen*, not necessarily *artists.* What they were doing was something different.

The connection between the ideas that can be communicated in painting—the experiences that can be shared by paintings, things painting can do that other arts cannot do, is what we delight in. For instance, shadow. The delight in shadow, that is real as you see things—that delight can be expressed in painting, better than in words. I think you'd have to be a very great poet to come near it. There's something amusing about shadows, I don't know why it is. It's as if this strange reproduction of something was made by light. But it's not light—the thing—really; shadows are not always distorted, after all. But too many things are missing to tell you very much. It will only really tell you the outline. Well, photography is a bit like this. There are too many things missing that are real in real experience.

Again, for instance, the strangest images that are made now are at sporting events that we see—usually in a news-

Giovanni Paolo Pannini: *Young Gentleman holding his Hat* (Metropolitan Museum of Art, New York) Bequest of Harry G Sperling, 1975.

paper or book. They show you pictures that are extremely unrealistic, in the sense that you never saw anything like that if you were at the sporting event. You've never seen anybody suspended in air. You have never seen the ball stood still. And in photographs they *seem* still. Because it's got very little time in it. The sports photograph is a fraction of a second and that's what you see. But that is not what you felt. You felt the time moving on, in the sporting event. The photograph has great difficulty in depicting time. And if we go back to the Piero—I suggested, in this painting, this bird was still, but another part was not. Well, of course, painting, imaginative painting, can do this. And in this sense it is much closer to true experience. It tells of the experience more vividly.

About sixty years ago most educated people could draw in quite a skilful way. Which meant they could tell other people about certain experiences in a certain way. Their visual delights could be expressed. And today people don't draw very much. They use the camera. My point is they're not truly, perhaps, expressing what it was they were looking at—what it was about it that delighted them—and how that delight forced them to make something of it, to share the experience, to make it vivid to somebody else. If the few skills that are needed in drawing are not treated seriously by everybody, eventually it will die. And then all that will be left is the photographic ideal which we believe too highly of.

So here's my short plea for an art of depiction to be kept up. And that means, when I say, 'keeping it up,' I mean there are certain things in an art of depiction that can be taught to anybody, and especially, one would think, any educated person.

Because slowly what would happen, of course, is that primitive art would develop again and the skills slowly

Edgar Degas: *After the Bath* (National Gallery)

would return, it's true. This would take time, though, because it would take a long time before people began to realize that an area of experience was being lost, and would be lost, because people would not have the ability to share it with someone else, which is one of the great delights of art. That it is indeed a sharing experience. Which is why in some way that art is our salvation.

List of Exhibits

1
David Hockney (born 1937): *Looking at Pictures on a Screen, 1977*
Canvas, 72 × 72in/183 × 183cm. On permanent loan to Walker Art Center, Minneapolis, from the collection of Mr and Mrs Miles Q Fiterman.

2
Piero della Francesca (born about 1416 – died 1492): *The Baptism of Christ*
Wood, 66 × 45¾in/167.5 × 116cm NG 665.

3
Johannes Vermeer (born 1632 – died 1675): *A Young Woman standing at a Virginal*
Canvas, 20 × 17¾in/51.7 × 45.2cm NG 1382.

4
Edgar Degas (born 1834 – died 1917): *After the Bath*
Pastel on paper, 40½ × 39in /103 × 99cm NG 6295.

5
Vincent van Gogh (born 1853 – died 1890): *Sunflowers* Canvas, 36¼ × 28¾in/92.1 × 73cm NG 3863.

Chair lent by Mr Peter Schlesinger.
Screen lent by Mr Paul Cornwall-Jones.

106 *David, Celia, Stephen, and Ian,*
London, 1982

106

108

That summer I went to Europe with Ian for the photography show at the Beaubourg. We spent quite some time in Paris and I did a bit of painting. I made a painting consisting of four different portraits, twisting the bodies round, putting different heads in and so on, trying to take and use the ideas from the Polaroids. The first efforts were simple, quite simple, but I could begin to see what to do in painting and it was exciting. But I wasn't sure. What I didn't realize, of course, was that I hadn't finished with the photography.

When I came back to California in autumn 1982, David Graves and Ann Upton came with us and we drove to the Grand Canyon and Zion Canyon. I took a little Pentax camera and while we were there I tried different experiments, shooting many, many pictures of the Grand Canyon in order to show the space. When I got back I began to glue them together and I realized there was a whole new area I could explore, also using memory. I had thought that it would be more difficult using an ordinary camera, because you would have to remember what you'd done, rather than seeing the image immediately, as with a Polaroid. I got drawn into it very much and I also started developing the idea in different ways, working on it until Christmas. And then I thought I'd stop.

But when my mother came that Christmas, I did some pictures of her, and then, just before she left, I decided to push the idea still further. My mother is keen on

107 *Ann & Byron Upton, Pembroke Studios, London, May 6th 1982*

109

Scrabble and I decided to use that as an action around which to set up a photograph. I deliberately set up an action, as it were, to use as a subject. I thought a game of Scrabble would be good because Scrabble is itself a bit like a collage: it is a crossword puzzle, putting letters together to make words. It was a real game we played – it had to be, although I wasn't fully concentrating because I was taking the pictures and planning this piece. And when I pieced the pictures together I took off again because I realized I was opening up something else, that here was a marvellous narrative; what I was doing became clearer: I was using narrative for the first time, using a new dimension of time.

I rushed back to London when Ann Upton's son Byron was killed; that was about November 1982. David Graves, with whom Ann was living, was going to come to California for a while because we were going to make some editions of these photographs – we thought that as I was using an ordinary camera we could make editions of three or four. When I got to London I suggested to Ann that she should return with me to California; I thought it would help her, rather than staying in London – different surroundings would help her forget the worst, anyway. So David and Ann came back after Christmas. They stayed with me for about a month, at the beginning of 1983, and then found a house up in Beachwood Canyon which they rented.

I took a lot of pictures of the Grand Canyon when I went there in the autumn of 1982 with David Graves and Ann Upton. I used a little Pentax camera. When we got back I began to put them all together and I realized that this was a whole new area to explore. Because I hadn't seen the image immediately – as I would have done if I'd used a Polaroid – I had to remember what I had done. Memory became an important part of the process.

I got quite excited and began developing the idea. The *Scrabble Game* (*opposite*) was done when my mother was visiting at Christmas. Ann Upton, David Graves and my mother played. I joined in too, though I couldn't concentrate much on the game because I was taking the pictures. It was while I was doing this piece that I saw that I was using narrative for the first time, using a new dimension of time.

108 *Grand Canyon Looking North, Sept. 1982*

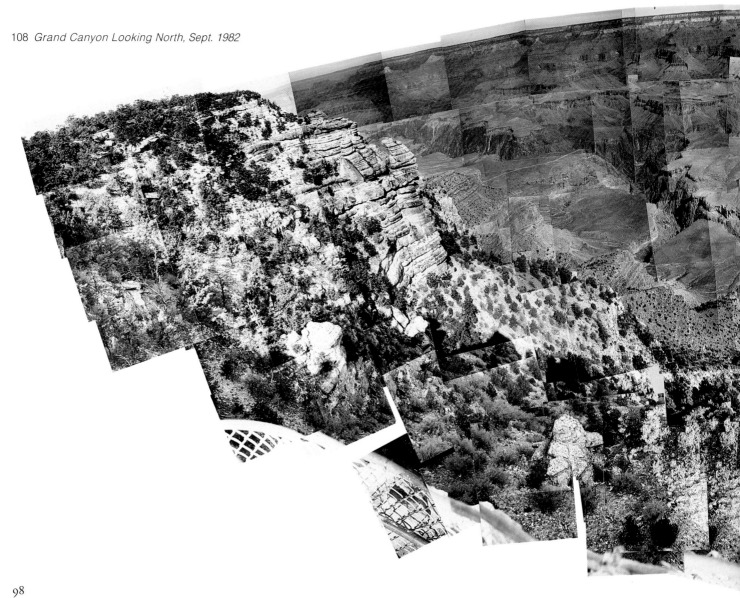

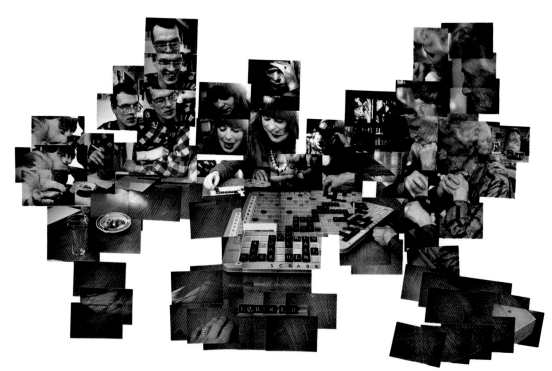

109 *The Scrabble Game, Jan. 1, 1983*

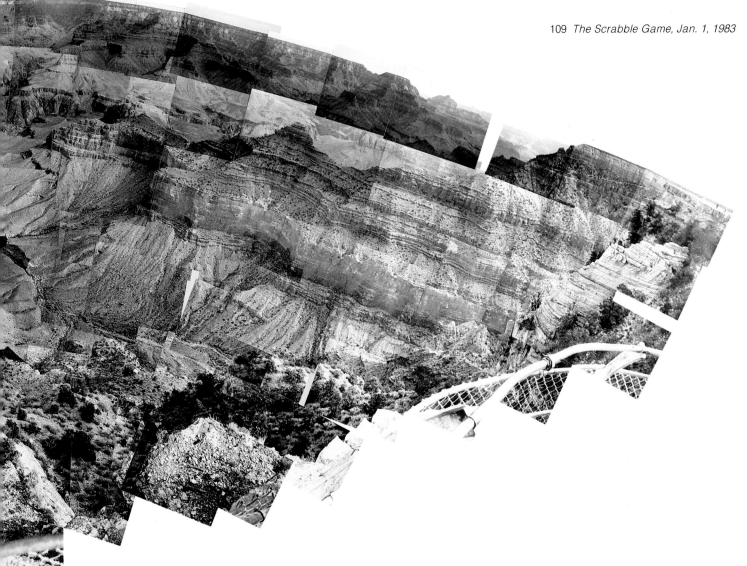

110 *Walking in the Zen Garden at the Ryoanji Temple, Kyoto, Feb. 21, 1983*

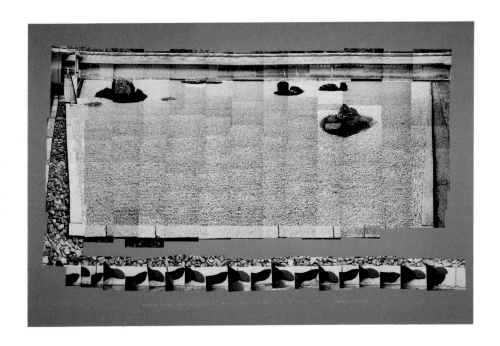

I went to Japan with Gregory in February 1983 to give a lecture at a conference on the uses of paper in art. While we were there I took a number of pictures, keeping notes for very complex photo-pieces, which I put together when we got back. For *Walking in the Zen Garden*, I took more than 160 photographs. When I first pieced them together I thought I had made a photograph without perspective.

REVERSE PERSPECTIVES

Then in February 1983 I went to Japan for a paper conference; they had invited me and Robert Rauschenberg to speak about using paper as a medium. I'd been to Japan once before, in 1971. Gregory came with me and we were mostly based in Kyoto. I was still deeply into the photographic idea, so I brought a camera and took quite a lot of pictures, though I didn't develop them there. I methodically kept notes every time I took photographs for one of those complex photo-pieces, I made diagrams of how I would lay them out. When I got back I spent quite a while piecing them together. What really excited me was when I pieced together the Zen Garden in Kyoto – the second version with my feet at the bottom. It was then and really only then that I began to realize that one of the areas I was really examining was perspective, that this was what you could alter in photography. I had not realized this until then, not fully – just as I didn't fully realize the implications of the ideas in *Kerby (After Hogarth) Useful Knowledge* (1975) until about nine years later, when I began to make and use reverse perspective quite seriously. To do it in photography was, in a sense, quite an achievement because photography is the picture-making process totally dominated by perspective. Most photographers think that the rules of perspective are built into the very nature of photography, that it is not possible to change it at all. For me, it was a long process realizing that this does not have to be the case.

In the late seventies, when I didn't do that many paintings, I worked a lot in the theatre. Now the theatre, or the kind of theatre I was working in, the opera, is Italian theatre, that is, it is deeply connected with perspective, it is illusionistic theatre beyond a plane, it is a box: there's a proscenium and that proscenium

110

17

100

represents a plane. Beyond that plane is an illusion. In front of the plane is you, the audience, and, in a sense, there's a separation between you and it. There is, of course, another kind of theatre, very well known in England: the Shakespearean theatre, which is quite different. The Shakespearean theatre is Cubist theatre in a way, in the sense that it is not an illusion behind a proscenium. The stage juts out into the audience and occupies the same space as the audience, so different people see completely different angles. Shakespeare did not need illusionistic settings. I think perhaps that's why Shakespeare never fully works on television, because television, being a box, belongs to the Italian conception of theatre. Beyond the screen is an illusion and, of course, the box. These illusions involve perspective.

In 1979, when I was in Italy doing *The Rake's Progress* at La Scala, Milan, I went to visit Vicenza, where I hadn't been for sixteen years. In the famous Palladian Teatro Olimpico, with its permanent set by Scamozzi, the town of Vicenza itself is put on the stage. The people of the city saw themselves and their city beyond the stage. And although the stage is not curved, the auditorium is, so that when you look up on the stage you always get a street disappearing into the distance. It is a beautiful theatre and you're very conscious of this depiction of space in real space, an illusion of space in a real space, which is of course different from the illusion of space on a flat surface.

As I described before, after *The Rake's Progress* the next stage work I did was *The Magic Flute* and in it, especially in the second act, I played with the space, using perspective ideas a great deal, linear perspective, one-point perspective. At Glyndebourne it never totally worked to my satisfaction because, as I said earlier, we had to squeeze the drops up. They had told me that I could use the thirty-five drops in the theatre, but they had made a mistake: I couldn't because *Don Giovanni* was up there as well and it had spiky sets that kept ripping our *Magic Flute*. I used to like *Don Giovanni* as an opera but at Glyndebourne I grew to hate it. When *The Magic Flute* was redone at La Scala in 1983 on a much bigger scale, the perspective, the spatial games in it, were much more interesting because you could space out the drops better. Working in the theatre certainly makes you think about illusions, illusions of space within space.

PICASSO'S REALISM

My dissatisfaction with naturalism and the depiction of naturalist fixed-point perspective space, and my work in the theatre, led me to an increasing admiration for Picasso, especially since his death in 1973. I had always had a great interest in Picasso, but I never quite knew how to deal with it — like most artists. He seemed too big and his forms were too idiosyncratic. How do you learn? How do you use them? But you have to learn. One of the most important things, one of the most

difficult things, is to learn not to be intimidated, not to be afraid of working through even his forms to find your own way of doing it. It took me a long time, for instance, to realize fully that, contrary to what some people may think, there is no actual distortion in Picasso. What he does may appear distorted only if you think of one particular way of seeing, which is always from a distance and always in a kind of stopped, frozen time. The moment you realize what Picasso is doing, how he is using time as well — and that is why you could see round the back of the body as well as the front — once you begin to realize this, it becomes a very profound experience, because you begin to see that what he is doing is not a distortion, and slowly it then begins to look more and more real. In fact it is naturalism that begins to look less and less real. And that, of course, leads you into thinking about the nature of realism and what it is and what it isn't. You become aware, perhaps more than ever before, that there are different forms of realism and that some are more real than others.

I became aware that Picasso's way was far more real than anything else, and I also began to understand why it was more vivid. In December 1984 I went to Paris with my friend Celia Birtwell to visit a sick friend, Jean Léger. The big Watteau exhibition was on at the Grand Palais, and there was also an exhibition at the Beaubourg of Kahnweiler's gift of Picasso paintings. In the Watteau exhibition, which was wonderful, I noticed, as Celia and I were going round, an absolutely marvellous, charming little painting called *The Intimate Toilet*. It is of a rather grand lady attended by a servant. The painting reeks of perfume and sensuous feminine charms. Celia said, It's delicious; that feeling is just delicious, it's wonderful. I said, Yes, it's just marvellous, I agree. The next day, we were looking at the Picasso pictures in the Beaubourg and there was a little painting of 1932, which therefore must have been of Marie-Thérèse, and Celia said again, That's delicious, look at her, she's delicious. I pointed out to her a vast difference between the Picasso and the Watteau: in the Watteau, if you thought about it, you wondered where you, the onlooker, were looking at it from. It was as though you were in another room, looking through a little doorway at a lady being powdered by a servant. But in the Picasso painting, because you could see the back and the front at the same time, you would not ask yourself, where am I? You were *inside* the picture; you had to be, because you couldn't be simply outside it and move round it. In the Watteau picture you are a voyeur, you look at the scene through a keyhole; in the Picasso you don't.

111 Jean-Antoine Watteau, *The Intimate Toilet*, c. 1715

112 Picasso, *Femme couchée*, 1932

AGAINST EDGES

We do not look at the world from a distance; we are in it, and that's how we feel. Some people may not like it, other people do. I tend to like the thought that I'm in

the world. I don't want just to look through keyholes. So, what I am talking about is the world, and pointing out that there are different ways of depicting space; one way is a keyhole way, essentially the window idea, the one-point perspective. The window is just a big keyhole with edges around it. And you begin to realize that it is the edges that define the keyhole. You are deeply conscious of the edges. I began to be obsessed by them and also by the realization that you might be able to break them. It took me a long time to realize you could break the edges, and, certainly, reversing perspective helps to do it. The edge then becomes a lot less important. Any photographer will tell you that the one cardinal rule of photography is that when you pick up the camera and look at things through it, you are very, very deeply conscious of edges. It is the edges that make the composition in a photograph and it is what you leave there that will enable you to see things in the middle. The amateur photographer is the person who is not aware of edges – the casual snapper just points the camera at something without noticing the composition that's going to result. But the composition is only made by the edges. When I began the experiments in photography, I decided to try to make photographs in which you could alter the edges a great deal.

The edge has to do with movement and time and most essentially with the representation of space. But there was another preoccupation in my work, which has to do with the surface; and the edge of a picture is of course related to its surface. All painters are concerned with the surface. It is a first principle, a cardinal rule in painting, just as noticing the edge is a cardinal rule in photography. In painting you simply draw, you are working on a flat surface and the surface has to be acknowledged. The moment you acknowledge the surface, you also acknowledge the edge.

It has occurred to me that perhaps a two-dimensional surface, if it exists at all, has to do with scale. Perhaps there's no such thing as a two-dimensional surface; it can only exist in theory. If you took a canvas and looked at it carefully, the closer you got to it the more bumpy it would look. You would notice that it was not actually two-dimensional: it only *looks* two-dimensional if you are distant from it, if a certain scale is established between the viewer and it. I have thought about this and I'm rather amused by the idea that a two-dimensional surface could only exist in theory, because a two-dimensional surface has to be absolutely flat from the start. How big could something absolutely flat be? How difficult would it be to make? Does it matter? Is it important? It seemed to me of some importance because part of the art of painting is using this 'flat' surface – we think it's flat – to express ourselves on, making marks on it. The moment you make marks, they begin to play with the surface. The eye might see one at a different time from another and, therefore, space is made out of these marks. I think that's how space is made in pictures: each mark asks the eye to sense different time. I think that is why photographs came to feel

flatter and flatter for me, because in a photograph the time is of course the same on every section of the surface. In a painting this cannot be the case because a hand moving across it means time is involved and a line drawn: it has time in it because it has a beginning, a middle and an end and somehow this helps to make a space. I have often thought that maybe that's how it works in real life.

DIMENSIONS OF TIME AND SPACE

I got deeply interested at one time in how many dimensions there are. If you read a little bit about mathematics or physics you get interested in these ideas. The theory now is that we live in a four-dimensional world, in three dimensions of space and one dimension of time. In mathematics they start speculating, to help solve some problems, that there may be six dimensions, eleven dimensions, thirty-five dimensions, ninety-nine dimensions, an infinity of dimensions. But suppose you go backwards, go the other way, and speculate that there are only two spatial dimensions: it would mean that everything would be on one plane, which could be a sphere – an edgeless plane is a sphere – and we would be points on it. Suppose that, somehow, it is our consciousness that creates this illusion of other dimensions in time. It could be. It might sound ridiculous or silly, but so initially did lots of ideas which turned out in the end to be rather interesting, especially in science. New ideas often seem to go against common sense. I thought, why can't I put these ideas into my painting? When you begin to understand such ideas, it does seem possible to create a different kind of illusion of space on a canvas. It leads you into such strange areas that at times you even wonder if they're of any value at all. Nevertheless, I can't help thinking about them.

I read once in the *New York Times* a story about astronomers finding an object in space further away than a quasar, which they'd previously said was the furthest object that had been perceived. If you ask how far away it is they say you measure it in light-years. Now, the furthest object away they had seen, they calculated, is about thirteen billion light-years away. According to current theories the Big Bang was only about fifteen billion years ago. So the object we were seeing the light from began thirteen billion years ago, i.e. two billion years after the Big Bang. Well, you might ask yourself, where were we then? Where was the earth then? It's rather fascinating when you start thinking that, because you then become aware that the further out in space you're looking, the further back in time you're seeing and the idea of seeing backwards in time is a bit of a mad notion, or we think so at the moment. It makes me wonder, is all space an illusion? What is space? Just as it's very hard for us to think that if the universe is finite, space must end and there must be an edge there. And then, what is beyond space? We cannot comprehend it, it is unknowable. In fact, to my mind, the only possible thing you could think of, if, say,

space ends, is that it is the exact opposite of space, a sudden wall, a solid mass. But even then you'd think, where does that go? On and on for ever? Does that have an edge? And even edges then begin to fascinate you. They do me. You realize that they relate to where you think you are and therefore who you are. You then begin to link spatial ideas with identity; or I do. When I see the link between them, it makes me think of all kinds of other things.

I often have these strange ideas in the morning, the moment before I am fully awake. I have been able to use this moment since I was about ten, when I first became aware of it – the moment when you're just waking up and moving from an unconscious to a conscious state. What is it that happens, how long is this moment? I've always found it difficult to describe. But it is the moment when certain ideas occur which do not otherwise. I assume this happens because the mind is free and uncluttered. When we are awake too much gets in the way. When I was doing all that photography, each step I took was based on sitting late at night looking at the work, thinking about it and then going to sleep. Then, in the morning, sometimes I'd wake up and think, of course, *that's* the next step, and I'd realize it had been thought out in the moment of waking. I don't know how long it lasts. You're not even aware of time and the mind seems freer. I think many people experience this – it must be very common. As you become aware of it you can use this moment of half-awake and half-asleep, use it to let your mind move into areas that in full consciousness you might doubt, or think absurd, and therefore not allow your mind to enter. It is hard to describe it but I'm quite positive that it is there because I have used the awareness it gives me.

CAMERAWORKS

My early photo-pieces were only made for my own enlightenment: I was interested in Polaroid pictures and I was just making experiments. But I always finished up with a rectangle because I accepted the grid of the white border round each rectangular picture. When I started using an ordinary camera, I didn't always finish up with a rectangular picture; the edges were all over the place. At first I liked that, but having to glue them down onto something meant that the backing was usually, for convenience's sake, again a rectangle. When I came to do the book *Cameraworks* (1984) – and after all none of those pieces was made to be put in a book, I was not thinking about how you reproduce them – I became aware that I had photographs that actually couldn't be reproduced; once I'd made a collage like that it couldn't be reproduced in the same way as a photograph. Any ordinary photograph can be copied, technically. A good technician could take a superb copy of an Ansel Adams, say one of the very beautiful black-and-white prints of Yosemite, with a plate camera, and you would hardly know the difference. This, of

In 1985 I was invited by French *Vogue* to do a 40-page section for their Christmas issue. Rather than use existing work, I created a number of new photo-pieces (e.g., ills 114–117). I also designed the pages myself and did the layout. The whole thing took three months.

113 Cover of French *Vogue* magazine, Christmas 1985

116, 117 *pp. 108–109*: Double-page spread from 'Vogue par David Hockney', French *Vogue* magazine, Christmas 1985. *Left*: 'Word Tree'; *right*: *Jardin de Luxembourg, Paris, 10th August 1985*

course, is not possible with my photo-pieces because they are collages of photographs and a collage acknowledges surface, it is a physical thing, and therefore you cannot just duplicate it — it would not be the same.

Some pages in *Cameraworks* are good, but I think the best are those that bleed to the edge. One of the main problems with a book of that kind is that, instead of the edge dissolving, you become even more aware of it meandering around, and you've got all this white or grey paper interfering with whatever you're looking at. For my kind of photography to work, it must work on the page. Another aspect of photography — and a reason why photography has spread so much — is that the half-tone process makes it possible for photographs to be well reproduced in books. I have always thought reproductions of photographs in books work as well as the real photographs. An original photograph, of course, is a document, of interest to a museum. But it's just as good to buy a book of Cartier-Bresson photographs as to see his originals. I realized that to make my kind of photographs work on the printed page, I had to deal with the edges, which are the edges of the page itself.

This is why I agreed to do the piece for the Christmas issue of French *Vogue* in 1985. When they first asked me I refused; I didn't know enough about fashion and I was not interested in it, anyway. Then they said it didn't need to be about fashion, it could be about anything. I thought, if it can be about anything, then I'll do it. I thought we could make my kind of photo-collages work on the page — on the printed page of *Vogue* — and show, therefore, that it's possible to break photography up, change it, provided it worked on the printed page. After all, forty pages in the middle of *Vogue* is forty pages in the middle of pictures which make use of one-point perspective, because all the rest of the photographs in the magazine are made in the conventional way. I wanted to show how photography could be done differently.

I spent three months on my photo-pieces for *Vogue*. They thought all I was going to do was send them some photographs of paintings, that they would then get a text by someone and then lay it out like other people who'd done the Christmas issue, who had just made a selection from their existing work. I think the year before they had done one by Zeffirelli. The credit said *Vogue* by Zeffirelli, but it was more like Zeffirelli by *Vogue*, in the sense that they were mostly pictures of Zeffirelli. It was *about* Zeffirelli, not a work *by* Zeffirelli. I didn't want to do that. I saw it as an opportunity to test my recent ideas about photography. So I made a number of photo-collages specially for *Vogue* and I made sure they would bleed to the edge of the magazine's page. I told them I wanted no borders around the photographs and no internal borders, which would mean more edges.

We started working on the photo-pieces, but making them into a rectangle was of course not easy, because the way I had pieced things together up to then, none of them ever became rectangles. Making them into a rectangle was much more

complex; it meant you had to be moving about. In my previous photo-pieces, I had usually included my feet at the bottom to indicate the angle for each shot. Now that I had to be moving about, the photographs stopped having the feet in them. In the first photograph, the one of the place Fürstenberg, where I moved about considerably, if I put my feet in they'd have been all over the place because I was walking in the space all over the place. I thought that in the end it did work as a piece. It also, of course, led me to other ideas. I realized that the whole section in *Vogue* was a work by me, not comment on my work by *Vogue*, it was my work deliberately made for the magazine. I designed the pages, I did the layout, I did everything. I said I wanted to control every square centimetre of those pages from beginning to end, even the way they put the numbers on the page. And so the whole section became the work.

At just about that time, the proofs arrived of the facsimile edition of one of my sketchbooks, *Martha's Vineyard*; they were proofs of drawings made actual size; nothing had been reduced. Reducing in reproduction is the equivalent of pushing you, the viewer, away. It is as if you're seeing a drawing or a picture from a greater distance. I realized that when a work is not reduced but is reproduced exactly the

114 *Place Fürstenberg, Paris, August 7, 8, 9, 1985*

115 *Chair, Jardin de Luxembourg, Paris, 10th August 1985*

le temps
l'espace
l'illusion
le regard
le dessin
la couleur
la surface
le collage
la gravure
la perception
la suggestion
la perspective
la photographie

et les magazines

Voici quelques ideas et quelques images

à droite, une promenade dans les jardins du Luxembourg et
la double page suivante, une promenade Place Furstenberg

118 *The Desk, July 1st, 1984*

same size on the page, the hand that made the marks is the same size as the hand that's holding the book; you are brought closer, a great sense of intimacy is created. Having this insight, every mark I made for the *Vogue* piece – every single mark, my writing, anything – was reproduced exactly the same size. And I also put in a drawing near the end which was of the room where I was working. The photographs couldn't be the same size as I'd made them, which was quite big. I could have taken the negatives and printed them smaller, but actual size in a photograph is less important than actual size in a drawing. Actual size is important when the hand works.

The Desk was done about 18 months after *Walking in the Zen Garden at the Ryoanji Temple, Tokyo* (see p. 100) and was very important to me because it was part of my attempt to learn how to establish an object in space. In *Walking in the Zen Garden* I'd done a space, now I was doing a solid object. I managed to put the two things together later, in *Pearblossom Hwy* (pp.112–113).

REPRODUCTIVE PROCESSES

This is when I began to get deeply interested in reproduction itself – although I had always had some interest in it. When in 1981 I organized 'The Artist's Eye' exhibition at the National Gallery in London, my catalogue essay anticipated, quite unintentionally, ideas which were going to obsess me later. Only afterwards, for instance, did I realize that in the essay I was writing mainly about photography, suggesting that the best photographs were perhaps photographs of drawings and paintings, of *flat* objects, in which the photography is used a little like a photocopying machine. In that essay I criticized photography, but what I criticized I only began to deal with a year later. My concern in that essay was both reproduction made by my own hand, i.e., copying, and the photographic reproduction of a painting, buying reproductions, having them in a book, and so on. My own painting in the exhibition was called *Looking at Pictures on a Screen*; the exhibition was called *Looking at Pictures in a Room*; and the catalogue was called *Looking at Pictures in a Book*, each one dealing with what the title suggested, how one sees pictures in different ways.

94–105

The painting *Looking at Pictures on a Screen* came from an earlier period; it was made in 1977. It is of Henry Geldzahler looking at reproductions of pictures pinned on a screen. I'd quite forgotten about this painting and only when the National Gallery asked me to do the exhibition, which was supposed to include one of my paintings, did I think that it might be an interesting idea to use *Looking at Pictures on a Screen*, because all the reproductions pinned up on the screen were of paintings in the National Gallery. I had bought the postcards there and I always had them pinned up on the studio wall. For this picture of Henry we pinned them on a screen and had Henry looking at them. So I thought it would be amusing to make the exhibition around that. On one wall in the exhibition we had my painting. On another wall we had the real screen, the real chair, and the reproductions pinned on it. And on the third wall we actually had the real paintings, all great masterpieces: the real Piero della Francesca, the real Degas, the real Van Gogh and the real

93

119 *Pearblossom Hwy. 11–18th April 1986, #2*

I started *Pearblossom Hwy.* when I was commissioned by *Vanity Fair* to illustrate a piece by my friend Gregor von Rezzori, retracing Humbert Humbert's journey in search of Lolita. It was my last photo-collage and the most painterly. I spent nine days doing the photographs and two weeks assembling it. I see it as a panoramic assault on Renaissance one-point perspective.

Vermeer. So on each wall were the four paintings in a different form. The catalogue essay was about these ideas, about looking at the pictures in different ways, about reproduction itself and about the role of photography. It was this, working on the catalogue, that made me begin to be aware of printing. That was the first time I became deeply aware of what printing does, how important printing is to ways of seeing, and that without printing we would know very little about painting because without printing the only paintings we would know would have to be the ones we had actually seen. When one thinks about it, most people know about painting now through printing of some kind, some reproductive process.

Then I also realized that, of course, even with a printed thing on a page each of us sees something different because each brings a different memory to it. I, being the person who painted the picture, never forget, for instance, what the scale of the real one is; somebody else might, somebody else might never have seen it. So we are all seeing something different. Images on a printed page evoke different memories. Even in a reproduction there's nothing that is objective. Scale makes a huge difference: the experience of the painting in life and the experience of it on the page is vastly different because of the difference in scale. Then there is the difference in surface, the physical surface that the eye sees.

In one of the pages in the *Vogue* piece, crayons and pens are photographed in actual size. If on that page you started adding a penny, or a cigarette lighter or a cigarette, they would all fit in with the page because they would relate as they do in real life. I listed in *Vogue* what I wasn't able to do in that piece: ideas about time, space and so on. And one of them was printing and reproduction. I did not know at the time how to get inside the printing press. So everything was still reproduced in the ordinary way using a half-tone process, screens and so on. I would have loved to have used the printing direct, but I did not know how to do it. I found out how a little later, again by playing with a different kind of camera.

I think I first became interested in reproduction at the time when a lot of people were making posters. European galleries especially, when they were having an exhibition, often wanted posters. There is a tradition in Paris of making them for exhibitions; they're stuck up around St Germain, lots and lots of them. I can remember suggesting to Paul Cornwall-Jones of Petersburg Press that perhaps it would be better sometimes if we did posters rather than prints, and I said the same to galleries. They did start making posters and some were better than others. At the same time, prints were beginning to get very expensive, certainly my prints were getting expensive. All through the sixties and early seventies they'd been quite modestly priced; almost anybody could buy them. The prints I did with G.E.L., of Celia smoking, were three hundred dollars; they sold out very quickly, which meant they were probably underpriced. Almost anybody who had a job could actually buy one if they liked it. But they started jumping up in price and I think

possibly at that time I became a little more aware that the poster was replacing cheap prints. After all, no matter what you do with it, how expensive can a poster be? The poster can be a marvellous reproduction, bigger than anything in a book, and if you print them well and take the photographs of the paintings well, the posters are worth keeping, people might like them, they can pin them on a wall.

I am aware that a great deal of my work is known mainly through reproduction; in fact, most if it is. Certainly, by the late seventies I was taking a keen interest in how the posters were made, printing them on good paper, etc. The difference in price for a poster printed on good paper with good printing and a poster printed on cheap paper with cheap printing is not that big for what you could sell the poster at. If it costs two dollars more to print it on a better paper, then you do it that way; somebody will pay the extra two dollars; it's not a great amount of money, and most people are willing to pay that bit more if the paper's better and won't fall apart.

When we made a poster of *Pearblossom Hwy.* (1986) we printed five thousand 119 copies for an exhibition at the International Center of Photography in New York. I realized that was the way most people were going to see this work, in this form of reproduction, because the number of people who could see the real piece, which is ten feet across, would be quite small. If you sell five thousand posters, not only are five thousand people seeing it, but maybe ten other people see each poster, so it means a lot of people. Therefore, I thought if that is the form it is going to be seen in mostly, let's make sure that we do it as well as we can technically. That's why my posters began to be rather good. We took a little more care just making sure the work was photographed very well and the printing was of good quality. I was surprised that so few artists seemed to take an interest in that. I think now more and more artists are becoming aware that reproductions of their pictures are the way most people see them. After all, artists should have known that, because that's the way they themselves saw a great number of pictures. For me, reproductions of my work were something that became more and more important, beginning with my first big book, *Hockney by Hockney*. I realized that not only had I got my work at my fingertips, I could flick through it, flick through my life as it were; I realized too that others could flick through my work, and I think this is also a part of art.

PICASSO'S EXAMPLE

In about 1978 I got the last ten volumes of the Zervos catalogues of Picasso's work and I studied them closely: that's the only way you can study late Picasso. Later on I bought all the Zervos catalogues. The early ones are out of print and I had to buy the original editions, which are quite expensive. I realized that Picasso must have

known what Mr Zervos was doing; he had begun cataloguing the work in the twenties. Picasso must have been fully aware that this incredible document was constantly being made of his work; and Picasso dated everything by the day. Virtually everything of the later years was put in, not every drawing, but every painting, in the order in which they were painted. These thirty-two volumes are a unique document; no other artist has ever had his work so thoroughly documented. Zervos's catalogue raisonné was being made as Picasso went through life, rather than after his death, when such catalogues are usually done. I think Picasso knew this and knew that whatever he did, somebody would be able to retrace his steps in this way.

That is how I learned, for instance, how he worked in series. By studying the catalogue I could see at what point he began and at what point he ended. In January 1983 I gave a lecture on some Picasso paintings, 'Important Paintings of the 1960s', at the Los Angeles County Museum of Art, about thirty-two pictures, which Picasso made in a period of ten days in 1965. They all seemed to me to make one work. And if you saw it as one work, you realized what a marvellous, brilliant, complex work it was, made by a stunning old master whose work we had not been looking at in the sixties. Some people at that time were ignoring the work Picasso was doing then, thinking he was just repeating himself, that it was all the same, that the work had lost its power. But it can only seem like that if you don't look at the work carefully. The moment you begin to look carefully you discover that far from being repetitive, the work he was doing in the sixties was, in fact, inventive on a very, very high level.

I assumed Picasso knew that this could be discovered just by looking at the Zervos catalogue, even though the paintings are reproduced there only in black-and-white. Consequently, he didn't even need to exhibit them. Certainly the vast majority of the work was not being exhibited – if it had been, some of it might have been sold. But we weren't seeing great big Picasso exhibitions of current work in the late sixties or early seventies, except for an exhibition at Avignon in 1970.

Picasso must have understood that he could use a process, a technology, that had been, after all, only widely available since the twenties. The half-tone process of reproducing photographs on any kind of paper only began, I think, a little bit before the First World War. But by the end of the War the process had got quite cheap and more widely available and pictures could start appearing in newspapers. Instead of printing line drawings, newspapers were able to print photographs. By the late twenties photographic magazines began to appear. Zervos used this technology to start his catalogue raisonné and, as I said, I have no doubt at all that Picasso became aware of it and used it. Those thirty-two volumes became a gigantic diary, the most extraordinary diary ever made.

The last three years of Van Gogh's life are also extremely well documented. We think we know everything he did. If you put the letters, the drawings and the paintings together and consider how much time they took up, the only time left in that period would have been for sleep. And he covered it all, in detail, in writing. If you're on your own, sitting in a little room and you wish to make contact with human beings, of course writing letters is a very good way: you're talking to somebody. I tend to write longer letters when I'm on my own in a remote place. When you're with crowds of people, and talking, you don't feel the necessity. So Van Gogh's life is incredibly well documented for those three years. Probably no other human being's life is that well documented.

But in the case of Picasso you get nearly seventy-eight documented years. I think the first things in the catalogue were painted when he was about fourteen, and he lived to be ninety-two. That is an enormous number of photographically documented years by an artist who painted more pictures than anyone else. He is even in the Guinness Book of Records — not even a hack has painted more!

There are, then, all these different forms of reproduction of images, whether these are images from the world or invented images, like paintings, as in the Zervos Picasso catalogue. And I became fascinated with the idea of taking it all further and actually using the reproductive techniques themselves. To go back to the *Vogue* Christmas 1985 piece — that was a work deliberately made to go on those pages. Deliberately made, knowing the process by which images are put on the page. A little later I got to the point where I could put something on the printed page that was not a reproduction at all. And that seemed to me to break another edge; another barrier. Not long after the *Vogue* piece I started playing with a photocopying machine which had been used for it, to make up the model. We would photograph the photographs and then make a colour copy of them, of a certain size, to stick them on the *Vogue* pages. Having that model I knew exactly what happened when you turned the page. I didn't make the photocopies myself. We went down to a place in Hollywood where they would copy the photographs for you on a four-colour copying machine. I grew to like some of the ways the machine interpreted things, this kind of mechanical, cheap printing. Although I had not played with the machine myself, the moment I did I made some other discoveries.

PHOTOCOPIES

I wouldn't have known the potential of the photocopying machine, how to use it for my purpose, without my experience with printmaking, which I did very intensively at Ken Tyler's. I spent nearly two years making a lot of prints and very little else, most in 1984 and 1985 when my house in Hollywood was being repaired and altered. I used all kinds of techniques. When you are making prints your mind

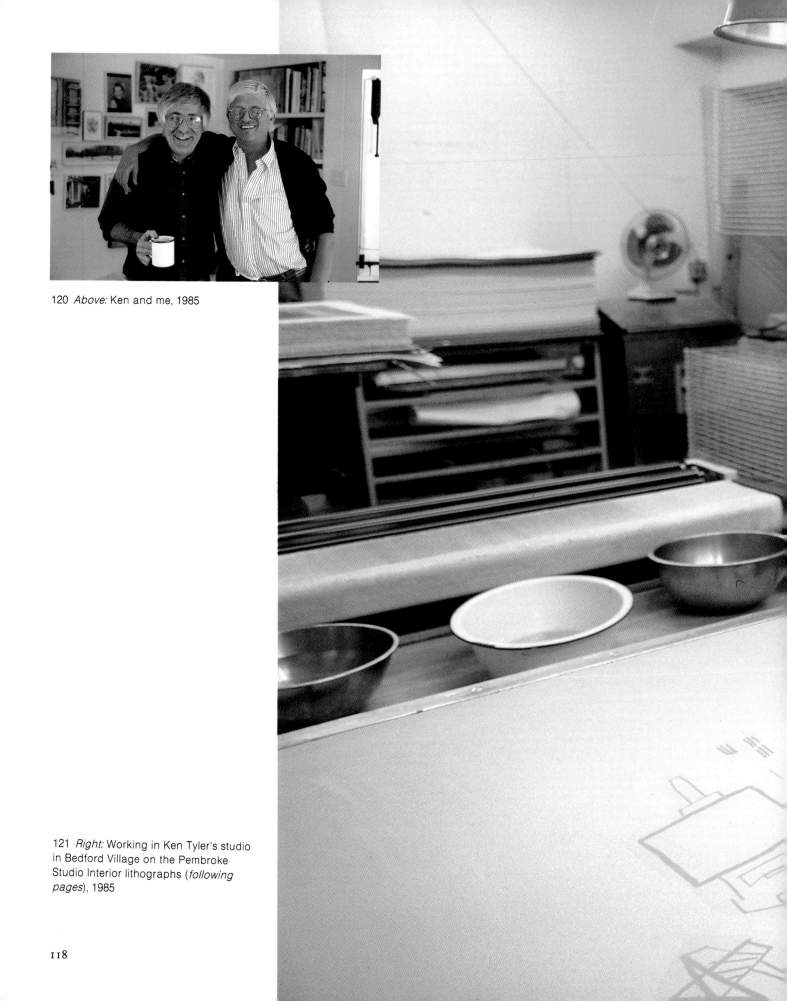

120 *Above:* Ken and me, 1985

121 *Right:* Working in Ken Tyler's studio in Bedford Village on the Pembroke Studio Interior lithographs (*following pages*), 1985

118

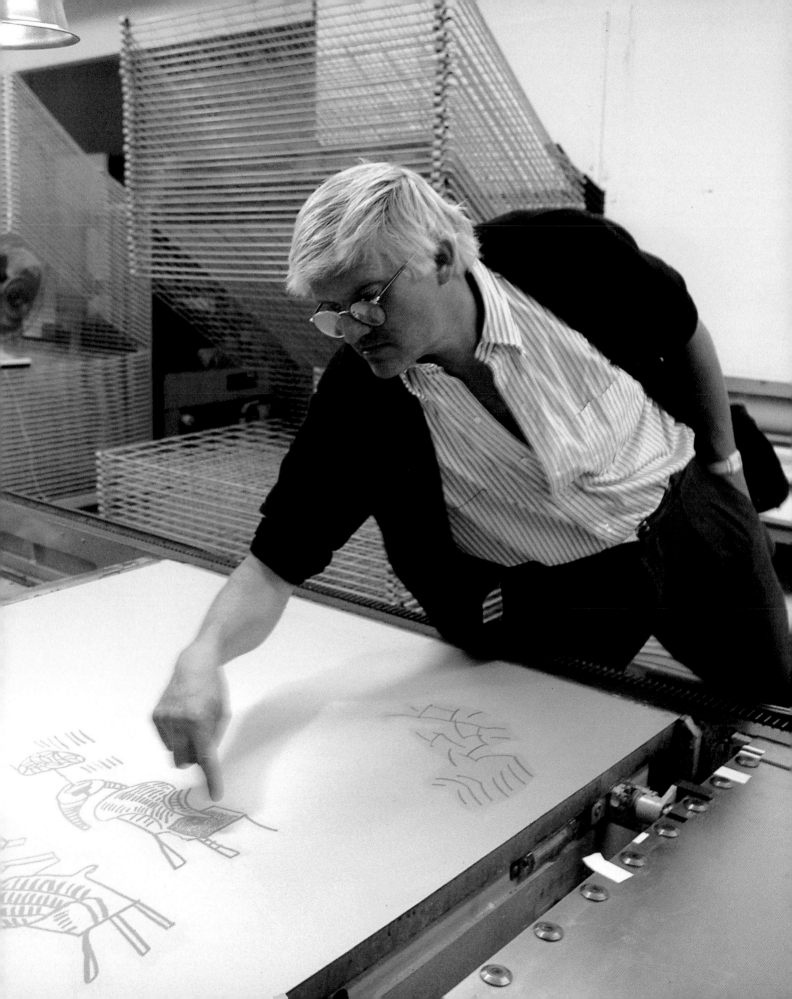

122 *Two Pembroke Studio Chairs*, 1985

Because of the many viewpoints in these pictures, the eye is forced to move all the time. When the perspective moves, the eye moves, and as the eye moves through time, you begin to convert time into space. As you move, the shapes of the chairs change and the straight lines of the floor also seem to move in different ways.

123 *Below: Pembroke Studio with Blue Chairs and Lamp*, 1985

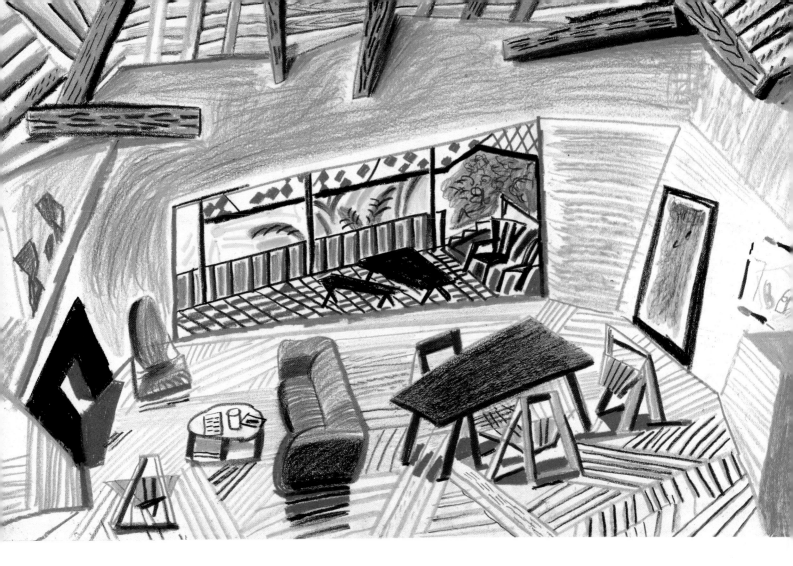

starts thinking in layers; you are separating colours and thinking in layers. Without all that, doing it for two years, I don't think I would have explored the copying machine as quickly or found out so quickly what it could do. So the copying work was a direct result of the earlier work with Ken Tyler.

The works I did with the copying machine, starting in 1986, were not reproductions; they were very complex prints in the same way that a print is not a reproduction but is just itself. One is using printing techniques to construct an image, as in making a lithograph. When I made the discovery of how to use copying machines to make prints from no pre-existing image I was very, very excited. I felt it was, in fact, the most spontaneous way you could make prints. Never before could you have been that quick doing it, and I galloped away making all kinds of things in rather a short period of time. Most of those that I call Home Made Prints were done in that period of about six months and they developed from very simple things to very complex prints, complex in the sense that sometimes a piece of paper went through the machine as many as twelve times.

124 Untitled, 1985

125 *Tyler Dining Room*, 1985

Home Made Prints

126 *Left: Flowers Apple & Pear on a Table, July 1986*

127–133 *This page, clockwise from top left: Mulholland Drive, June 1986; Red Blue & Wicker, July 1986; The Round Plate, April 1986; The Juggler, September 1986; The Drooping Plant, June 1986; The Red Chair, April 1986; Dancing Flowers, May 1986*

One reason, among others, why I think Picasso is so crucial is because he brings very much to the fore the question of verisimilitude versus the remaking of appearance. And what led me into questioning the verisimilitude of naturalism was that it was not real enough. Because the problem is not that naturalism is too real, but that it just is not real enough.

What was exciting to me in reading a book like *The Fourth Dimension and Non-Euclidean Geometry in Modern Art* by Linda Henderson was that it made it clear for me that the early modern artists did believe they could change the world and that it was not until later on that this belief died out. But when someone says that artists used to believe that and now they know they can't, I cannot agree. I think they can. And I think modernism is being betrayed because it did not involve all the kinds of images that it could have involved. And the reason for that was that photography took over image-making.

We have to remember that it was not so long ago that the photograph first appeared. Photography might be over 150 years old now, but not many people would have seen photographs early on. It wasn't really until, I suspect, about the turn of the century that many people realized the implications of photography in art. When photographic studios began to be set up, making portraits, recording weddings, photography spread rapidly and became part of life. Almost anybody alive today could dig out photographs of their great-grandparents at the turn of the century. I have a wall in my house of photographs: my parents, my parents' wedding, my mother's parents, even their parents. There's one picture of my great-grandmother, probably taken at about the turn of the century in Bradford. But until the invention of the half-tone process photographs wouldn't be seen a great deal. The moment that process becomes available the photograph becomes ubiquitous; it's just everywhere, it dominates the way we see the world. Now modernist assumptions about depictions of the world, of course, do not seem to be very different from those assumptions people make about the 'reality' of photographic depiction. Modernist artists think they are playing with the world; the world, they think, looks like the photograph; and what they are doing is rearranging it in an artistic way. But the world isn't just like that. I think it is much more than that: it challenges all the time any static notions we may have of reality and representation. And I think we have become aware of that partly because we are now beginning to see the limitations of photography.

We tend to think of the photograph as a perfect record of life. But in fact the photograph is the ultimate Renaissance picture. It is the mechanical formulation of the theories of perspective of the Renaissance, of the invention in fifteenth-century Italy of the vanishing point, which many people think was one of the most profound inventions of all time. Brunelleschi, looking through a hole at a street in

Florence, makes a depiction of it from a fixed view-point. The Renaissance painters, of course, always suspected the rigid rules of perspective and bent them – as all good painters would.

In photography, however, it has to be rigid, of course. The camera is a lot older than the photograph itself; it is actually a sixteenth-century invention. The *camera oscura* is older than that, but by the sixteenth century it was developed with lenses. The photographic process is simply the invention in the nineteenth century of a chemical substance that could 'freeze' the image projected from the hole in the wall, as it were, onto a surface. It was the invention of the chemicals that was new, not the particular way of seeing, which goes back to fifteenth-century Italy. So the photograph is, in a sense, the end of something old, not the beginning of something new.

And then there is something beyond it, beyond the frozen photographic image. But you can only convince people that there's something beyond the conventionally made photograph if you alter it, by making it even more vivid, more vividly real. Cubism in painting does precisely that, but it became harder and harder to see what Cubism was actually doing because of the photograph getting in the way. You could always hold up the photograph and say, See, it looks like this. Until what we call Modern Art, which begins at about 1870 or 1880, people could look at pictures and understand them to some extent, even if they were untrained. Pictures were meant to be understood, like all those pictures in churches. Peasants who could not read could understand the Christian stories by looking at the pictures; that was the purpose of pictures. The painters wouldn't have painted Biblical scenes that the peasant couldn't even see, let alone understand; it was important that they see them. Modernism began by looking outside Europe, by discovering a different way of measuring the world, a different way of seeing.

New ways of seeing and depicting reality parallel scientific discoveries about a new way of measuring the world. But when it came to Cubism most people would say, The world does not look like that. Picasso looks full of distortion to them. Looking back at what people said in, say, 1925 – a year when, after all, great Cubist works had already been painted, when Picasso was in his neo-classical period – to the average person, even someone who had taken an interest in pictures before, the Cubist pictures seemed confusing and many people thought that this was not reality in a painting, that it was something else. To most people Cubist paintings were not of what they understood to be a shared reality, but a private version of reality.

Coming, as it did, soon after Expressionism, Cubism seemed to many people to be about one person's subjective perception of reality. And that was what Einstein's theories also seemed to be about. Before Einstein, space and time were considered separate and absolutes – they always existed. Einstein said, This is not

the case, they're not absolutes and they depend a great deal upon the observer; different observers see different events at different times. Such a view also seemed to break up the notion of a shared reality; it established that we all see something a little bit different.

But our memory causes that to happen, anyway. Conventional art history takes the line that Cubism was a forerunner of abstraction by 1925. That was the year that saw the beginnings of Mondrian and much else. In fact, what they would have called pure abstraction had happened before. But that is where we run into a problem, because people then thought, ah yes, we have abstraction, what we call abstraction, which does not seem to look like the world, or it doesn't matter whether it looks like the world or not; and then we have representation, where things do look like the world; and the ultimate representation is the photograph. The argument then went on: now that we have a photograph that mechanically records exactly what the world appears to be like, painting does not have to bother with this, so there is no need for topographical painting any more; painting can be about itself. But painting had always had to be about itself. This is what led us to believe that there were two separate things: abstraction and representation, and that they were very different.

I, like everybody else, went along with that thinking. But now I am not sure at all about that. I think, in fact, the more you go on the more you realize there's actually only abstraction. The photograph is a refined abstraction, a highly refined one, just as perspective is. In this sense, a Canaletto painting is a more abstract, and much less 'real', picture than an eighteenth-century Chinese scroll. And the reason why I made a film about this, in 1987, was that most people would think the reverse, that the Canaletto represented reality and that the scroll was a kind of invented, cartoony, stylized kind of reality. The photograph too is stylized, though it's no more stylized than anything that is a depiction; it has to be stylized, what else can it be?

What I have thought about the most in the last years has been this question of the position of the photograph and depiction, representation and abstraction. I have played with it, therefore, in some good ways and in some not very good ways. Sometimes you go off on tangents that turn out to be cul-de-sacs, so you simply abandon that little journey, come back to your main road and go on again. But you can't always see ahead very clearly and the road keeps bending; that's what happens.

If someone were to say that some kinds of art, like a painting by Rothko, are representations of inner states rather than outer appearance, I would answer, so is everything else. Someone once said to me while we were talking about Cubism, Isn't Cubism about the inner eye? I said, But that's all we have, that's all there is. There isn't actually any other kind.

4 Memory and Making it New

Even in science people began to realize that you can't make a measurement without a measurer, that the experimenter had an effect on the experiment. The very fact of observing something has some effect on what is being observed. Scientists acknowledged the problem and that led them into making some immense discoveries. I'm only a layman, but what strikes me when reading are some of the phrases scientists use, though I suppose they mean them metaphorically. But I realized that if you make pictures, such statements could almost be meant literally, phrases like 'new horizons are appearing', 'wider perspectives are seen', are visual metaphors that could be applied to pictures. Scientists wouldn't necessarily make that connection because they're not particularly concerned with pictures. The only people who think about pictures and the way they are constructed are the people who construct them, painters. Photographers do not. They construct their pictures by looking at the edges through a viewfinder. Painters can put the edges where they want, even if they're depicting a scene right in front of them.

The argument that painting is about itself, that it does not need to concern itself with the description or appearance of the visible world, rests on the idea that this can be achieved much better by photography – which is like saying, we know what the world looks like: it looks like a photograph. This seems to me to make the world a duller place. I don't think we fully know what the world looks like, because I think you begin to realize that whatever you're looking at, what you experience is, after all, through your own consciousness. So you realize it's not possible to separate what you're looking at from yourself; at some point it's connected with you when you're looking at it.

The problem started when we began to measure the world as though we weren't in it, partly because we had been seeing the world that way. To a certain extent, the spatial abstractions made from the Renaissance on were this box, this spatial box, with us outside it. The ultimate spatial box, oddly enough, was achieved when they tried to make the photograph even more vivid with stereoscopic photography, a Victorian invention. And although it's true that you get a rather more vivid feeling of space, you are nevertheless outside it – you're even more outside it than in an ordinary photograph. You have to ask yourself, where am I? You're in a void, looking out of something into something – the world. Well, you then ask, where have we put ourselves?

There is no doubt we are intrigued by illusionism and *trompe l'oeil*. I would think one of the reasons for this is that it seems a little god-like; maybe that's its appeal: if you assume that God stood outside and made the world, the fact that we can recreate a little bit of it makes us think we are actually being a little god-like. I once thought that maybe that's what creativity was.

The day I saw the great Chinese scroll, which I found so thrilling, at the Metropolitan Museum's Department of Far Eastern Art, I spent four hours on my knees looking at it and talking to Mike Hearn, the curator, about how marvellously it dealt with space, time and narrative, how exciting it was, how charming. On our way out – we had been in the private rooms of the museum because the scroll was not on public view – we stopped at a circular room with, I think, an early nineteenth-century kind of mural of Versailles, the back of the palace. What you had to do was stand in the middle of the room on the platform with a little rail round it, and you could then turn round 360 degrees and see the view; if you were to stand in a certain position in Versailles, this is pretty much how it would appear. But I had just been through a Chinese city; I'd spent hours wandering up one street, down another, up another, and I was not fixed in one point. To stand rigidly in this place now, only allowed to rotate in order to see the view around Versailles, I thought I was dreaming; it was unthrilling being back in Paris. I was not moving, I was not connected with it, it only worked if I actually stood rigidly. To make it work, I had to be a tiny immobile point. In short, my body seemed to have been taken away, whereas in the Chinese scroll I still had my body. I was wandering through it, which was much more real to me. That's what excited me. At first glance, the Chinese scroll looked far, far more stylized and, therefore, less real, because we think reality is not stylized. Yet by comparison with the Versailles panoramic view it was much more real.

HOW/WHAT YOU REPRESENT

I may seem to be passionately concerned with the 'hows' of representation, how you actually represent rather than 'what' or 'why'. But to me this is inevitable. The 'how' has a great effect on what we see. To say that 'what we see' is more important than 'how we see it' is to think that 'how' has been settled and fixed. When you realize this is not the case, you realize that 'how' often affects 'what' we see. For instance: in television news they have to provide pictures, images, the way radio news does not. They want to keep you there, they need an audience and so they have to find a way of introducing some kind of excitement. It's easier to show Rome burning than Rome being built. Consequently we see more pictures of Rome burning. By linking 'how' with 'what', as I am doing now, I am trying to show that we achieve a profound effect. You cannot dismiss this 'how' and say it

should only be 'what', because you have then fixed it too much, which will dictate what you see. So, 'what' and 'how' can't be divorced; you must always keep asking the question 'how'. It must be asked and dealt with, and that's all I'm doing.

One criticism of my photography has been that it is of nice, pleasant subjects. However, the moment you move away from conventional photography – the view through the keyhole – you become involved in the subject in a very personal way. It then becomes difficult to represent certain things. Whereas in using the view through the keyhole method you could depict, say, cruelties – one person being very cruel to another – and still believe that the depicter had not much to do with it, the moment the keyhole goes, the depicter has a great deal to do with it. To demonstrate this I have often used the example of the famous photograph of a little girl running down a road in Vietnam, aflame. We tolerate that photograph because we assume it's taken with a telephoto lens; we assume that the photographer is at some distance from her and that, therefore, he could not have immediately helped her. Because if he hadn't tried to help her and had instead started taking close-up photographs of her, the subject, then what would be conveyed would not be the little girl in flames, running; there would be the much more dominant subject of the cruelty of the photographer in not helping her. My method of constructing my photo-collages was so slow that this alone would have meant I was acquiescing in whatever was happening in front of me. If somebody started to strangle somebody, you might be able to take a snap, throw your camera down and then run to help the victim. With my method you couldn't, you'd actually finish up with the victim murdered and the photographer would have been part of it, an accomplice. That is why my subjects happen to be what they are. I thought I'd simply take most of my subjects from my own backyard, my own friends, just the intimate world I know. In fact, it becomes difficult not to do that with the method I used.

All this has a great deal to do with what is called 'subject-matter'. So 'how' we see the world greatly affects 'what' we see. No doubt, we have not always been at this level of consciousness, from what we know of history. I think now, however, spatial feelings and, therefore, depictions of space, have a great effect on us, a profound effect. It was the growing awareness of this on my part that made me begin to be a little obsessed with ways of depicting space.

There is an area of photography that I have followed closely for many years. I am deeply interested in old pictures, all kinds of representation, and that includes pornography. For a long time I purchased gay magazines with pictures from the early sixties; they were usually small black-and-white publications. If you compared them to today's magazines you would actually get a rather interesting history of photographing the figure – I've often suggested that some museum might look into this area. If you look at the history of the last thirty years of gay magazines, you even see advances in printing. Nowadays most of the pictures in

these magazines are in colour but colour photographs were very rare in the early sixties; only the cover might be in colour. You would also notice that in today's magazines the camera seems to have got in closer to the figures. Earlier on, it was usually the whole figure that was represented; the camera had to be at a certain distance, away from the figure. One day I am going to try making an exhibition of my collection of gay magazines to show how, as cameras and printing developed, the photography moved in closer so your eye sensed flesh more and you got closer to the figure. Also, the single figure came back. There was a kind of high point, in what is called hard porn, showing two figures together, but that meant again that you, the viewer, were some distance away, a voyeur. Then the camera seemed to move in nearer and nearer to the flesh itself, so that the viewer was not just a voyeur looking at two distant figures, but actually became connected with just one.

We now have these anti-pornographers who say such magazines and photographs should be destroyed, but we all know we would not destroy anything, no matter how pornographic, if it were five hundred, or a thousand, years old; we would regard that as irresponsible because we would want to study that material, we would want to know whatever it told us about what people were thinking, what people were seeing. This is a valid argument that should be used, especially in England, where anti-pornography campaigners urge that such material be destroyed. If they said, We are going to destroy all the pornography in the British Museum, people might take it a little more seriously and perhaps oppose them. Certainly historians would. They would think, no, no, you can't do that, you can't move into the British Museum and decide these are disgusting, they must be burnt. And if that were seen as an irresponsible attitude, why pick on people today? After all, we know perfectly well that some of the material in the British Museum was not done originally for people to study, it was done for the same reason people make and buy such magazines now. Of course, you don't intellectualize or analyse with the magazine in front of you, but afterwards you think about it, or you remember what the pictures were like in the past and you see that the photographs now seem to be closer and you wonder what this is, why can I sense flesh here that I couldn't sense before? Is it merely the printing, is it that the cameras have got better? Any curious person, interested in the subject, would ask such questions because they have a bearing on the way we see.

PAINTING VERSUS THEORY

Although I am interested in theory, I am not of course a theoretician. I ask such questions and make the theories only afterwards, not before — only after I have done something. I keep pictures I have done around the studio; you want to look at them. And it takes a while to realize what I really did there, how it works; then I

may use that in something else. But though painting can't be done theoretically, all painters must, to a certain extent, analyse their work afterwards. I'm sure the Cubists didn't plan it that way, they didn't self-consciously sit down and say, Well, perspective has to be broken, that's what the problem is. It's a groping, they're groping slowly and in different ways; each of the artists groped in a different way. Picasso or Braque would have looked at their pictures after they were painted, they were not self-consciously thinking of Cubist theory while they painted. You allow a semi-consciousness to tell you how to go on, or else the painting would be intentional, and you couldn't be doing it intentionally. You make the discoveries of what is going on inside you; you don't need to know this; you work intuitively. Cubism was discovered intuitively, it was all intuition. Most artists, good artists, trust their intuition. I trust mine. Sometimes it leads you to make mistakes, but that hardly matters. You don't see it that way, you don't even bother whether it's right or wrong that way. There is no such thing as failure, you just learn from it and go on. That's the way I see it.

I remember, for instance – I think it was the first time we showed the photo-pieces in New York – somebody wrote, 'He's done it all wrong.' I thought, you can't say that, there is no such thing as being wrong. First of all, it depends on what you are doing it for. I knew I was learning a great deal: if I'm learning a great deal I can't be doing anything wrong. It was simply the typical arrogance of a critic who seemed to have a rather set view of modernism. For instance, it looked in the seventies as though modernism had collapsed, but it had not really collapsed. A lot of critics thought they could predict the next steps. But if you could predict the next steps there wouldn't be much point in taking them, they'd already be made. It wasn't the painters who proclaimed the collapse of modernism, it was critics. I love the remark De Kooning made when Clement Greenberg said that it was not possible, for a serious artist, to paint a portrait now. De Kooning's reply was, Yes, and it's not possible not to. Well, his reply seems to me wiser. What could Greenberg's statement mean? That the only portraits we could see were photographs, that is, seeing in one particular way? But this would mean that no future generation would be interested in making a depiction of a face in a way other than the conventional keyhole view-point way. That seems to me highly unlikely. After eight thousand years of depicting faces, I have no idea why this urge should suddenly disappear at about 1955. It seems a naive idea to me; people aren't like that. I felt that Greenberg's remark did not show a very good understanding of artists, whereas De Kooning's did. The depiction of the human face cannot be left to the photograph or the photographic way of seeing. Doesn't Greenberg's view derive a great deal from the fact of photography? The fact is that we do have this very deep urge to depict. There is no doubt about it. You can't argue against it. It is there throughout history. Why would our generation suddenly abandon it? No

reason at all. Anyway, it wasn't abandoned. This view of Greenberg's is an example of theory veering off too much from ordinary commonsense. With a little commonsense you would know it was absurd, too absurd, because it would mean human beings had changed totally and we have no evidence of that. The more interesting question is: given that depicting, the urge to depict, is part of human nature, how do we go about it? What methods do we use and what assumptions do we make about depicting in this or that way?

Which brings us back to the question, what is an abstraction? We keep coming back to this and the reason why we do is, I think, because the emergence of abstract art is directly related to our belief that photography is true, realistic depiction. But the moment you think the photograph can be made differently, can be altered, all issues about the fixed view-point disappear. If the view-point presented in a photograph is not fixed, everything becomes more interesting. Suddenly the world is more interesting to look at and we begin even to doubt what we see. To me, what is exciting now is that all such issues are becoming more apparent to more and more people. It always has to start with just a few people realizing something. When I began doing a different kind of photography I was attacked quite a lot. People would say, He's wasting his time, what's he doing, why doesn't he paint, and so on. I took no notice, I couldn't. If you are learning something from whatever it is you are doing, you are not going to be put off because somebody says it isn't art. I couldn't care less whether it was art or not, I felt excited by it. I felt that the things I was doing were at least discoveries for *me*, whether they were for anybody else or not, and I found them thrilling. I can ignore a lot of the time what other people might say. I am confident. You only tend to be deeply affected by critics if you believe them. If they say something that you actually think, it means that you have had that belief before, even though you might have tried to hide it. But if you don't believe it, it hardly matters. When my photography was attacked, I just shrugged my shoulders. I never thought of stopping until I was ready to stop. The discoveries were too big for me, much too big. The three intense years I was doing photography were for me very exciting, and also confirmed the idea that there was no distortion in Picasso, that what he was doing was much more real. And that made me look at the late Picasso paintings yet again, more intensely. I think very few people indeed have looked at them intensely. Most people want Picasso to go away, in a sense, but he won't. The massive output of work is still difficult to take in and that is why it is so much easier to appreciate, as it were, the masterpieces up to 1940. And of course looking at them from a distance of fifty odd years makes it easier. (It is always difficult to see the present.) The Zervos catalogues enable a student to study the work in a way which would be impossible otherwise. To see all those Picassos, where would you go? You wouldn't even know where to go.

I have always believed that art should be a deep pleasure. I think there is a contradiction in an art of total despair, because the very fact that the art is made seems to contradict despair. It means at least that you are trying to communicate what you feel to somebody else and the very fact that you can communicate it takes away a little of the despair. Art has this contradiction built into it. All one has to do is look at its history.

A few years ago at the Metropolitan Museum of Art in New York there was a show of Fragonard. He is an artist who has been thought sometimes to be much too pleasurable, much too playful, much too sweet to be serious, and certainly in the early nineteenth century that's how he was dismissed. It was only the Goncourt brothers who started looking seriously at his paintings and buying them. Today we see him differently. To me Fragonard is a wonderful artist. I think you can't have art without play; Picasso always understood that. I think you can't have much human activity of any kind without a sense of playfulness. Someone once criticized my work, saying it was too playful. I said, That's hardly a criticism at all, that's a compliment. I do see it as a compliment because I believe that without a sense of play there's not much curiosity either; even a scientist has a sense of play. And that allows for surprises, the unexpected, discoveries. Anybody who gets good at it knows that. You can use it. I use it. People tend to forget that play is serious, but I know that of course it is. Some people have got the idea that if it's boring it's art and if it's not boring it's not art. Well, I've always thought it was the other way round. If it's boring, more than likely it's not art, if it's exciting, thrilling, more than likely it is. I don't know of any good art that's boring, in music, poetry or painting. Isn't that why Shakespeare is so exciting?

In a certain sense, one only makes pictures for oneself. I work on the assumption that if something I am doing interests me it might interest someone else; but I can't be bothered too much if it doesn't, as long as it interests me. I am an artist who is always working. I know some people think I spend my time just swimming around or dancing in nightclubs. That's fine. But I don't, actually. I work most of the time because it excites me and gives me very great pleasure and because if I didn't work I wouldn't know what else to do; I think I would go mad if I didn't; I think I might not like the world if I didn't. Maybe I'm doomed in this sense. Sometimes I think it might be better just to sit back and enjoy it, but I'm not capable of that. I wish I were. I am capable of enjoyment, but unfortunately I have this urge, this compulsion, to share my enjoyment, which is what artists do usually. Most artists have that urge, a belief that it is possible to do this, to share your perceptions. It seems to me that, however rotten you might think the world is, it is always possible that there is something quite good about it. This makes me to a certain extent an optimistic person. I think I tend to have a somewhat Oriental

attitude to tragedy, not a Western attitude. The Oriental view of life is different; it doesn't see life as tragic in a European sense, and in a way I find myself quite drawn to that. It seems to me one of the great sadnesses is that all of us understand tragedy to a certain extent, or sense it in our lives: loved things disappear, people you love die. But it's the comic side that some people can't see.

DEATH'S ADVENTURE

My father's death meant a very great deal to me. He had told me that we should not mourn when he died. As far as he was concerned, you could throw the body away. He had enjoyed life, I think he had, although he had quite a hard life in a material sense. But in a non-material sense I think he had a very rich life, just as my mother says she's had a very rich life even though most of it has been physically quite hard. The last time I saw my father was when the *Paper Pools* were shown in London in February 1978. I had been working on them with Ken Tyler in upstate New York and when we were finished we sent them to London for an exhibition. I went too and my parents came down to London. They stayed at the Savoy Hotel, because the gallery was just walking distance from it. That was the last time I saw my father. After the exhibition he went back to Bradford and I stayed in London for one day longer. That day I called my mother and she said, Oh, he's gone into hospital to balance. He was a diabetic late in life but he kept nibbling on chocolate biscuits. If you are a diabetic you are not balanced, it's as though you're drunk. All the people in Eccleshill, in Bradford, knew who he was even if he didn't know them well, and if they saw him staggering around (my father never touched alcohol, so they knew he was ill) they'd bring him back home to my mother. My mother always felt safe there and that is why she never wanted to move. The neighbours were kind about it. So, he went into hospital the day they got back from London. My mother said, Oh, he'll be all right, they're just balancing it out. I said, All right, and went back to New York for a night before going off to California.

The telephone rang at six in the morning and it was my brother. When I heard his voice I knew there was something wrong because my brother knows about the time difference. He told me my father had just died in hospital; he had had a heart attack, a big one, and just died. I put the 'phone down and burst into tears. I got the next plane back and went up to Bradford. My mother said, Oh, you've come back to a sad house. In a way, at first, I was thinking of my mother more. Suddenly, a partner gone – they were about six months off their golden anniversary. My first feelings were to try and strengthen her. My mother is a very strong person, but I thought she'd be very vulnerable then and I felt that my first duty was to the living. I felt I was being quite brave, although at the funeral – he was cremated – I couldn't speak or say anything. I just felt tears thinking about him. We had printed a little

card and I put some fluorescent spots on it. My father used to put fluorescent spots on his letters to attract attention to something he wanted to emphasize. Everybody else underlines, but he'd put Dayglo spots so it dazzled your eyes. I remembered what he had said, Don't mourn. He just seemed to accept that death would come. Well, I do too. We all have to accept it. I stayed in Bradford for a few days and I made some drawings of my mother.

When I came back to California I kept thinking about him and I thought, in my head he's still there. He is always there, won't go away; and so it is now. For my mother, of course, it wasn't like that. She'd had him about the house for forty years. He was seventy-six when he died. He'd had a very full life. He had five children who were still there, grandchildren, and I thought, it *was* a rich life: we shouldn't mourn for him, we should be pleased, actually.

Since then I've had quite a lot of friends die who were much, much younger. An old person dying seems perfectly natural, whereas somebody aged thirty-two is not. The first friend of mine to die was Joe MacDonald. I always went to see him

134 *Mother, Bradford, 19th Feb.,* 1978

Bradford.
19. FEB. 78

when I was in New York. He'd had every sexual disease there was; and he was the first person I knew to become ill with AIDS, just after 1981. We'd just done *Parade*, *Les Mamelles de Tirésias* and *L'Enfant et les sortilèges* at the Metropolitan Opera, in February 1981. While I was working on it in New York, from late 1979 on, I saw quite a lot of Joe. Then I started on the Stravinsky triple bill, which opened at the Metropolitan Opera in December 1981. Then I left New York to go back to California. I used to ring Joe up every two or three days and chat with him and he used to ring me. One day I rang and there was no reply; I assumed he'd gone away. Eventually his mother called me and said that he was in hospital with pneumonia. I thought, pneumonia's not that serious, it's a curable thing. Now if somebody mentions pneumonia I dread it. Joe got worse and I went to see him a lot; I brought him to come and stay in California for a while and I could see he was ill, very ill. When he returned to New York, I kept going to see him. I last saw him about four days before he died. His mother had rung and said he was worse. It was horrible. In hospital they made you put on masks and rubber gloves and said we shouldn't touch him and I thought, God, poor Joe, all his friends, he's not even seeing their faces; if he's dying wouldn't it be best just to see a face of a friend? He made jokes, he said he'd had a good time. He knew then, the last time I saw him, that he was very close to death and yet he said he'd had a good time, which I thought was typical of Joe. He liked to have a good time. At one point earlier, about six months before, he'd said he felt guilty about things, his life. I said, I wouldn't do that, Joe, you shouldn't think like that, make the best of it while you can.

That was five years after my father died. Then there were more deaths, each person dying in a different way. Joe, when he died, looked like a ninety-year-old man. He'd lost most of his hair and his face was very sunken in, almost like a skull. But not everybody I knew who died looked like that. My aunts had died earlier, but they had died comfortably in a little hospital in Bradford. They'd had a lovely life, they'd enjoyed it, however hard it had been, they'd loved it. All this makes you think about death itself, but I'm not sure I see it as totally tragic. Sometimes I think maybe it's just another adventure.

THE END OF SUFFERING

As you get older, first of all your view of time becomes different. If you're eighty years old, one year is only one eightieth of your experience; if you're ten years old one year is a tenth of your experience. As for me, I find, as I get older, that life gets more and more interesting, and one also accepts certain things. I was brought up basically in a rather genteel world in England: even working-class life then was genteel compared to most other places. My family are genteel. Although I was brought up during the War and we were bombed when I was young, the suffering

that people had to put up with in our genteel world was very minor. I haven't witnessed, I haven't lived the horrors of, say, the Jews in Germany. I don't know that world. In your mind you can imagine the horrors, but I do not have direct experience of that kind of suffering. And yet we all have a relatively direct experience of suffering, including myself. I know people say that I avoid it in my painting, in the subjects I choose. To a certain extent this might be true, but I'm not sure. If I described my own, as it were, suffering, it would be about loneliness. There are times when one feels intensely lonely – this is a form of suffering. But I stop myself because I think, as my mother would say, there's always somebody else worse off and I think I can manage; somehow I'll manage. So, you manage. You don't burden other people with it. Therefore, you don't even deal with it too much. It is forced to come out at times, you cannot stop it; if you could consciously control it a little, you would, but there are moments when consciousness cannot totally dominate.

Then there is the suffering, as it were, from the sense of betrayal when people let you down. But most of it seems trivial compared to the more positive experiences like that of love. Looking back, I see that my family were very loving and I really had a very rich childhood. Poverty doesn't mean much to children, as long as you have enough to eat: the fact that the house isn't very big doesn't matter so long as you're warm and you have something to eat. Children don't give a damn about luxury, it doesn't mean much to them at all. The old might enjoy a little more comfort, but children don't care. Unhappy children are simply unloved children. Otherwise kids are happy playing in mud or playing with bits of stick or something; it's love that counts and, frankly, it's love that counts in everything. Love is the only serious subject. The absence of love is fear of anything unknown. I think that if you can love fully, in the full sense of the word, you have less fear. I think that's even a Christian belief. Loving fully may mean even loving the world, loving life itself, seeing it as a marvellous gift. You may see it that way, however melancholy you might be, however much suffering there might be; it's still a gift and we tend to cling to it. Most of us want to live. We have a very deep desire to survive because we like the experience of loving. Those who really despair kill themselves. There have only been very, very few occasions when I have contemplated killing myself and I'm not sure how serious it was. As I said, I think that the absence of love is fear; if one understands love, one can, to a certain extent, be fearless. Then even death becomes something else. I have a curiosity about it, I admit. In fact, I tend to think that it is not an end at all. I do think about it, and ponder. I've thought and even played games about it, with the idea of nothingness, absolute nothingness, which is as difficult an idea to grasp as the idea of God.

What does one see to be one's duty as an artist? Maybe this is my didacticism coming in. I enjoy life. I can enjoy life on a very simple level. I can amuse myself; I

don't find myself boring, so if I'm alone I can get by. I feel loneliness at times, at other times I don't even though I am alone. I can somehow amuse myself in my head or by deriving pleasure from looking around me, playing games in my head with it. I think, if I can do this, shouldn't I tell somebody else about it? Which is, I think, what I'm doing in making pictures, and it seems to work. People do seem to get something from it, and I think, if that's how I feel, I should tell people, maybe help them not to see the world as quite so terrible a place as they think it is. I tend to disagree when people say, Ah, we live in a terrible age. Well, it's the only age we've got, we can't actually compare it with any other age. It is a silly remark. However bad our age may be, we know, I know, that somewhere, somebody, probably two people, have just fallen in love and there is nothing better at all than that. It is all right for the statisticians to tell you that India is a very poor country, but they tend to talk about it as if there were nobody there, no people who as well as suffering deprivations and pain also fall in love. And if you are in love, even though you may be living in a squalid little hut with not much to eat, you're frankly better off than somebody in a mansion who's not in love. But that is not to say that there is no suffering. Of course there is. There is always, everywhere, an enormous amount of suffering, but I believe that my duty as an artist is to overcome the sterility of despair.

PAINTING THE STAGE

In 1983 I was still making photo-collages. I went to Japan in February and made quite a few, which we showed in New York in May, then in Los Angeles. Then I had to stop, to work on Martin Friedman's exhibition of my theatre work at the Walker Art Center in Minneapolis, 'Hockney Paints the Stage'.

Martin, the director of the centre, had persuaded me – although I was at first reluctant – to do an exhibition of all my theatre work. I had by now designed six operas, three ballets, and *Ubu Roi*. But I didn't think showing theatre drawings was that interesting. You don't make them as drawings, you don't even care particularly whether they're that good. They're often no more than diagrams to show people how to make a costume or something. I had always thought exhibitions of theatre designs were a bit dull, really, and I told Martin this. I said, I'm not sure there's that much material; there are the models, I know, but they're not that big and I don't know how interesting they are to people who have not seen the opera. But Martin had bigger ideas and suggested including some of the real sets. I pointed out that they'd be far too big to put in a museum; they're meant to be seen from some distance, they're crudely painted. But he persuaded me we could reinterpret them for a show. He got me interested enough to commit myself without realizing what I was letting myself in for. I'd just had my studio built,

which was going to be ready by the summer, and in June I was going to begin working on the great big tableaux. These were meant to be interpretations of the sets, all specially made for the show. The exhibition was in November and Martin got more and more nervous until I started work. He had already arranged for the exhibition to travel to about five places, so he wanted to make sure there were new things in it; he also decided to include paintings. Once I started, what was interesting was to realize that the work I had been doing with photography was proving a great help.

The tableaux should have been reasonably easy, as all we were doing were variations of the sets. I thought it would all be rather straightforward. But I had to animate them somehow. I'd pointed out to Martin that you couldn't just put a set in the exhibition, because sets are not designed to be just looked at, there are almost always people in them. He mentioned that there was somebody in Minneapolis who made stuffed animals.

The first tableau I did was the one for *Les Mamelles de Tirésias*. I was wondering how on earth I was going to do the figures for it. A year or two before, in Paris, Jerry Sohn had found a great many very small canvases. I got him to buy the lot on a hunch that somehow the photography I had been doing would lead me to use them. So these small canvases were around and suddenly one day, having finished painting the variation of the set for *Les Mamelles*, I picked them up and started painting faces on them and I realized immediately that I could use these to build up the figures for, say, the husband swapping into the role of the wife by swapping the canvases over. I did the figures in segments and I thought it was a good solution and that it looked good. Immediately I could see that my photo-collages were offering me some solutions to this. After doing the figures for *Les Mamelles* I made the ones for the Bedlam scene from *The Rake's Progress*. This piece was relatively easy because the figures all had masks — as they did in the opera — and I could see how to make those. And then I began *The Magic Flute*. I painted the massive backdrop and then the animals. I decided I would cut out the figures from Styrofoam board and break them up to show them moving, and I started fragmenting. This too came from the photography, and it turned out to be an interesting solution, much more interesting than stuffed animals. As you walked past them they all seemed to move — you, the viewer, were, in a sense, making them move. Once I'd discovered this I got very excited. Martin came to see them and he was thrilled to see I had found a way. After *The Magic Flute* piece I painted the Ravel *L'Enfant et les sortilèges* — the outside — the one with the ceiling was painted here in my studio. I made the little models of the princess getting out of the book and the shepherds coming off the wallpaper. They were all made in this technique, using fragments. The last piece I made in my studio was of *Rossignol*. Then I shipped everything to Minneapolis.

14–15

138,139

140

141

81

135 Set design for *Les Mamelles de Tirésias* (detail), 1983

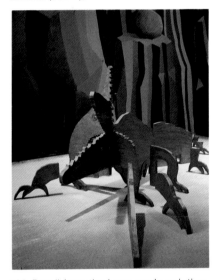

136 Detail from the large-scale painting with separate elements based on a design for *The Magic Flute*, 1983

For my theatre exhibition 'Hockney Paints the Stage', I reinterpreted, as enormous tableaux, a number of sets that I had created previously. Since sets without actors are fairly lifeless, I decided to animate my tableaux by including figures. It was a massive amount of work, since I did all the painting myself. I began in June 1983 and the exhibition opened at the Walker Art Center, Minneapolis, in November.

I had decided against just, say, hanging costumes in the exhibition; I thought it would be too dull doing that. I went to Minneapolis about six weeks before the show opened and did there the auction scene for *The Rake's Progress* and the Ravel garden scene. All that was massive new work, quite experimental in a way; it was thrilling to do because I didn't repeat much; I get bored just doing something over again. It was a mad six months. We worked seven days a week, twelve hours a day. The moment I'd done one of those tableaux I realized how long they were going to take to work out, especially as I wanted to paint them all myself. I did have an assistant – Ron Elliot – who was sent to me from Minneapolis to help me in my studio. He was terrific. In fact, when he left he never went back to work for Martin; it had changed his life, he said. He was a very nice person and he was wonderful to work with. He always knew when to leave me alone and when to help. When things needed cutting out he was good with the saw and he did all the measuring needed to make sure that what we did would fit in the gallery. But he also knew I needed quite

12

138,139

137 Working in my studio on *Les Mamelles de Tirésias*, for 'Hockney Paints the Stage', 1983

a bit of time on my own when I just sat and worked things out and did them. He would then leave me alone and go and swim or do something else. We had a marvellous time doing it. Afterwards he said it was the most wonderful six months he had even spent. And I too thoroughly enjoyed it.

Martin Friedman himself is a great and unique person. For twenty-five years he ran the Walker Art Center in Minneapolis, which is not a very big city. Not many people would go there just to see it, but it has a lively theatre, the Tyrone Guthrie Theater, next to the Walker Art Center. Martin put on marvellous exhibitions there, like his De Stijl show for which they recreated the Café L'Aubette in Strasburg, of 1928. He had a great flair for exhibitions. He is one of the very rare people in the museum world who is very creative himself, a very generous spirit; he has a wide taste in art and is very intelligent about it. I could see he was greatly valued in Minneapolis by the trustees and the people who donated money to the museum because they knew they had somebody really good there whom they trusted. He did wonderful things for that community and I am sure they miss him now he's no longer there. Martin had been planning the exhibition of my theatre work for about three years. The moment it opened, he went very flat. He asked me to stay on for a week. I could see he was down so I stayed. He said, It's all right for you; you can just go back and carry on working now. I could see how deflated one might feel after working for three years on a massive creative project. When we began we had no idea what it was going to be like. It was a risk Martin took, it cost a lot of money, but he trusted me to do it and I did it, I didn't let him down. Not every artist would have done it that way, I think.

The exhibition went from Minneapolis to Mexico City, where it was seen by a quarter of a million people. I went too, and fell in love with Mexico. Martin had wondered, when the Mexican museum asked for the show, whether it should go there. I was in favour of it. I had never been to Mexico, only to the border towns. I went and stayed for a month and helped them put it up because it was such a complex exhibition. I actually found out that it had a life of its own: in every place where it was shown it looked different. The Mexicans loved it. I worried a bit that if they did not know the operas it would not mean much to them. I think what attracted them was the hand-done look it had, the colour. Mexicans love colour and they're good with their hands. In some ways they're very close to art, perhaps closer than North Americans. I loved Mexico City and I have been back a few times. They had television programmes about the exhibition and lots of people came to it. Sometimes I'd meet people in the street and they'd say, Ah, Mr Hock-e-ney, Hock-e-ney. Children particularly loved it. I had painted a whole puppet theatre for the children and it was wonderful what they did with it; you could see how excited they were. They didn't know my work at all until then in Mexico, it didn't mean anything to them.

138, 139 *Overleaf:* Two details of the large-scale painted environment based on a design for a garden in Sarastro's kingdom, *The Magic Flute*, for 'Hockney Paints the Stage', 1983

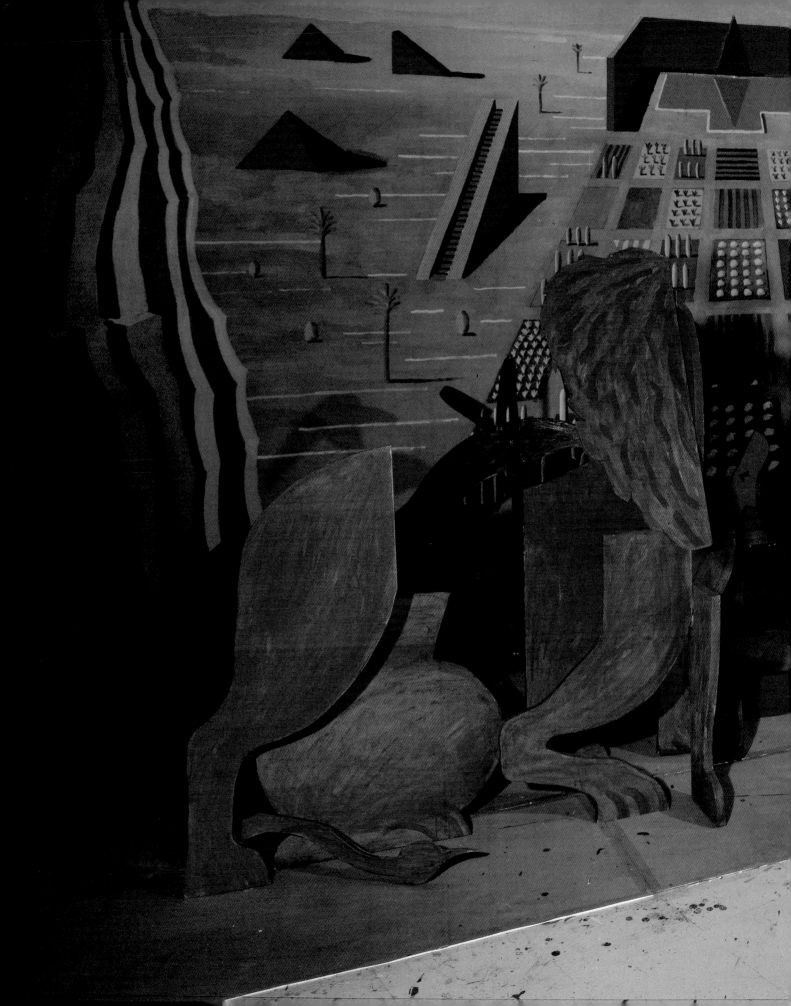

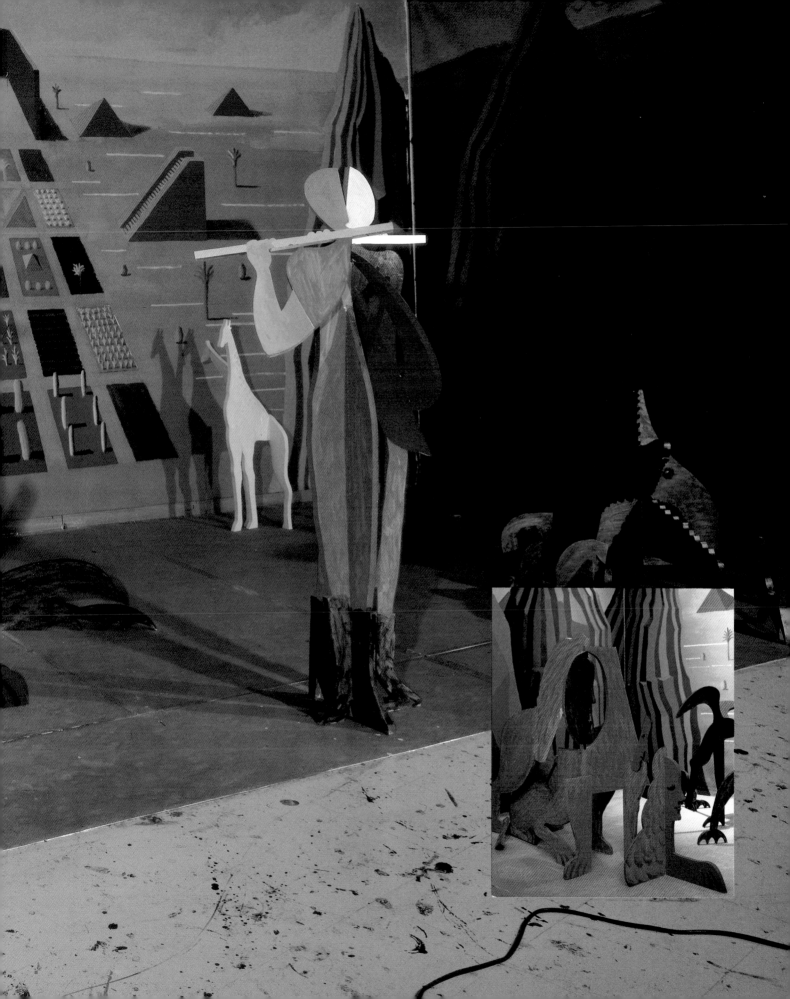

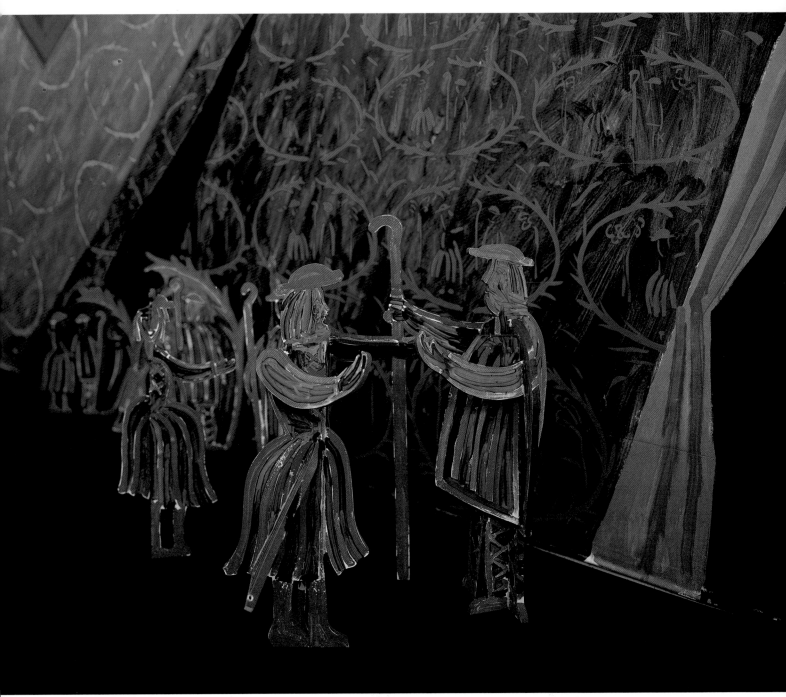

140 The Shepherds and Shepherdesses appearing out of the wallpaper

Details of the large-scale painted environment based on a design for the room and the garden in *L'Enfant et les sortilèges*, for 'Hockney Paints the Stage', 1983

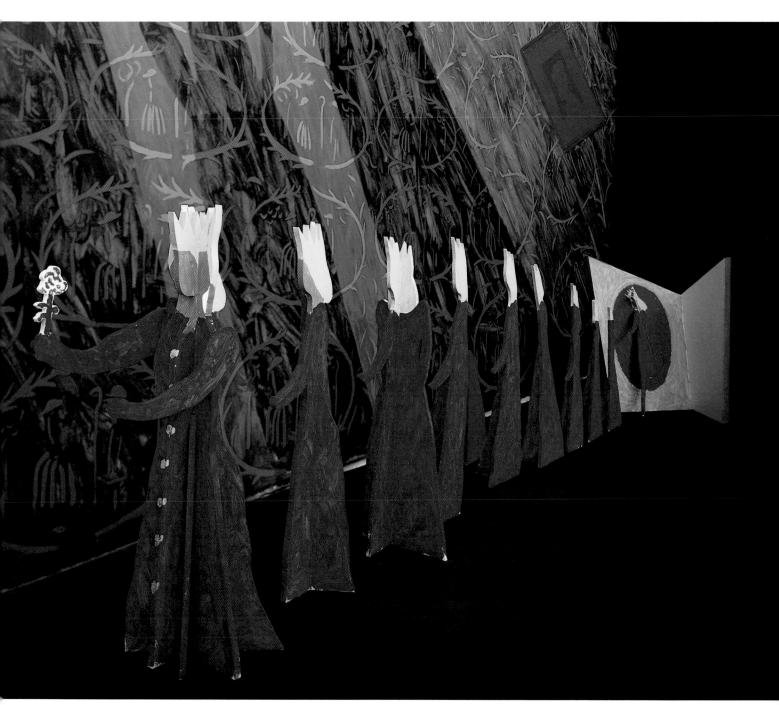

141 The Little Princess coming out of the book of fairytales

The exhibition then travelled to Toronto, Fort Worth, Chicago, San Francisco and finally to London. It wasn't originally going to go to London, but when it opened in Minneapolis people came from the Arts Council to see it and arranged that at the end of that tour it would go to the Hayward Gallery in London. And it looked, I thought, splendid there, the way it took up the space. So, all in all, almost a million people must have seen that exhibition. I thought that was wonderful.

ENGLISH BLUES

In England it was received very well by the public, but the only mean writing about it was there. Frankly, I expected that; I expect that kind of thing from England. They were petty little pieces; I just put that down to the mean-spiritedness of part of the English art world. They are always trying to knock things. People say the Americans worship success while in England they hate it. I think this means that they are both taking it too seriously. If you were to scratch an American he'd at least admit that it might be shallow to value success so much. But when you scratch the English, if they hate success, what do you find? It seems to me that it's better to approve of success; anyway, it's more positive. I have never liked that side of England at all. I always thought there was a mean spirit in official England and I never felt very happy with it; I always thought it wasn't democratic enough. I often felt impotent in England, as if I didn't have total control of my life.

I have always fought committee people and the English variety are dreary. They are usually self-appointed: hundreds of self-appointed committees, who appoint others like themselves, who would never appoint somebody for his Rabelaisian view of the world. I am deeply English, never been anything else, but I'm an Englishman who will shout. I don't want some puny little official telling me what to do; I'm an Englishman and I would tell him to piss off. People in England don't complain enough. I am always complaining. I think sometimes that people are too polite. I am a polite person myself but I'm not going to be pushed around. Of course one of the problems with England is that people are always leaving; they have been leaving for nine hundred years; that's why they speak English in California. Obviously a lot of the people who leave are rather lively or get fed up with the pettiness or the mean-spiritedness. Out of my family in Bradford three of us live abroad: I have two brothers who live in Australia and I'm sure they left England thinking they'd have a better chance somewhere else; and it is usually of course the working class who do that. The aristocracy do not emigrate to Australia. I come to America as an English working-class person and I am terribly impressed with all the labour-saving devices like a washing-up machine; the aristocrat comes, or somebody very rich, and is not impressed because they always had a washing-up

machine – it was a *person* who did their washing. It's only if you have done the washing-up yourself that you get impressed with washing-up machines. I used to feel I should shout and stand up for things, and I did an awful lot, but I got fed up sometimes. People thought, Oh, it's just David going on, moaning again in that Bradford accent, moaning away. Sometimes I think maybe it was the accent that put people off; I should have spoken a different way. When I was at the Royal College of Art they sometimes used to ask me for advice; I told them to get rid of their General Studies Department and take drawing seriously. They thought I was joking and they took no notice. So I thought, well, I will never offer them advice again.

I think I would find it very difficult to go back to England to live. The pettiness of things would get me down, that nanny attitude. The sad thing is that you either had a Labour Party – which was progressive in some ways, cared about people, but then it developed a bureaucracy that killed off the entrepreneurs – or you had Mrs Thatcher, who supported the entrepreneur, which I can understand. But you also got your old Tory back in who wanted to introduce petty legislation like the anti-homosexual Clause 28. It is the same little people, small, unimaginative minds, frightened to death of things. I don't mind these people but they shouldn't be running the country. Only one Prime Minister this century actually trusted people, trusted the English and, frankly, he knew that if he didn't he would lose and so would England: Churchill. I loved his comment about, I think, Noel Coward living abroad. People thought it was terrible that Coward did not live in England and somebody asked Churchill what he thought of it. And he gave a marvellous, wonderfully arrogant, reply. He said, It's an Englishman's inalienable right to live wherever he chooses.

I have always thought of myself as coming from an English tradition, a deep one. If you feel you are part of nine hundred years of history that is about power being shared more and more, you are part of a democratic tradition, but I think you have to guard it because there will always be petty little people who, given the chance, would take it away. Luckily they are not given too much of a chance, but they do get on local councils or get to be MPs. I think that if you complain you can achieve something, so I don't despair. I must admit that in California I feel more in control of my life and I don't even have a vote. America is a much more democratic country. People can speak up on all kinds of issues, and they do; they're gutsy about it. They form pressure groups. They won't let themselves be trampled on by petty bureaucrats. Americans have a much more spirited tradition in that way. That tradition exists in England as well, but unfortunately the very people who would uphold it often leave. And that is sad. I think few people leave England just to make more money. I didn't, for instance, leave for tax reasons. I would never care what the tax was; I pay whatever they say. But I care a lot about other things.

Sadly, well-meaning people can do wrong. For example, I once lent a drawing by Lucian Freud to an exhibition called 'The Human Clay' (1976). I had bought it many years before. It was a lovely drawing of a boy playing with his prick. The Arts Council people who were organizing the exhibition said, No, we're not putting it on; it's too risky because the show will travel to the provinces. I thought, wait a minute, you're saying that to the wrong person. I am provincial myself and I would hate to think somebody in London was editing shows especially for the provinces because people there are too dumb to understand. I hated their paternalistic attitude. And I told them so. I suppose they might have been worried that some local greengrocer might go in and complain, or a Mary Whitehouse. But one cannot and should not worry about those people; for one thing, they are not the majority, they are a minority, and you can ignore them; I think you should.

ART VERSUS THE ART WORLD

I don't have much of a connection with artists and the art world in England any more. I've never had much to do with the art world, anyway, which is a very small world. And I have lived in California now too long to have much connection any more. I am settled here. I don't even show much of my work in England. They made me a member of the Royal Academy but I have never shown there except when I was included in some of their exhibitions. I know they want to make it livelier and I can understand that. They have suffered a great deal because of their past presidents, and their attitude to early modernism was foolish. I can see that it has changed now but I'm not sure how much it can change. When the Royal Academy was founded by Joshua Reynolds about two hundred years ago, if Parliament had been discussing depiction of any kind, I am sure they would have consulted Reynolds. The Academy was about depicted things in the world and they would have assumed that he was an expert at it.

As it happens, the Parliament in Reynold's days was not much concerned with depiction. But today they actually do discuss it: whether or not you can photograph in a court room, whether a photograph has genuine documentary status legally, etc. They might not think they are talking about art, but any debate about depiction is, to a certain extent, about art. Therefore they would make rules about what you can and what you cannot photograph, and so on. However, they would never think now of listening to the advice of the President of the Royal Academy on this matter; they would probably wonder who he is. What people can photograph has nothing to do with the Royal Academy, they'd say. So what purpose does the Royal Academy really have if it cannot provide advice or arbitration in matters that concern depiction? The problem with academies, it seems to me, is that they can always begin well because they have clear ideas, but after a long time these seem to

get lost and an academy's main interest becomes simply to preserve itself as an institution, rather than to serve the purpose for which it was formed. That is what has happened to the Royal Academy, and though I think they are aware of this, they do not know how to deal with it. If my arguments about depiction are correct this could mean that in the future the Academy should not just be about painting but about all kinds of pictures: film, television, anything that is pictorial. The time is perhaps right to form another kind of academy now. And I think this will happen. The photograph is going to lose its veracity and another kind of institution may be needed to deal with all the various forms of visual depictions, because all these forms will be put on an equal level again. When this happens a profound change will come about in such visual matters. I think that this will take place within the next fifty or sixty years. Whether I will be around to deal with it when it does happen I do not know, and, in any case, I want now to spend my time quietly doing my work. I have got a lot to do.

I am not really in close touch with other English artists except for Ron Kitaj. I always see him when I go to England and he comes to California, and I talk to him on the telephone a lot. He is my oldest friend. But I tend to avoid art worlds and I have always been aware that the appeal of my work extends outside the so-called art world. A lot of artists are very well known within an art world but outside they are not; their work does not mean much to people. There are very few artists who can work outside the art world and I know that if you are one of them a lot of art-world artists will resent you. I can understand that but I am not going to worry about it. If you reach outside the art world, artists tend to think that the people you are reaching are ignorant of art; they don't have a high opinion of them. But, frankly, I have never thought people were stupid; I don't think most people are stupid at all.

For instance, I love music, all kinds of music. I got to concerts, I also go and listen to contemporary music which, at first, doesn't do much to me. But I do not join in music-world arguments. I am sure there is a musical world and those who are part of it are no doubt a little bitchy to each other. But I am not interested in their arguments because I am outside that world and I don't care; just as I think there are many intelligent people who are outside the art world and do not care. Such people would perceive the quarrels in the art world in the same way: they would think that artists are rather a silly lot. The fact is that many people are deeply interested in art and in ideas about art; they are not stupid. Even so, I am aware that one is not ever talking about a massive number of people; it is still not like a sports event, it is still relatively restricted. All the same, there are many more people than one thinks who are interested in pictures but who would not join in arguments about formalism and anti-formalism, which would seem to them a little like scholasticism, like medieval arguments of no great relevance to their own interest. And I think they would be quite right: sometimes the arguments are quite pathetic.

Art, after all, is part of life. When one talks about ways of seeing one is not just talking about the way an artist sees, but how a person sees. I had an argument once with an art writer who told me that art is not for everyone. I found this shocking. I thought, if it isn't, then it must be on the same level as jewelry, it reduced art to the level of jewelry. Jewelry is very nice but we can live without it. I do not think we can live without art of some form. Most of it might be pretty poor, but it is still art of some kind, and we need it.

THE POWER OF ART

I remember reading once in an English newspaper that somebody had said it was much better when there were only five people in a room at the Tate Gallery and you could contemplate the pictures. I thought this was the worst kind of elitism. I am not anti-elitist: I think there are always elites, they happen naturally. Nevertheless, I would encourage a growing interest in art if they could get more and more people going to the National Gallery and the Tate Gallery.

I believe in the power of art. And if you believe in its power then of course you think it better if more people go to see it and are affected by it. I don't think anything will change my view as far as that is concerned. I also believe that art can change the world. The way the world is depicted has a deep effect on us and I do not think, in the end, that you can divorce the way things are depicted from art. I therefore think that art still has an immense influence on the way we perceive the world. I know that a lot of people would not agree but, to me, the argument is very clear, very, very clear.

The systematic history of art is not that old. It was a late nineteenth-century German invention to tidy things up. I think art history has had an effect on art itself. For instance, the word 'Cubism' was actually coined by a journalist and it stuck, and then it stuck permanently because art historians used it. Now 'Cubism' is a very unfortunate name for what it is about. But the fact that it has stuck has an effect on how we view the work which is so named, and then one tends to think, yes, Cubism is a certain period. Just as you have a sense of history, say, of political events or other events, you begin to get the sense of art history that is put forward. But I realize, of course, that art history, like all history, is going to be rewritten: it is going to be constantly rewritten, because art's history can never be fixed. A rewriting of art history is taking place right now; the orthodox view of modern art in the twentieth century is being reconsidered: we have rediscoveries and reassessments. This is a natural process. And historians tend to forget sometimes that it is artists who make art history, not art historians. Respectable, ordinary historians would wait a while before they felt able to comment on events. For instance, the full history of the Second World War is still not that clear; scholars

could find all kinds of facts that are still unknown and which will have to be taken into account by the historians: it takes some time. The trouble now, I think, is that art historians are sometimes coming much too close to us, pronouncing on current work, when perhaps they shouldn't.

I am not talking about the art journalist, who does something else, whose main job should be to inform people of what is going on and maybe make some comments. It is when they make judgments that they are in great danger of being wrong. If you see some new paintings, you can't say: these paintings are very significant. For works to be significant, they have to be influential, and you can't know that. They might turn out to be influential, obviously some will be, but not all. Students were, and perhaps still are, being trained in a kind of art history that is, on the whole, narrow, biased and orthodox. When I discovered the importance of Chinese scrolls, I was astonished at how ignorant well educated and trained art historians were on that subject; many would never have seen them unless they were specialists in the field.

Artists tend to see art in more open ways than historians; they are less interested in when or where it was made. What matters to an artist is that it was made by some artist a bit like you, and it is irrelevant whether it was a thousand years ago, five thousand years ago or yesterday. So I think, in that sense, it is sometimes more interesting when artists speak about art. Ruskin could say in the late nineteenth century that there wasn't much art in Africa outside Egypt. But ten or fifteen years later Picasso wouldn't say that. Who is more interesting on the subject? I think Picasso; Ruskin could not see it. I am not saying that Ruskin was an ignoramus. He was a marvellous writer on art, but he simply couldn't recognize what the Africans had been doing as art because he was not an artist. Picasso, on the other hand, could: he was ready for it, he saw what those artists were doing and he used it. The African sculptures Western artists were looking at, in the first decade of the century, were not in art museums, but in a museum of anthropology, at the Trocadéro, in Paris. The African objects were perceived as strange artefacts made by uncivilized people. Picasso saw something quite different. It was his eyes as an artist that were acute and made us see, revealed to us, what those objects were as art. That is what an artist can do which the art historian cannot: it is the artist's way of seeing.

To perceive something in another artist's work which opens up doors and releases the imagination is how art develops. But I think that a recent tendency to imitate, copy or quote from the art of the past, not as a way of learning or redefining, but as an end it itself, in what is called appropriation, surely indicates a failure of the imagination. If you took an interested member of the public who was not part of the art world into an exhibition of somebody's work who had copied Picasso they would just think, he has copied Picasso – so what? I know this isn't

how the art world sees it but, as I said before, when one is talking about the art world one is talking about a tiny world which is not always correct.

I might once have held some views about using different styles eclectically, but I'm not sure I would now. Let me put it this way: what does history tell us if we look back at the art of the past? The way we see the world is constantly changing. The way the Egyptians depicted the world of space was one way, the way the Greeks did, another, the way the Renaissance did, yet another. The idea that we have now reached an 'objective' description of the world in a picture is, I think, naive, as though new perceptions of the world had ended, as though in our age it were all settled after all those years. That would be much too cynical an attitude for me. It suggests that we cannot find new ways to depict things, or do things. Well, we can, but it is not easy and probably not many people will do it, but I think it will happen. Somehow, now, it has to be connected with photography, which has to be dealt with. So we are back to that; we always keep coming back to it, at least I do.

Somebody left behind a copy of *Life* magazine from 1950, and I noticed how many drawings there were in it – advertisements and so on. If you compared it with *Life* magazine today, practically all the pictures now are photographs, there is very little drawing. I am sure that's because drawing has not been taught for a long time. It is coming back now, drawing is being taught again in art schools because people see that the invention of new ways of depicting has to come from it. If the conventions of photography can only be extended through drawing, then, if I am right, drawing will have to come back. It is interesting to look at glossy magazines, including the advertisements, and notice how many drawings there are and how many photographs. The photograph is still thought to be more 'real' than the drawing, because it is not seen as an interpretation but as an objective record. I think this may change.

5 The Plurality of the New

THRILLING SPACES

I like clarity, but I also like ambiguity: you can have both in the same painting, and I think you should. Clarity is visual clarity; ambiguity is both visual and emotional. I have always been attracted to clarity in pictures; that is why I love Piero: it seems to me the space is so clear in his paintings. The magic seems to me to be in the space, not in the objects.

In a painting space itself provides some of the emotional content, it is through that space that you feel things. If you are in Death Valley, standing there, one of the thrills you feel is spatial; or if you are looking into the Grand Canyon from the edge, the thrill, I think, is seeing a defined space, a finite space. I think all people feel this when they stand on the edge of the Grand Canyon. What is it you're looking at? I think the thrill is spatial, in that you are looking at the world's largest hole: a massive space that has a defined edge. You can see the other side – it is ten miles across – and you can sometimes see about fifty miles down the Canyon – it is thirty miles down if you stand on the south rim. The fact that it is a hole, that is, it has got an edge around it, means we can understand it. After all, you can turn your gaze and look up into the sky and see a much bigger space, but an incomprehensible space to us, in the sense that most things must have a definition around them to be comprehensible.

I have sat there myself and looked into the Canyon and felt that as you look, as your eyes move and your head moves around, you think, what is this space? I believe this is true of all spectacular views. When you drive through a tunnel and you come out and see a valley, it is the fact that it is a valley with edges round it that we can comprehend and we feel something: we feel small and at the same time filled with awe.

I suffer from mountain fever, the urge to jump off high places like a bird. I feel this very strongly. When I was staying in Switzerland once, in a chalet up in the mountains, I went for a walk, and you could see across the valley a pathway that was a narrow ledge on a vast cliff. I saw some people walking on it and I said, I couldn't do that; I would feel like jumping, I would have to move back. It is an incredibly physical feeling, in the body. What is it? Is it that you want to fly? Is it because you want the feeling of even more freedom?

There is a marvellous painting by Miró in the Museum of Modern Art in New York, a man throwing stones at a bird. The man is represented by just two big feet, wonderful shapes that sort of look like feet. I have always assumed this picture was about a man with his feet stuck on the earth, jealous of the bird moving in any direction in space, and the man can't, and it is as though he is getting at the bird and throws a stone at it. Usually when I'm in the Museum of Modern Art I go and look at this wonderful picture.

I first felt the urge to jump off a high place when I became more aware that I was going deaf. I first became aware of this in 1979 when I was spending a week teaching at the San Francisco Art Institute. I have never done much teaching; I am not very good at it. We had a seminar in quite a big room and I found that I couldn't hear the people at the back at all – especially the girls, because they tend to speak a little softer. And I had to say to them, I'm sorry, I cannot actually hear you; and it dawned on me there was something in my hearing that was not that good. When

you are just working in a studio on your own and just talking with people rather close to you, you don't notice it. I can hear perfectly well if somebody is quite close to me, even without the hearing aid. What occurred to me was that hearing, after all, is a spatial thing. You locate yourself in space through sound as well as sight, depending on the direction where the sound is coming from – behind you, in front of you, to the side of you. You adapt your responses depending on sound; as you hear something getting louder and louder, you think something is coming towards you, and so you act. Perhaps, if you are losing your hearing, there is a shift to another sense to make up for it and sound becomes more spatial to you and you think about it more.

My awareness of my loss of hearing coincided with my irritation at spatial flatness. I saw it very clearly. I was irritated by it and after a while I thought, I wonder if it is to do with losing my hearing? When we lose one sense we tend to compensate by over-developing another: that's no doubt why many blind people work as piano tuners, having developed an exceptionally intense hearing. Losing one of the senses gradually might happen to anybody but one would probably not be aware that it was happening unless you relied on it in your work all the time.

SPECTATOR AS ACTOR

Some people have observed that, since about 1980, the human figure is absent from my work. The main reason for that is that I have wanted the viewer to become the figure. The figure is still there but in another way entirely: not depicted, it is meant to be felt. That was a conscious decision. The human *clay* is not there, literally, not in the same way as before, but the *mind* is. So I would now say that, of course, Cézanne's apples have the human presence; they do, of course they do. This is a shift in my view.

What it is about, I would think, is this awareness that there are not these two separate things, representation and abstraction. That is the idea which has grown with me: that you can have the feeling of the human presence. I used to think that one is not moved by a figureless picture in the same way as by something that has the human figure in it, that it is not a deeply emotional way of being moved. But I am not so sure now. What is it that moves us about Piero, or Michelangelo, whose work is, of course, very much concerned with depiction and space and clarity? Is what moves the viewer deeply an abstraction, that is, the human predicament, rather than the human figure itself that is depicted? Take the big Piero *Madonna*, the pregnant *Madonna* in Monterchi. It is an amazing spatial, visual experience, even though we may think that what most moves us is her face, her pregnancy, her bulk – we may think that the spatial experience is not important. But it is in fact part and parcel of the same thing – you cannot separate one thing from the other. We

have the humanity of the figure, on the one hand – the humanity of the face and her pregnancy – and, on the other, the way this is placed within a space. And I tend to think that what is *most* important is the way the figure is placed in the space. That that is what makes it a great work. If the spatial aspect of the picture were missing, sheer sentimentality would result, and it doesn't. What happens when artists use space with their imagination is an attempt to pull you, the spectator, in, to make you the figure in the picture.

A SILENT WORLD

The spectator in *A Walk around the Hotel Courtyard, Acatlan* (1985) wanders in the space. You are a lonely figure. Aren't we all? In the last few years I have been lonely. The only creatures close to me who are very warm are my dachshunds, though it might seem that I'm surrounded by people. It is partly due to the deafness: it isolates you. What I cannot do any more is go to many concerts. I can't bear background music at all; I have never particularly liked it. Now the only place I can listen to music, apart from in my car, is in bed on a disc player with earphones. I can then hear it all, but otherwise I can't.

I am not able any more to go into a large room with many people talking and join in. There would be a background noise, a blurred sound that makes it incredibly difficult to hear, and so I avoid large gatherings. I don't want to go, whereas before I might have enjoyed chatting away to people here and there. I can't do it now.

It isn't actually as though it were a silent world; it is quite a noisy world, paradoxically, but it is a blurred sound. Sometimes, I even think it might be better not to have to go to big, crowded gatherings. It is unpleasant when I go into a noisy restaurant; it is incredibly hard. There are certain pitches which are exaggerated and others you don't hear at all. And I am sure it must have an effect on all kinds of things. I avoid large dinners, for example; in fact I avoid anything that is not intimate. I find I don't particularly care what the occasion is because I know I cannot actually, totally, join in. That is why I would rather stay at home and have two or three people for dinner than go out to a restaurant.

Now I think about it, face it, deal with it. I have even got two hearing aids – both ears are equally bad. The doctor said that a lot of people wouldn't put two in because it makes it look as though it's terrible. And I said, Well, I'm not vain that way; I'd rather hear. I don't mind, you can make a big red one and a big blue one for either ear and put a great big knob on it for all I care. So long as I can hear I don't mind. One simply re-invents oneself as a person with these plastic things stuck in your ears. Unless you are deaf you have no idea what it is like: but it isn't just silence; I like silence.

142 *Hotel Acatlan: Second Day*, 1984

143 *A Walk around the Hotel Courtyard, Acatlan*, 1985

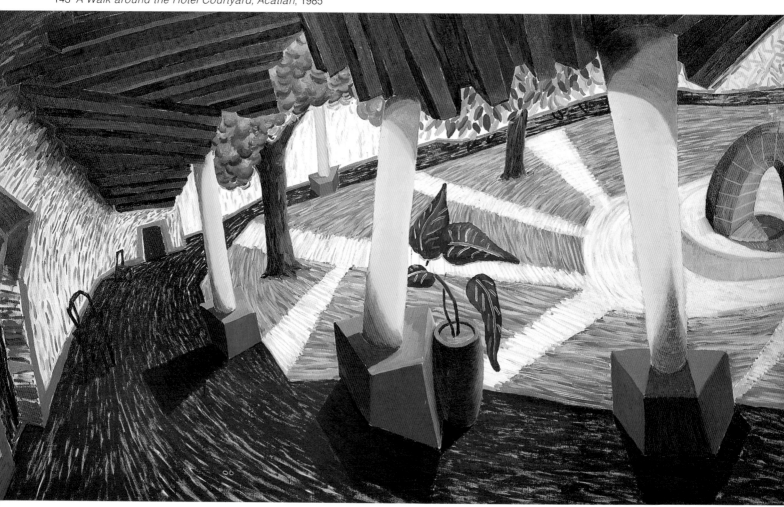

When I was in Mexico in 1984 for my exhibition 'Hockney Paints the Stage', I was driving with Gregory and David Graves to Oaxaca when our car broke down and we had to spend the night in a hotel in Acatlan. The hotel courtyard was very beautiful and I made a number of sketches there towards an oil painting. *A Walk* is not about a hotel, but about an attitude to space. At the same time as you acknowledge the spaces outside, you are still moving round in it. The longer you look, the more spatial it gets.

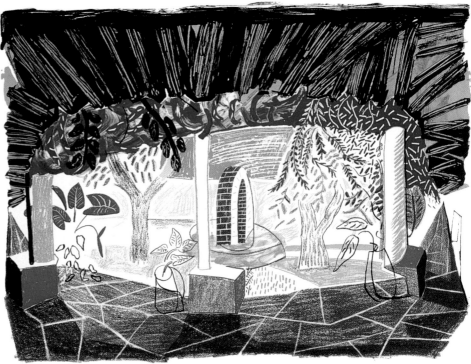

144 *Views of Hotel Well, I*, 1984–85

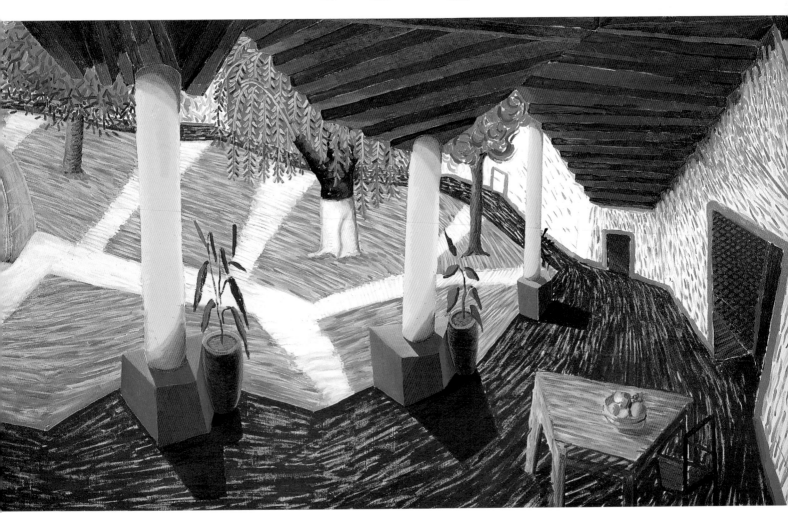

Goya became deaf, stone deaf. All those screaming people in Goya's late work are actually silent – must have been silent to him: those mouths that scream weren't heard, just seen. I might study Goya from that point of view because, naturally, it fascinates me, given my own condition. I think it was at about the age of forty-eight that he went deaf. I might start looking into this myself to see what I can find. I've always loved those pictures. In the Prado, when you go through the rooms of Goya, they begin with these rather lovely, pretty people dancing in lovely sylvan glades; very charming pictures. As you move through his life, past the portraits of the royal family, you end up with these black pictures, mobs, crowds of people who seem to be peering and screaming. There is sound, there must have been music in the early pictures: there's a certain feeling of music and delight, the sound of a mandolin, the playing of lutes, flutes, dancing. You can *see* that sound, somehow. But in the pictures at the end there is a raucous sound – if there is a sound at all – a raucous row. If there is a sound, it is not a harmonious one, it isn't pleasant at all; it is something you might want to avoid, to switch off.

THE REMOVAL OF DISTANCE

In late Picasso paintings what was always strongest, or began to get strong for me, was a sense of removing distance; there is a definite feeling of closeness to things. If you look at a figure in one of the late Picasso paintings, you think, how far am I from the figure? It is not something that you can even measure any more, whereas you can in a Piero, you could remake a model of it, a three-dimensional model. Somehow I think it is that aspect of late Picasso paintings that draws me to them. In the end, the canvas itself becomes the figure. That is what I am trying to do, or deal with. But then I think that perhaps I can't deal with it until I have a body that is close to me. I can't just paint the figure theoretically. If it is not there you deal with the fact that it is not there, you deal with the absence.

That is what the paintings tried to do. Even though *A Walk around the Hotel Courtyard, Acatlan* might be a walk round the hotel courtyard in Mexico, it is also about the absence of another body next to mine. I don't mean to say that you have to paint the person in the bed; I am talking about feelings. I got two little dogs who delighted me and I started painting them. The 1987 painting I did of one of the dogs was a very sweet, little, tender painting; there is a lot of feeling to it and that is because the dog was there.

A friend of mine said that the big lithograph I did of Gregory sitting on a chair felt as if it were my farewell to Gregory. It might have been. We are still friendly but he is not always there. There are periods in your life when you have to readjust. The moment Peter Schlesinger had left me the figure disappeared out of the paintings for a while – although a presence, some human presence, an absent figure,

145 *Little Stanley Sleeping*, 1987

actually did remain. Then the figure came back because Gregory came into my life. Then there is a picture of Ian Falconer and me. Every morning when I woke up and started touching him, he didn't like it and he started to poke me and that's what got in the picture. Those things, the moment they happen in your life, you deal with them, they appear in pictures in some form; this is something that you can't make happen artificially because it has to do with real emotions that you can't invent.

When Picasso became impotent in old age, it deeply disturbed him. When there weren't warm figures around for him to touch he actually stopped working for short periods. And for Picasso not to paint for two months would be a unique two months. But in old age he readjusted: the memory of the figures became obsessive.

Perhaps that was one reason why I did all those drawings of myself in 1983. I just thought I'd look at myself. I did a little self-portrait once behind a drawing – and a lithograph – of Henry Geldzahler and he pointed out that it made him look quite old while I looked very young. Henry is just two years older than I am, but I have always thought he was older. When Christopher Isherwood died, there was a vast difference in age between him and his friend Don Bachardy: Christopher was forty-eight years old when he met Don, who was eighteen. Obviously Don always

146 *Above:* Untitled, 1983

147 *Below:* Untitled, 1983

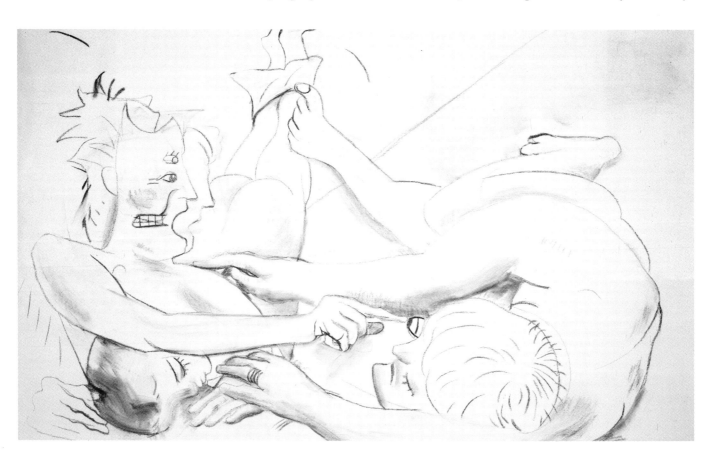

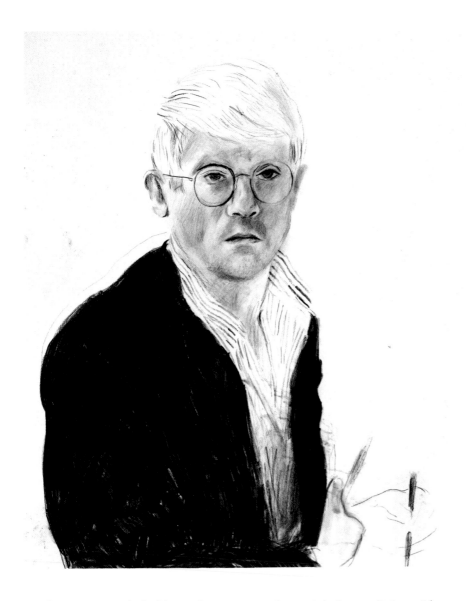

Every few years I do a series of self-portraits – I've been doing them since the fifties. There was a rash of them in 1983, when I suddenly became more aware of ageing.

149 *Self-Portrait, 12th Sept. 1983*

148 *Left: Self-Portrait, 26th Sept. 1983*

150 *Self-Portrait, 28th Sept. 1983*

151 *Self-Portrait with Striped Shirt, 1983*

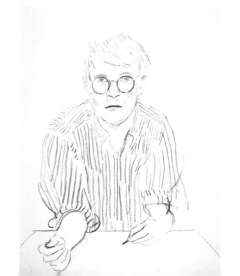

saw him as a great deal older. When Don was forty-eight he was living with a man of seventy-eight.

I became aware of ageing myself and I wanted to look at myself. As I go deafer, I tend to retreat into myself, as deaf people do, and since I go out a little less, I meet fewer people and so it makes it more difficult starting new relationships. So I did want to look at myself. You can't force relationships; they just happen. They happened in the past. I'm not a disagreeable person, I hope. As a matter of fact, I do some self-portraits every few years; I have been doing them since 1954, when I was seventeen. Then the etchings of 1961–63, *A Rake's Progress*, are all self-portraits. In the mid-seventies the self-portraits came again, very specifically. Obviously, I will do more, and if in the end I have no other figure, I will use myself. But I'm hoping that some other little warm body, other than the dachshunds, might come my way.

152 *Overleaf:* My studio, showing *A Walk around the Hotel Courtyard, Acatlan,* 1985

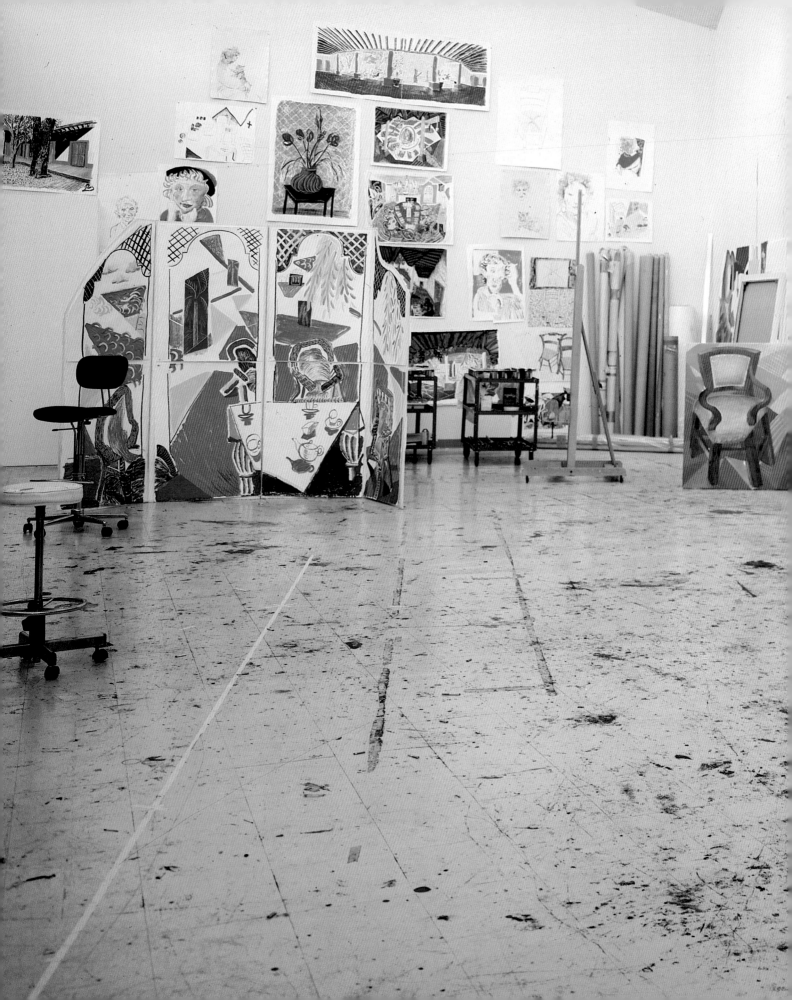

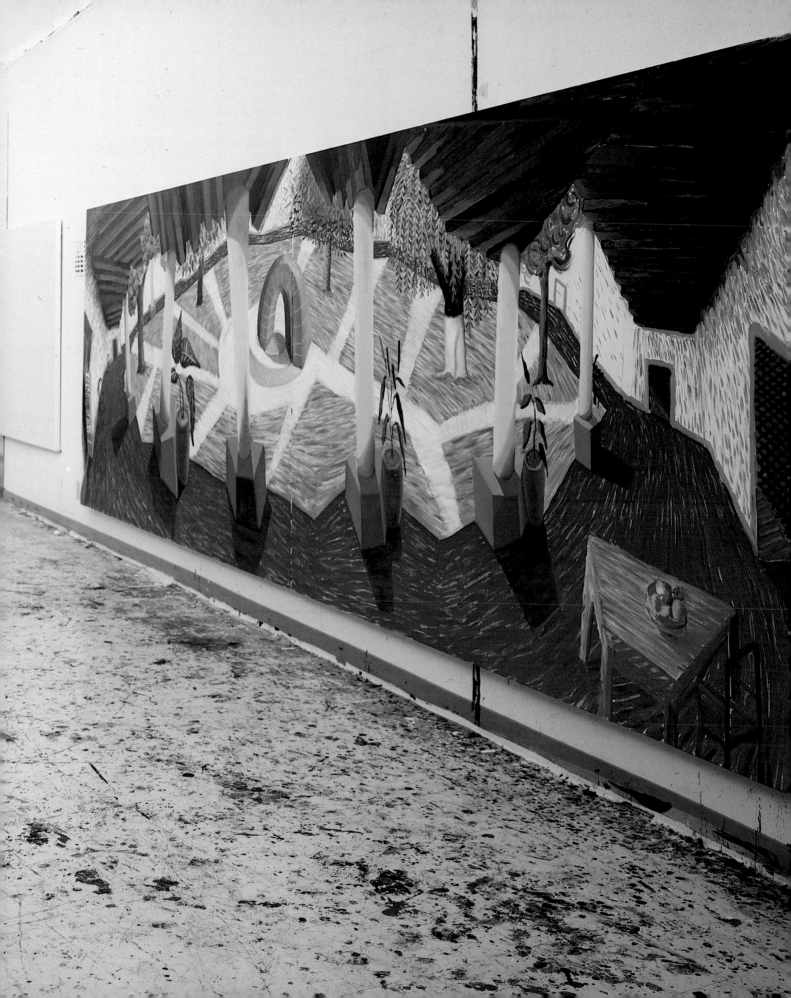

What I am reasonably conscious of, however, is that I want to paint the figure in another way from the way I had used in the past. I know it can be done differently to make it very vivid and real, as Picasso did, and I know that you can take off from Picasso, accept what he did, and push it further. I intend to find out how to do that. I am developing ideas about how this could be done. Take a painter of the figure, like Francis Bacon: the figures are put in a room with conventional rendering of space. It is that conventional rendering of space that makes the figures look distorted in a way they are not in Picasso, who places the figures in a space which is not the conventional room: in Picasso's pictures the space itself has been moved about.

It is moving the space about that deeply interests me, and how to do it, and I have a feeling there is a way you can do it now, starting from Picasso's achievement but pushing it further so that eventually it doesn't look like Picasso, but will look incredibly real. What I want to do, in short, is to make a new kind of illusion. And just as there have always been new kinds created in the past, so there will be in the future. I have seen that this is possible and that is why I dismiss all those people copying images, because it all seems to me just boring; it is like admitting that there is no new way to do something. That seems a rather despairing, pessimistic attitude.

I can understand that pessimism if you cannot see a new way of doing something, a way that is more real, by moving away from the conventional place we think things have to have. Picasso's remark is very true: a face has two eyes, a nose and a mouth and you can put them where you want. It is true; you can put them where you want. And it can be very real, not distorted. I am doing it first with simpler forms than the figure, which is the most complex form. I am trying to find my own way to do it; at times the pictures veered towards Picasso, but I didn't just want to take his forms. I want to find my own way. Perhaps I will need to have a figure in order to succeed, just to observe and feel it. But the figure, if there were no emotional connection, could be academic, you wouldn't care about it. That is what bad drawing is like: figures that you don't feel anything about, that you don't care about.

I remember once having an argument with someone who said that a million people had been to see the Picasso exhibition at the Museum of Modern Art in New York, in 1980, just because they had been told to go. I disagreed. I said that people wouldn't go just because of the publicity surrounding the show. You might get a certain number who went for that reason, but if they weren't getting anything out of it they wouldn't go in such large numbers. Whether they could analyse it, talk about what it was they were getting from the work, is another matter. But whatever it was, it was real.

In art, new ways of seeing mean new ways of feeling; you can't divorce the two, as, we are now aware, you cannot have time without space and space without time. It is only ninety years ago that they were thought to be separate and absolute – not that long ago. Now, anybody who thinks about it automatically connects space with movement itself, which is time. Movement means moving through space and therefore through time. It is this relationship between space and time that obsesses us.

I do believe that painting can change the world. If you see the world as beautiful, thrilling and mysterious, as I think I do, then you feel quite alive; I like that. I know there are people who can't see the world like that, who feel despair, who obviously cannot see much in the world, cannot see some immediate beauty. If they did, they wouldn't feel the despair. I see that part of my job as an artist is to show that art can alleviate despair. I think that we are at a very interesting point: the changes I am talking about in how we perceive things are occurring in all sorts of different areas and, to me, they link; you see the links. Politically, even, such changes are also taking place, including in what used to be called the Communist world.

DESPAIRING VIEW-POINTS?

There is an argument that human nature doesn't change much: 'Your windows are new and your plumbing is strange but other than that I see no change' – that's Kipling. Only the plumbing has got better. Oh, I understand that. Nevertheless, a new factor *has* emerged. Again, not very long ago, people thought when the First World War started that it wouldn't last long, that it would be a war with professional soldiers, with honour. In fact, the German Prime Minister resigned in 1916 because it had been decided to torpedo passenger ships. He felt that that was not war, but murder; he was still thinking of war as an honourable activity; there was a code of military honour: soldiers did not murder. You killed, but it was not murder. I can appreciate the difference in the argument, but that is now very hard to accept.

Not too long ago, in 1945, the United States could put all its military might into one effort: they dropped two atomic bombs, on Hiroshima and on Nagasaki. Today America could not possibly use all its military might. If they were to send out every massive weapon they have even a long way away from the United States, everything would blow back in their faces. Even if nobody retaliated, a catastrophe would occur. This is a very big change. Human beings have a deep instinct for survival. It seems to be the deepest and most real thing we have. The more we become aware of what nuclear weapons will do, the more we realize that to survive

we must change, because what choice do we have? We don't actually have a choice. We cannot possibly use the weapons. It is not as though we could accept destroying nature. We can't possibly destroy nature. Nature includes the weapons; it is fire, smoke, explosions – these are all parts of nature. We can destroy ourselves and our view of it, of course, and the fact that a world war now would destroy not only us but future generations is something again profoundly different. When the First World War started they thought a few people were going to be killed, but they didn't think that future generations would be killed. Now we know that might happen, even if you dropped a hundred bombs in the Sahara Desert. We wouldn't do that, we wouldn't dare. All this must mean that profound changes will occur within us, each one of us, because we want to survive. We're not suicidal yet, unless folly leads us to destroy ourselves.

During the Cold War period the idea that the United States would drop bombs on Russia and vice versa was something I never believed would happen. I always thought that whoever was running Russia must be reasonably responsible. I never thought the Russians were evil; they might be misguided in some of their ideas, but that's true everywhere. Nazism was evil, a totally evil idea, that had to be stopped. Churchill had to link up with Stalin because Nazism was evil. I think what is becoming apparent now is that wars are more confined and the big powers are a bit helpless because they have been thinking in terms of much bigger wars that might destroy everyone. There were always strategists who planned for nuclear contingencies: in Moscow, in Washington, in London, in Paris. Now these people horrify us. We think, how could they possibly do this? When the theories of the nuclear winter came about, from real scientists, not just politically minded scientists, the ideas of the strategists looked insane – more than insane – suicidal. Did any of us want, just because of some political differences, the whole of humankind to end for ever, or the world changed so much it would be totally different? Of course not.

I am a very pacifist-minded person. I tend to think killing is immoral under almost any circumstances. Not everybody does. The question of ultimate destruction never arose before and with nuclear capabilities, it did. New generations grew up in this awareness. When Ronald Reagan was a young man, if somebody had said New York City could be destroyed in two or three minutes, he would have laughed. It was not conceivable then: where would the bombs come from? Across the Atlantic? It would take too long. After all, the English Channel saved England many times and that is only twenty-two miles wide. The Atlantic and the Pacific Oceans made America a kind of impregnable fortress. It had a friendly border in the north, a reasonably friendly border in the south. But then we had a very different situation. A child growing up today knows that it is actually possible for a whole city like New York to be destroyed within a few minutes.

Sometimes, in my gloomier moments, I still get pessimistic and think, one day it'll happen; what difference will it make? We'll be gone and the world might be a sweeter place left to some other little creature that develops slowly again; or maybe *we* would develop again; it would just take another few million years. What difference does that make? To our timeless God it means nothing, absolutely nothing, doesn't it? I think we have to think about it now. Everybody has to think about it; one does every day. This is why we even think of death every day. I do. Is that a despairing view-point? I do not know. When I went to Mexico I knew very little about its conquest. Being there, I got interested in its history and I read books on it, learnt about the Aztec civilization. I read William H. Prescott's *The History of the Conquest of Mexico*, written in 1843, a wonderful book, I thought, for a scholar who had never set foot in Mexico – he had never left Harvard. One of this book's interesting insights concerns the Aztecs' practice of human sacrifice. It is something that horrifies and fascinates one. The whole story of the conquest of Mexico is fascinating. According to the religion of the Aztecs, it was predicted that a god would come back from the east at a certain time, who would be brave. This coincided with the arrival of Cortez. This made Montezuma cautious, it caused him to have doubts, so he did not attack back. And that was how such a small body of men conquered a complex and advanced civilization. It was not a Christian civilization, of course, and to the Spaniards Christianity was the only true religion. To them, the sculptures and temples did not seem beautiful. It took about three hundred years before they were seen to be beautiful. There is a big, marvellously formed pot in the Museum of Archaeology in Mexico City, a massive stone pot, carved quite beautifully. It was used to hold hot, throbbing human hearts that had been ripped out of bodies. Consequently, you can understand the Spaniards at the time not seeing its beauty; to them it was just a hideous thing; they thought the practice of ripping out human hearts barbaric.

They destroyed all the temples of the old religion. That is why there are so many churches in Mexico: where there had been a temple, they built a church. There's a point in Prescott's book where Cortez is talking to Montezuma and Montezuma says, You'll have to excuse me for a short while, and he goes off to the temple, rips out six hearts, and then he comes back to the conversation. Cortez thinks this is horrible. But Montezuma sees it as a religious necessity, such sacrifices are necessary to keep the world going.

Prescott points out that the Spaniards would burn people as heretics, and when they did so they not only took away this life, but they condemned them in the next or any future lives as well, whereas the Aztecs, when they ripped out hearts, though they took away this life, they did not think they were taking away any others. In fact, some of the people sacrificed became gods. People queued up. In one day about twenty-five thousand people were sacrificed. When the temple opened there

was a queue. Can you imagine this, people shuffling forward to be sacrificed? Why didn't they run away?, Prescott asks. Obviously, they had a different attitude. It is hard for us to imagine. How can you take out the hearts of twenty-five thousand people? It is like being at a football match, those priests working overtime with a knife ripping out the hearts, the bodies thrown down the steps. It is hard for us to imagine the stench, the blood. We think it is ghastly, yet they didn't see it that way, nor did the people lining up. Prescott's observation made me think that maybe those people queueing up saw their sacrifice as an opening; they didn't see life the way we see it, they didn't see it as terminating. We live in an age that is, on the whole, not really religious. Most people see death as a final, totally final, terminating thing. But people have not always seen it that way, obviously.

THE END OF POSITIVISM

The Western, empirical, positivist, scientific view-point is coming to an end. The notion of ultimate destruction gives us a blank feeling. In the past when people asked whether I believed in life after death, I would shrug my shoulders and even smile: you just die, you just die. But I'm not so sure now. Life itself is so mysterious, why should we be put off by the mystery of another life? In that sense, I am not a logical positivist at all.

In fact, I realized that was why I was in slight conflict with Jonathan Miller over *Tristan and Isolde*: I felt he had no interest in the metaphysical and I had. I put it down to the fact that perhaps as a doctor he tended to believe only in the physical, whereas I don't. I think that my preoccupations with movement, time and space may provide an insight into what I call the metaphysical, in terms of what painting can do, because I think they change things, just as Einstein's insights changed certain fixed scientific ideas. I think it was the President of Harvard University who around 1890 suggested that one didn't have to study physics much because virtually all the major problems had been solved, there remained only small things to solve. But those small things turned out to be the ones that opened another door – a vast one. That happens all the time: what you think may be a final answer turns out to be simply another layer, and something else, something even wider, opens up.

I think that is the case now. I only take a layman's view of science. In the last few years, I have read quite a few books which link modern physics with mysticism; it is just a poetic idea, interesting at that level. The first person to point out these links, in our day, was Joseph Needham, in his *Science and Civilization in China*. He was a genuine scholar, not a scientist. I find myself fascinated, as I said earlier, with the idea that the further you look into space the further back in time you go. And in some ways I think there is some connection here between the way a

surface can become space and space can become a surface. This is very interesting to a painter, but also to anyone, really: it makes the universe smaller.

I was struck by Einstein saying he thought visually. It's fascinating that his ideas came about visually, like pictures. I like the fact that when the clock hand moves exactly to noon, as it takes time for the light to reach our eyes, it is actually *after* twelve when it is twelve. I love this; it seems a madness; it contradicts so many things, it is deeply appealing in some way, as are the ideas of fractal geometry. In Euclidean geometry there are perfect shapes, perfect forms, like the cube. In fractal geometry the definition of a perfect form is much closer to nature. We would be surprised if our lungs were a perfect cube, but in fractal geometry they can be seen as perfect forms. I find that absolutely engrossing because it is another way of seeing. And not only that; it is, at the same time, another way of feeling.

6 Beauty Recaptured

I think it is my responsibility as an artist to be open all the time to new forms of awareness; I have a sense of duty in this respect, as I think that it is an artist's responsibility to be concerned about the world. I think that a lot of very different artists *are* actually concerned, in very, very different ways, of course. The art world, to a certain extent, is just a world of commerce and can be tolerated only on that level. But there is an art world that is genuinely concerned about humankind, ideas, what we feel, what we see of the world, and that, I like to think, I might be part of. If, in the eighteenth century, the *New York Times* were publishing their art pages, that section would have been called 'Art and Science' because the two were seen as being on a similar level. Now that section is called 'Art and Leisure' and the 'Science Times' comes out on a different day, as a separate section. No connection is made between art and science. But in the past connections were made. In the Renaissance many artists were also scientists. I believe that separation is now slowly beginning to disappear. This again involves deep changes in our way of thinking. There is an excitement in that. Periods come to an end and other periods start. Depending on your own interests, the way you look at it, as the period is coming to an end it will make some people deeply afraid; they won't like it because they are incapable of seeing that when an end comes there is a new beginning, and another, and another. Those people who can see a little more, or think they can, know when something is going to end and they feel some excitement because it means that there is going to be another beginning. Therefore, your view is more optimistic the further ahead you can see.

153, 154 Images from Quantel Paintbox, 1987

The Quantel Paintbox images were commissioned by Michael Deakin of Griffin Productions, who asked me if I'd like to draw on the TV screen with a computer while they filmed it. I was aware that what was interesting was not the finished picture, but the way you did it – what was going on. I also realized that it was using the TV screen, the surface, in another way entirely – I was creating an image with light on a piece of glass.

If someone were to say to me that the difference today is that, in the face of extinction, we cannot see a new beginning, I would say that had always been the case. What is new today is the speed and awareness of the changes. An ordinary person is now more aware of it, whereas changes in the past occurred slowly, and ordinary day-to-day life would have been little affected by them. The difference between, say, a peasant in thirteenth-century England and a peasant in eighteenth-century England would not have been that great. They would still have lived probably in the same place, they would not have travelled much beyond a small radius of where they were born and the world outside would have seemed to them totally exotic. Consequently, for somebody born in York in 1300, even if you had heard of London, it might as well have been in Australia. You would have had to be rich to make a pilgrimage to Rome or Canterbury.

Today it is obviously very different. Anyone sitting in front of a television gets a picture of the whole world. But what you probably wouldn't be looking at would be your intimate surroundings, because the television screen pretends it is not there. However, now there is a new television screen – the computer screen – that knows it *is* there: you don't fool yourself into thinking that you are looking *through* the screen, you know you are looking on the surface of it. It is a piece of glass and you are aware of it. This, again, is about the flat surface and space. Most people never ever think of the television screen as a sheet of glass with light on it which, in short, means that the immediate reality is denied. Now, with the computer screen the immediate reality is there; you are aware of it and, in a sense, an intimacy is brought back, it is not an illusion. I think that we might save ourselves from destruction by admitting what is close, what is intimate, which is what is real, by perceiving the world with greater intimacy, which, in turn, leads to kindness. It is much harder to be unkind in a person-to-person situation than it is to be unkind when you are in your big group against another group, when brutality becomes easier. The worst forms of brutality, after all, have to be conducted on an enormous scale, with the power of the state behind them, and each person sheltering behind that power; it is then not a personal thing.

Television, in one way, brings us into an intimacy, but in another it does the opposite. And I think that has something to do with the surface. Like the photograph, it brings something closer but at the same time 'objectivizes' it and dehumanizes it. I would like to oppose the idea that modern art is dehumanizing; I don't see it that way; I think it can humanize, it has to and it can.

There have been very few really good artists throughout history and the great artists always perceive life positively by offering us through their art different forms that delight us, in a way like great religions. That is why, to someone saying that art is not for everybody, I would answer that if a religion were only for the few, it would not be a great religion, it would be a mere cult. Any great religion has to be

for everyone, no one excluded. It cannot be just for bright people, it has to be for all humankind. Christianity is like that, Islam is like that, Buddhism is like that. Even in religions which are hierarchical, like Hinduism, everybody is included.

Art has never excluded anyone from understanding it and enjoying it in the past. If the art did not work for most people, the artists were not considered to be much good. (On the whole, what we call bad art is dishonest and tries to deceive the spectator.) So-called primitive art had a purpose and it had to work. The artist couldn't just make figures which, when carried in procession down the street, made people ask, What's that bit of wood he's holding? If they asked that, it would mean that the art hadn't worked. The art had to be read in a certain way or it was not thought to be any good. Good art is invested with a certain universality of feeling and meaning – this is one way of defining it – and that is why it can come from anywhere in the world as well as from any time. This is why even things made in civilizations we know little about work on us, because they hit on something universal. I think Picasso hits the universal – what people anywhere would be feeling and seeing. This quality is clear also in music, even in places with a very different musical tradition: it works in all kinds of ways. Black music, for example, which comes out of two or three different African traditions, obviously works for all sorts of people who know nothing about those traditions; you don't have to know about them. If some art works, you might not know *how* it works, but you know is *does* because it has an effect on you.

What we recognize universally, at all times, is that great art conveys the urgency an artist feels to communicate to others a new way of seeing the world.

LIGHT AND SPACE IN *TRISTAN*

Tristan and Isolde was commissioned from the Los Angeles Music Center Opera by its director, Peter Hemmings, who asked me if I would like to do it with Jonathan Miller directing. I was deeply interested in the piece and had seen quite a number of productions. I felt it was the kind of music that I would choose to work with in the theatre; there are some operas I wouldn't do, but *Tristan* deeply appealed to me.

As I mentioned before, I'd first been to Bayreuth in 1974 and again in 1978 to see the Patrice Chéreau *Ring*. I love Wagner. Like other people, I'm hooked on the music, it's unlike any other. *Tristan and Isolde* is a pretty static drama; it's essentially an internal drama. It takes place entirely out of doors, and nature, in a sense, is a part of it. I thought this too was interesting because the problem of putting nature on the stage is a challenge. One has seen attempts at verisimilitude, but I didn't think it could be done that way convincingly. Yet you do have to deal with nature.

Jonathan Miller commented early on that he thought *Tristan* was a rather silly story, which seemed odd to me because the story is told in the music, not in the words. The only reason you do an opera is because of the music; if that is no good, it doesn't matter what the story is. *Tristan and Isolde* was, after all, a new kind of opera in its day: recitatives and arias had gone and the music had become continuous. The internal drama is in the flow of music. Forms of shapes and light can also help make it the terrific theatre it is meant to be. Wagner was a theatre man, a theatre composer; he would have used every theatrical device possible at the time. He was also interested in theatre technology: he wanted all the latest lighting, everything that was available to create effects. At Bayreuth he had designed his own theatre, had covered up the orchestra, so that it's like a cinema when the lights go out.

No other opera house is like that. In traditional houses, when the lights go out, there's usually still a big glow from a very large orchestra, which is lighting up the curtain and the front of the scenery. At Bayreuth, Wagner *hid* his orchestra, but managed to keep the sound marvellous. The first time I went to Bayreuth was to hear *The Ring* directed by Wolfgang Wagner – I was excited to be there, sitting on those rather uncomfortable little wooden seats. As *Rheingold* began, and the lights went out and the theatre was very dark, as that long opening chord began, slowly a deep blue appeared – beautiful, I thought. I was very thrilled by the use of colour and realized that because the theatre was totally dark, colour could have more power.

Tristan was the first opera I had been asked to design for five years. We built a complex model and lighting system, knowing that the lighting had to be an important part of the design. The first thing we did was to put lights in the box and I then started cutting up shapes and playing the music. In the first act you have to feel that you are aboard a ship, you have to feel that Isolde is travelling on this ship, separate from Tristan, that she is living in a separate section of the ship – this is all important in the story. The model box was one inch to a foot. I started using my ideas about perspective, which I had developed in photography, from the complexity of *Pearblossom Hwy.*, which although it has actually got hundreds of perspectives, looks as though it's got a normal one as well. I realized one could maybe do this in space. I couldn't make hundreds of perspectives in the sets, on the stage, but I could make quite a few that still looked as if they were one. The effect, I thought, would be to pull the viewer closer into it. And that's what we finally worked out. There are different levels of the ship, different lines going different ways, there's actually a twist in the ship, as though you could look at it from many different angles.

I never made drawings, but kept cutting out shapes, placing them in space, then lighting it, all the while playing the music and realizing what marvellously different

119

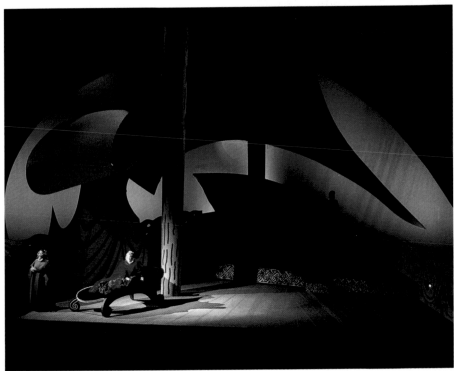

155–157 Scenes from Act I of *Tristan and Isolde*, Los Angeles Music Center Opera, 1987

The first act of *Tristan* takes place aboard a ship. I realized that the sails could be used so as to reduce the distance between the audience and the stage. The rest of the ship was painted in bold patterns, but the sails were painted in solid colour which, lit in a certain way, made them appear very close up, drawing the audience into the scene.

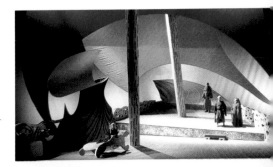

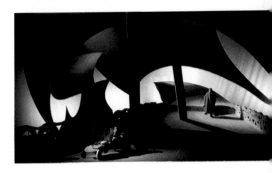

effects you could get from the use of the sails, how you could make it feel as though the ship were on an open sea, how you could suddenly make it feel as if you were close up on the deck. The sails were painted with a very bold texture, which if you lit it in a certain way looked as though your face were right next to the mast. Devices like this pulled you into the scene, called the audience into the space of the drama.

It was all done with lighting and with lines that made spaces, at times contradictory spaces. And I kept playing the music, constantly aware of the very strong dramatic effect it has, contrary to one's first impression of it as a static drama. The music creates a mood of excitement that makes you feel you are on a ship. I listened to the music over and over again, night after night. I loved sitting there with the model. I had to work at night because the studio was too bright during the day and I didn't have any way of blocking off the windows. I even had to rent a great big tent to make it dark so I could sit there through the long hours, because, after all, if you want to hear the whole piece in one evening, it's three and a half hours of music. I did that on many evenings, listening very, very carefully, trying to find things in the music.

There were three of us working on *Tristan*: my assistant Richard Schmidt, doing all the lights, Ian Falconer and myself. We made many versions of each set. For the last set, with the mountain, we had nine different versions to give the illusion of distance. I kept altering them to fit the music; I wanted every form you saw to do that.

158 *Overleaf:* Model of the ship for Act I, *Tristan and Isolde*, 1987

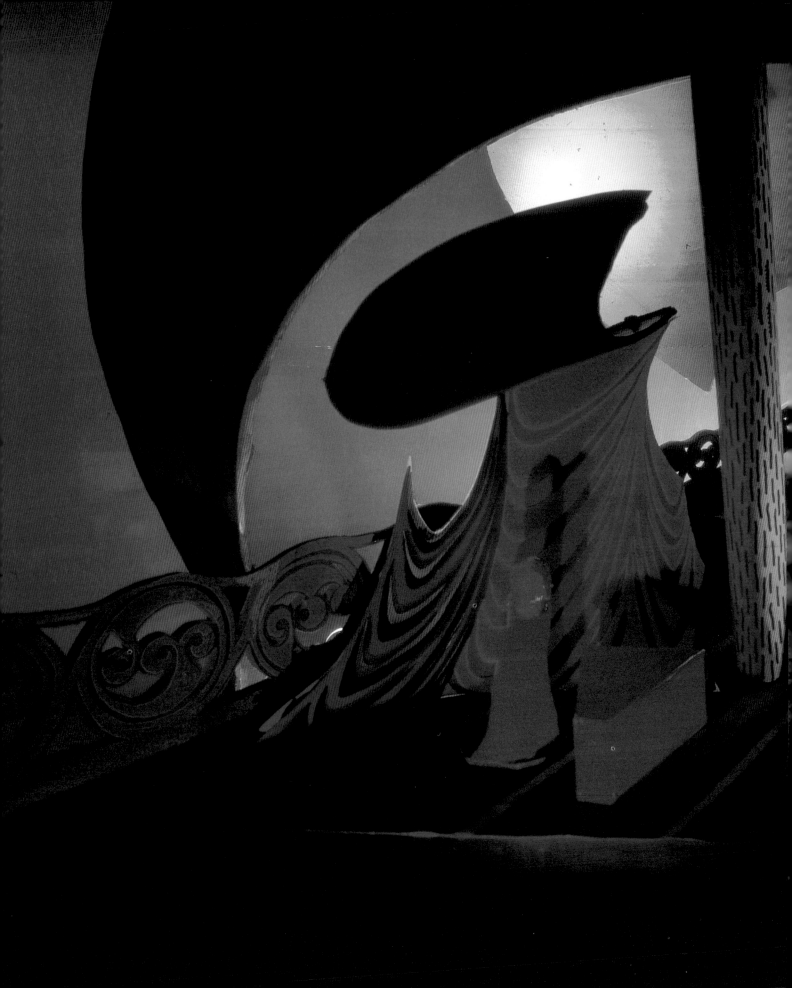

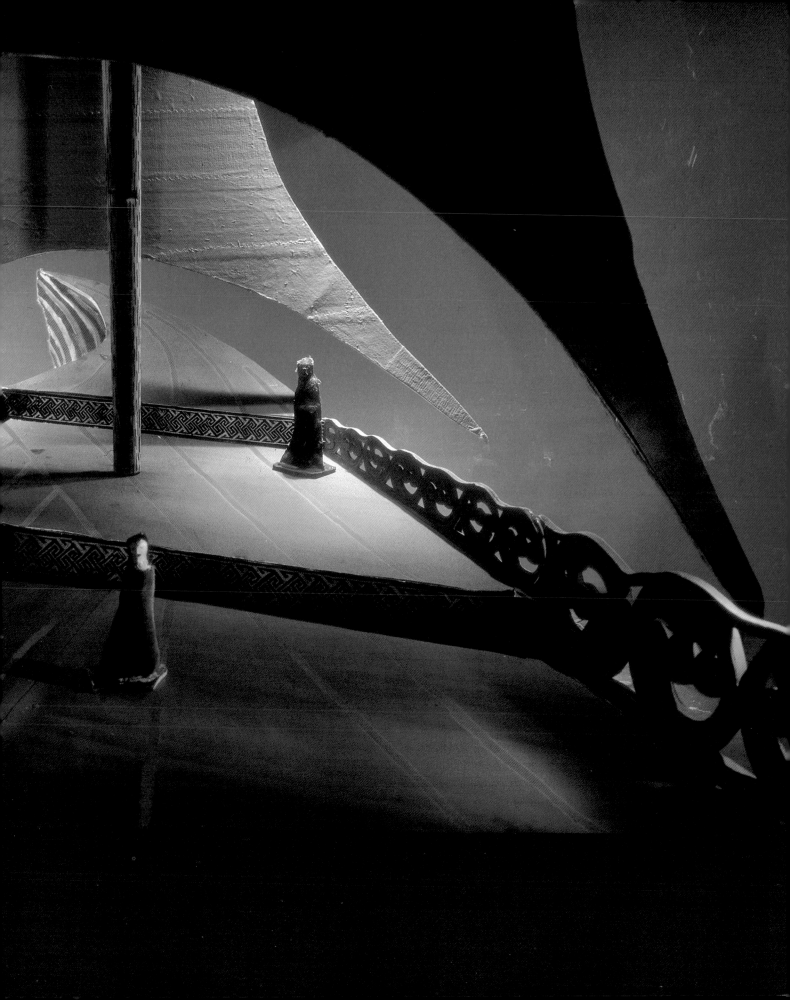

159 Scene from Act III, *Tristan and Isolde*, 1987

160 Scene from Act III, *Tristan and Isolde*, 1987

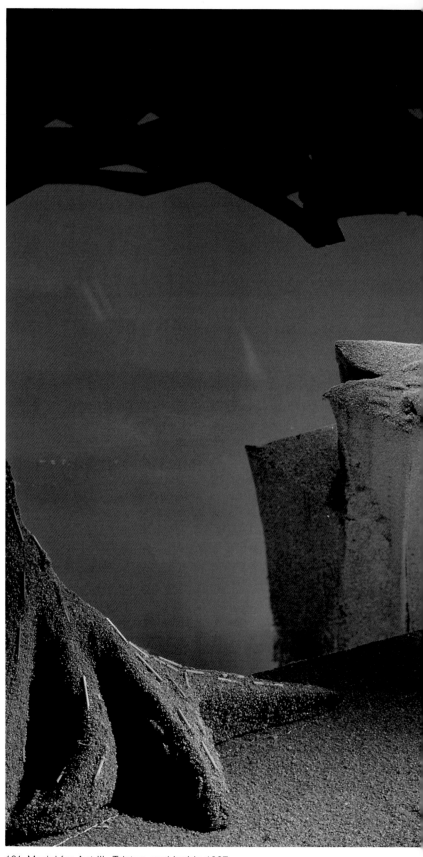

161 Model for Act III, *Tristan and Isolde*, 1987

I spent about six months on the models, doing very little else at the time except for a few paintings of the characters in the opera. Sometimes I would break off working on the model and make paintings quite quickly; I'd make a painting of a scene as we were building the models. For instance, the painting of Tristan with a yellow background, *Tristan in the Light*, was made when I was having talks with Zubin Mehta, who was to conduct. Zubin pointed out how parched the place is in the last act when Tristan is complaining about the high sun and when he also says, 'Do I hear the light?' – a marvellous mixing of the senses. When *Tristan* was put on in Los Angeles, the singers did literally hear the light because we used Vari-Lite, which does make a noise, and they complained. The Vari-Lite people reduced the noise, but I had to give a little talk to Martti Talvela, who sang Tristan, and who objected, and convince him that the noise was just part of a long tradition of suffering in Wagnerian performances.

Zubin Mehta would come up to the studio and look at the model and we would talk about the music and he would give me insights into it. I enjoyed working that way. The paintings I was making at the same time, or subsequently, like *Tristan Looking for Shade*, *Tristan in the Light*, *Tristan und Isolde II* and *III* and *The Love Potion*, were very different from other paintings of mine. They are, in a certain sense, diagrammatic; I was trying to picture the drama with the characters there. The paintings are about the characters. The model had only little figures in it, and in doing the paintings I was trying to put the characters in. That's what the paintings were doing for me. In a sense, the paintings are close-ups of what I thought the drama was going to look like. Their style hardly matters. I would use

162 *Tristan in the Light,* 1987

163 *Tristan und Isolde II.,* 1987

164 *Tristan Looking for Shade,* 1987

165 *The Love Potion*, 1987

I painted these pictures just for myself. They were my way of putting the characters into the models. I placed them around the studio as I worked and they brought the characters alive for me. They were all painted between making the models and staging the opera and were included in my retrospective exhibition of 1988/89.

166 *Tristan und Isolde VII.*, 1987

anything to demonstrate, say, Tristan holding up his hand to shade his eyes, *Tristan Looking for Shade*. In some respects I did the paintings to provide my own atmosphere: they're illustrative and they're meant to be illustrative. I would put them on the wall while playing the music. Whether or not they stand on their own hardly interests me. They were painted for a direct purpose. They simply stood there and I actually exhibited them as a part of the work. It is an odd little group, but there is one painting, *The Love Potion*, which is quite dramatic: in it Tristan is shown drinking the love potion – it is the most dramatic moment of the first act. Looking at that particular painting later, I saw that it was actually the source for a different development taking place in my painting: a certain flow is beginning there. It was the last painting I did which had figures in it. But it also has in it the beginnings for the portraits which I made in 1988/1989 in the little studio in Malibu.

When I moved down to the beach in Malibu, to live by the sea, I also developed a drive through the mountains while playing the music, once I had choreographed *Tristan* spatially in the model. I began exploring the Santa Monica Mountains, playing Wagner, realizing how dramatic it could be and I actually choreographed two drives after that.

167 *Large Little Stanley*, 1987

168 *Green & Blue Plant*, 1987

AFTER THE RETROSPECTIVE

At the same time I made a number of paintings which were included in my retrospective exhibition ('David Hockney: A Retrospective', Los Angeles County Museum of Art, February 4–April 24, 1988; The Metropolitan Museum of Art, New York, June 18–August 14, 1988; Tate Gallery, London, October 26, 1988– January 3, 1989): *Still Life with Magenta Curtain, Large Little Stanley, Golden Still Life, Green & Blue Plant* and *Still Life with Flowers*. These were made immediately after I finished work on the models, before *Tristan* was staged. The still lifes use very simple shapes, putting them on a colour background and making a space with them. That is what I was exploring.

After the retrospective exhibition opened in Los Angeles in February 1988, two months after *Tristan and Isolde*, I started painting a lot. Some of those paintings were added to the retrospective when it got to the Tate Gallery in London, the last venue, where there were additions. The final room in London contained paintings that had actually been done since the retrospective had begun in LA: *Large Interior* (1988), the portraits from 1988 (pp.188–89) and *My Mother, Bridlington, 1988*.

In late 1988, I moved almost permanently down to the sea. I stayed there most of the time. I painted the house. *Gauguin's Chair, Van Gogh Chair* and the interiors (pp.184–85) were all made after the retrospective. *Van Gogh Chair* was a

169 *Golden Still Life*, 1987

As soon as I had finished all the *Tristan* models, and before the opera was staged, I made a number of still lifes in which I explored putting simple shapes on a colour background and making a space with them.

170 *Still Life with Magenta Curtain*, 1987

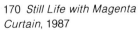

171 *Still Life with Flowers*, 1987

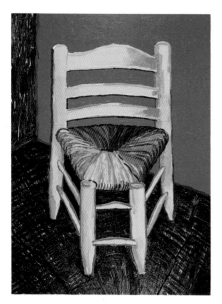

172 *Above: Van Gogh Chair*, 1988

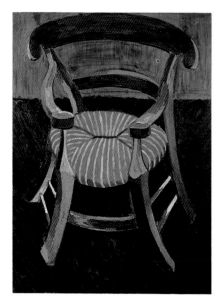

173 *Gauguin's Chair*, 1988

Van Gogh Chair was my homage to Van Gogh on the centenary of his arrival in Arles. Then I found Van Gogh's painting of Gauguin's chair, so I did *Gauguin's Chair*, too. Mine are both in reverse perspective.

commission by the people who ran the photography festival at Arles. Nineteen eighty-eight was the centenary of Van Gogh's arrival in Arles and they asked various artists to do a homage to Van Gogh, including Robert Rauschenberg and Roy Lichtenstein. I liked the painting so much, I made another version for myself because I gave the first one to the Van Gogh Foundation in Arles. At the same time, having done *Van Gogh Chair*, I did *Gauguin's Chair* because I found Van Gogh's painting of *Gauguin's Chair*, but I altered it and put them both in reverse perspective.

In these paintings I was still exploring the spatial ideas of perspective, as I was in the interiors, including *Large Interior, Los Angeles* and *Small Interior, Los Angeles* – the latter is a sketch for the former. *Large Interior, Los Angeles* is 10 ft × 6 ft; it was purchased by the Metropolitan Museum; Bill Lieberman understood what I was doing and found it very exciting. The texture ideas are bolder because I used a bigger scale for the wood. These interiors are all of the house in the hills. I began these first and when I moved down to Malibu I did the portraits cumulatively.

At the same time I also made *Big Landscape (Medium Size)*. The painting is made with two canvases; it began as one and I then made it bigger. I could see I was beginning here to play with spatial ideas. I worked on it off and on for a few months. I kept it in a corner and it looked a bit odd because it is a painting in which I'm exploring ideas. Nathan Kolodner from André Emmerich's came and asked me for a painting to put in an auction for AIDS and he wanted this one, which he liked,

182

176

178

175

174 *Above:* In my studio, with the chair paintings, May 1988

175 *Big Landscape (Medium Size)*, 1988

These interiors are all of my house up in the Hollywood Hills. When I did
them, I was still exploring the spatial ideas of perspective, as I had been in
the chair paintings (p. 182). *Small Interior, Los Angeles* (*below*) is a sketch
for *Large Interior* (*right*).

176 *Small Interior, Los Angeles, July 1988*

178 *Large Interior, Los Angeles*, 1988

177 *Interior with Sun & Dog*, 1988

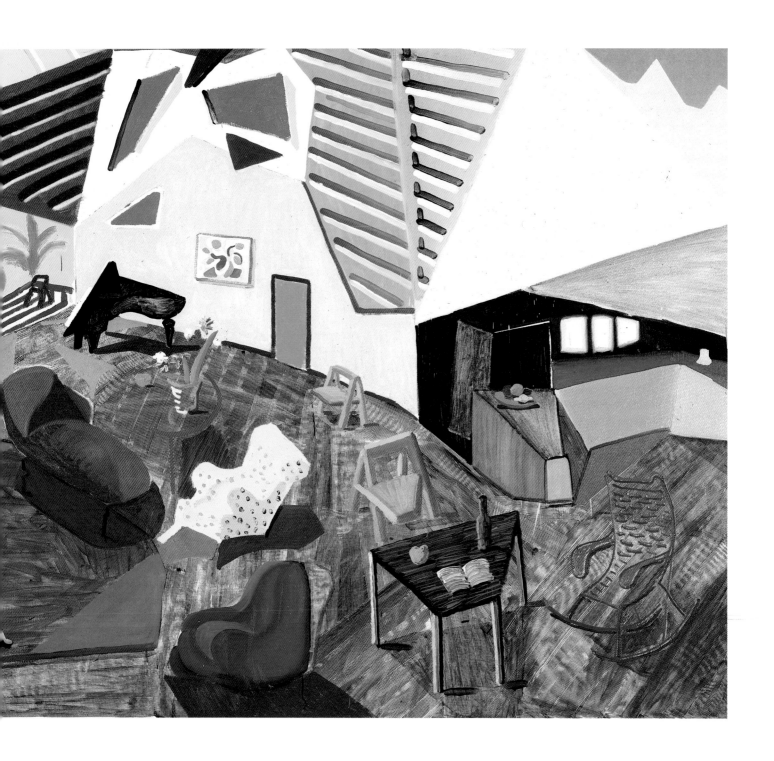

179 *The Road to Malibu*, 1988

This painting describes the journey from my studio in the Hollywood Hills to my small studio in Malibu. You can actually follow the journey – there are reference points and road signs.

and I said, Well, it's just developing into something, that's all. I said, I'm not sure if you put it in anyone would know I had done it unless they had seen it sitting around my studio. Now, of course, looking back, I can see that this particular painting led to more new developments in my work than the others from this period. Perhaps I sensed that at the time. I had put a lot of things in it, rather like notes of what I was going to explore, and perhaps it is a little overdone, but in some ways it is similar to *Showing Maurice the Sugar Lift* (1974) in that it has various elements of ideas that were beginning to emerge. It was done for myself. You might say that something from *Tristan* has come into it too, a certain theatricality of space, its preoccupation with space, with sculptural forms on a craggy space which have the illusion of near and far. And it is a landscape too; there is a hint of the sea, although it wasn't painted by the sea, but in the studio in the hills. There is another element, like a railing, in the middle left-hand side of the picture, which becomes particularly prominent in paintings done four years later and which is a device for making space.

179 At about the same time, I also painted *The Road to Malibu*, which is of the journey from the studio in the hills to the small studio in Malibu. This uses similar

175 techniques to *Big Landscape (Medium Size)* but you can follow the journey – it has quite visible references to road signs and so on, and in this way is similar to

70 *Mulholland Drive*.

FACES ON A NEW SURFACE

180–215

In 1988 I started doing a series of small portraits, painted very quickly, most of them on the same size canvas. I moved down to Malibu and decided I would stay down there now for a good few months. I rarely went up into the hills. I felt I wanted to look at my friends' faces again and I painted them rather quickly and crudely, but, as the paintings accumulated, they seemed quite interesting. Most of the people I had painted didn't like them – I don't think I'm that much of a flatterer. Nevertheless, it was useful to me to look at people again – they were all people I knew. If the best ones are of my mother, it is perhaps because I know her best.

I had a hundred canvases made $16\frac{1}{2} \times 10\frac{1}{2}$ inches because of the Canon colour copier which I had purchased in 1987. Canon in Los Angeles had asked whether I would like to come and see this new printing machine, a laser photocopier. Richard Schmidt and I went and the man said he had written to me because so many people had asked him, Has David Hockney seen this machine? He didn't know who I was. He gave us a demonstration and we were very impressed. We had taken one or two pictures along and we made a few copies and the colour copy of a photograph was quite amazing. But Richard said, Oh, why bother with that, you've been playing with machines a lot and you just really want to paint now, so why bother with it? After about two weeks, I rang up Richard one morning and said, You know, I've

I started these small portraits in 1988 and painted them all very quickly. They are all of people I know. Almost none of the sitters liked them – I suppose they're not very flattering.

180 *Mum*, 1988–89

181–215 *Top row, left to right: Ray Charles White*, 1988; *Paul Hockney*, 1988; *Albert* (Clark) *in Black Shirt*, 1988; Untitled (Albert Clark), 1988; *Gregory Evans*, 1989; *Sully Bonnelly*, 1989
 Second row: Carla Rajnus, 1989; *Ken Wathey*, 1988; *Maurice Payne II*, 1989; *John Hockney*, 1988; *Stephanie Barron*, 1989; *Margaret Hockney*, 1988; *Richard Buckle*, 1989; *Brian Baggott*, 1989; *Mum*, 1988/89; *Ian* (Falconer), 1988; *Henry* (Geldzahler), 1988
 Third row: Bing (McGilvray) *II*, 1988; *Bing* (McGilvray) *I*, 1988; *Karen S. Kuhlman*, 1989; *Bob Littman*, 1989; *Peter Duarte*, 1989; *Armistead Maupin*, 1989; *Maurice Payne I*, 1989; *David Morales*, 1989; *Philip* (Haas), 1988; *Johnny Reinhold II*, 1989; *Neil* (Hartley), 1988; *Richard* (Schmidt), 1988; *Peter Goulds*, 1989; *John* (Cox), 1988; *Don* (Cribb), 1988
 Bottom three: Helmut Newton, 1989; *David Plante*, 1989; *Nikos Stangos*, 1989

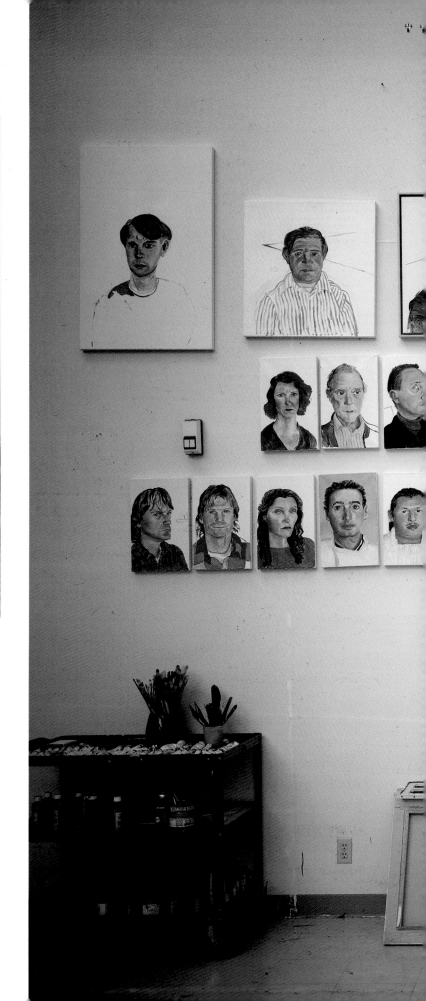

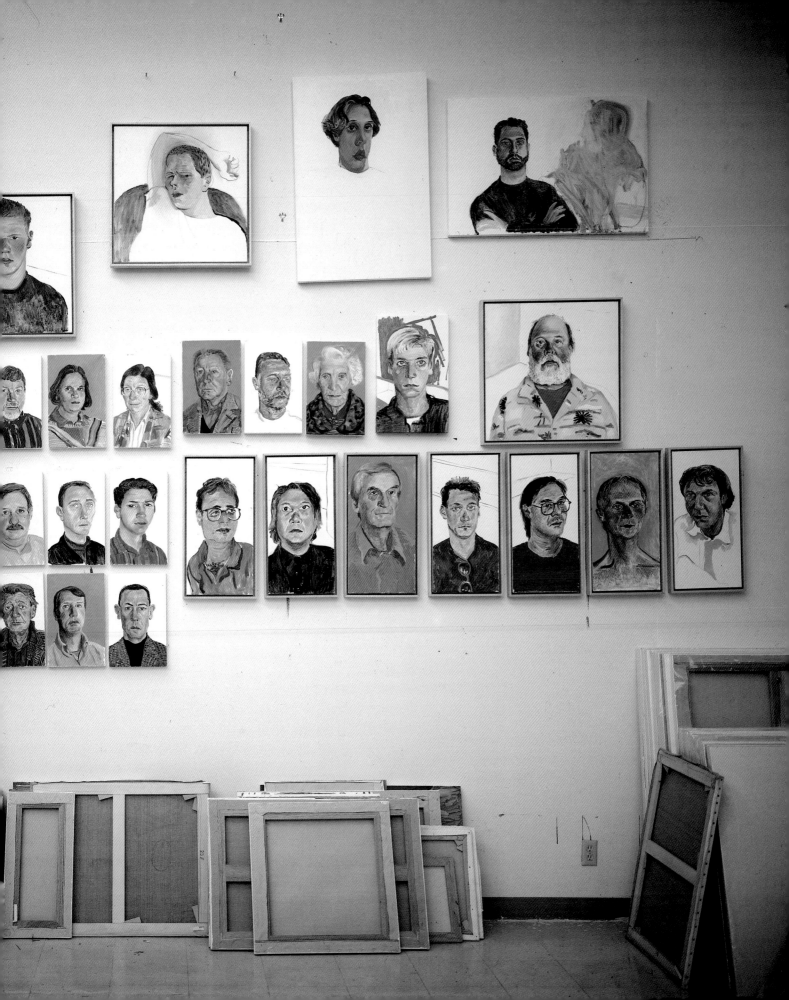

been thinking about that machine and I have a hunch there's something there that they don't know. The man couldn't demonstrate it to us, because he doesn't know about it. And I said, I think we should play with it, and I've thought about it, and it costs $40,000. Richard kept saying I should just carry on painting.

I got it finally. I had just finished a portrait of Henry Geldzahler on a square canvas, and the moment the machine arrived I put the portrait on it and made a copy. And immediately I knew my hunch was right. This was something new: you were getting a very different-looking reproduction of a painting because it was made direct from the painting, same size. It was extraordinary to me how it looked as if it were on the surface: the reproduction was not below it, it was *on* it! That is when I ordered the hundred canvases made to the maximum size you can have for an original to go on a copying machine. Then I slowly began to use those canvases to make the portraits and then to make copies of them. So I was exploring a few things: I was exploring painting my friends' physiognomies and also exploring this other process. I didn't know where it would lead, I didn't know what those repro-ductions were. I knew they weren't prints in the sense of my Home Made Prints, which were originals, not reproductions of anything. I realized these photocopies were something very different, but I didn't know what to do with it. I carried on painting the portraits; I would then make copies, give some away and pin some up around the room. The little studio in Malibu became full of faces and I kept taking the canvases to the other studio and just pinning up the copies.

126–133

PAINTING, REPRODUCING AND FAXING

I started the faxes in about October 1988, in Malibu. Many of them were made from paintings of the sea stretched on one machine, reduced in another way, crammed in, pasted up, made into a collage and then into a fax. I began sending them out to various people who immediately responded by asking me how I got such clear

216 *Big Waves*, 1989

217 *Even Another*, 1989

I started the faxes in the autumn of 1988 and played with them for about six months. The early ones were very much to do with the sea – I made a number of them from sea paintings that I was doing at the same time.

I made the gouaches shown *on this page* and *opposite* using opaque greys. I mixed different greys in order to develop quite complicated tones.

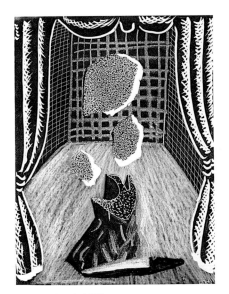

218 Untitled, 1989

219

222

pictures from a fax machine. I said I'd been exploring various methods. There's no such thing as a bad printing machine – so the fax, which is a printing machine, can be used in a beautiful way. To make half-tones, for instance, you don't use washes for something to look like a wash, you use opaque grey; the machine read the opaque greys and made the dots itself. I mixed different greys and so developed quite complicated-looking tones.

In terms of subject matter, they were a great deal about the sea. I used several of the sea paintings in the faxes. I played with the faxes for about six months. Next to the fax machine I had a new black and white laser copier with which I now began to do all kinds of things, not just reduce: I could use it to bend images, play with variations or put one image inside another. One fax shows how the machine can tilt the image, so I have written on it, 'Mind-bending fax coming soon.' The faxes were sent from the Hollywood Sea Picture Supply Company, which is a name I made up to send them. At the same time I was doing sea paintings and the flower paintings.

I was also making experiments with landscape paintings in different styles. For anyone who had been on my Wagner drive, *Pacific Coast Highway* would be recognizable straight away – it is a multiple view of the mountains and Santa Monica bay, the large views you see driving through them. *Mountain from Stunt Road* (1990) are mountain scenes from that drive. I painted, as it were, the composite picture, putting in as much space as I could – but some of the individual mountains were always seen at approximately the same time, because the drive depended on the sunset. Of course, at different times of the year I left at different times of day to make the journey. There's a low sun in most of these pictures, causing deep purple shadows in the mountains. I was, therefore, beginning to deal with landscape and the sea – with what was surrounding me in Malibu.

220 *The Valley*, 1990

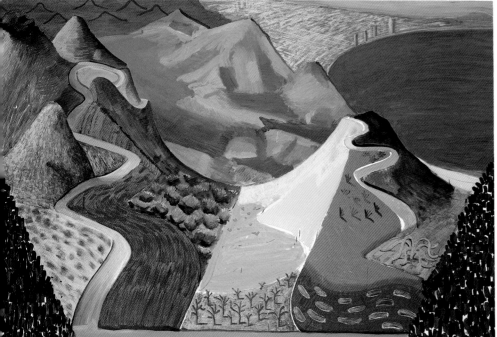

219 *Pacific Coast Highway and Santa Monica*, 1990

From 1988, at the same time as I was doing the faxes, I was also experimenting with different styles of landscape paintings. Anyone who had been on my Wagner drive would immediately recognize *Pacific Coast Highway* (*above*) – a multiple view of Santa Monica Bay and the mountains. Scenes from that same drive are also shown in *Mountain from Stunt Road*, *The Valley* and *The Cutting*.

221 *Mountain Waves*, 1988

222 *Above: Mountain from Stunt Road*, 1990

223 *Below: The Cutting*, 1990

224 *Bridlington Blue Flowers*, 1989

225 *Looking Down*, 1989

226 *Two Pink Flowers*, 1989

227 *Malibu House*, 1988

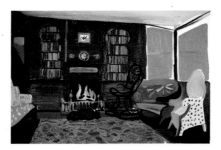

228 *Beach House by Day*, 1990

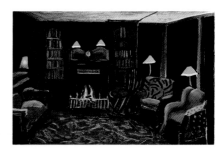

229 *Beach House by Night*, 1990

230 *A Bigger Wave*, 1989

At one side of my little house in Malibu is the Pacific Coast Highway; at the other is the beach. I step out of my kitchen door and there, right there, is the sea. So when I am painting in my studio I am very aware of nature, in its infinity, and of the sea endlessly moving.

231 *Breakfast at Malibu, Sunday, 1989*

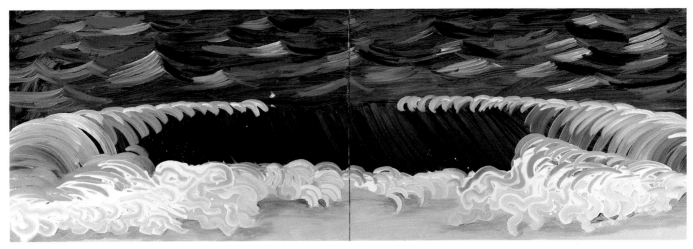

232 *Green Tide*, 1989

233 *The Sea at Malibu*, 1988

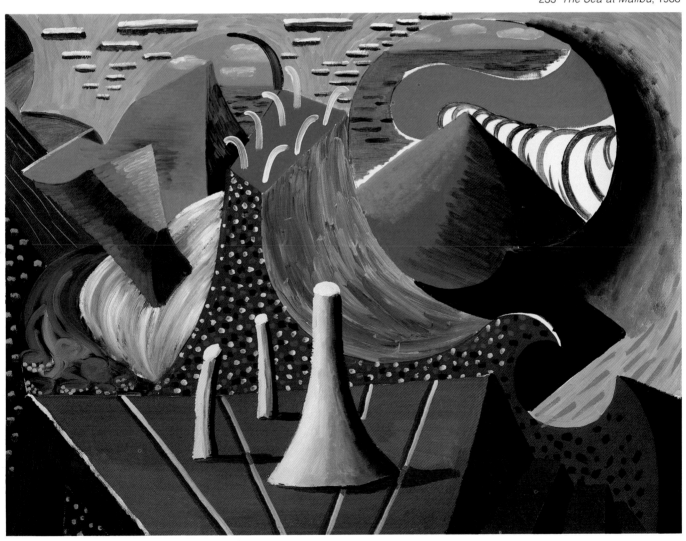

As I got more and more interested in the faxes, I began to make them bigger and more complicated. For the larger ones, I first made the whole image, then divided it with a grid, and then numbered the pages so that the image could be put together at the other end. I also began to experiment with bending and tilting images.

234

234 *Breakfast with Stanley in Malibu, August 23, 1989*

I painted the little house itself, its interior, its exteriors, the sea, and what was behind, which is all the landscape. All these pictures were being painted together, from late 1988 to 1990.

The faxes got more and more complicated, and bigger and bigger. I learnt how to make them bigger using machinery that blows details up on different pages. The first big ones were between sixteen and twenty-four pages, like the marvellous one of Stanley by the sea. As I began to send out the bigger ones, I had to make the whole image, then reduce it, draw a grid on it and then put a note in, saying: 'The following 24 pages make up another picture.' I sent them through, numbered, and whoever received them could put them together. In Autumn 1989, I was asked to have an exhibition at the Sao Paolo Biennale. At first they wanted to do a painting show and I said we couldn't borrow a lot of paintings back from collectors so soon after the retrospective. The owners had just got their pictures back after two years and they are often people who tend to live with my paintings and are reluctant to let them out again. So I cheekily suggested to Henry Geldzahler, who was curating the show, that since the recent work had all been done on the telephone, why not do a big fax exhibition? Henry had already seen quite a lot of the faxes and I told him I'd now learnt how to make them bigger. So we got a map of the room in Sao Paolo and made an exact model of it so that we could make some faxes specifically to fit the wall. We made about four very large ones. And they were faxed. We cheated a bit because we also included those we'd sent to ourselves, just in another room, that

print better, because the telephone lines to Brazil cost quite a bit of money. I sent Richard Schmidt to Sao Paolo to put up the show — I have never been there — because I had decided I shouldn't go: the point of the exhibition was that it was being sent through the telephone. The work had been dematerialized somewhere and materialized somewhere else, and I thought it would make it more interesting if I didn't appear. At first people were horrified that that's what I'd done — just sent faxes for an important Biennale. Yet others were impressed, realizing that nobody else had explored this way.

At the same time somebody came to see me about doing an exhibition of my paintings in the Soviet Union. He explained that I would have to pay for it and mentioned quite a large sum. But I thought, well, wait a minute, you can send exhibitions around much cheaper than that, and I explained that I'd just sent an exhibition to Brazil totally by telephone. You could do one in Warsaw, in Peking, you could do one anywhere — all you need are two fax machines, one at one end and mine at the other, and we could make exhibitions, of fresh things. Of course people want paintings, but I was amused by the idea of sending an exhibition down the telephone. And what value do these pictures have when they get to the other end? For instance, in Sao Paolo, they asked what they should do with them once the exhibition was over and I said, Well, you could send them back by fax, but that means you've still kept them. Which I thought was amusing. The faxes were unsaleable — although if they are kept carefully, they will become of some value since they are dated, part of my work, and we'll never send them out again.

I stayed in LA during all this. I said if the people in Sao Paolo wished to interview me, they could just ring up, and fax their questions. And so they did. A fax arrived from Mr Pepe Escobar, who worked as an arts correspondent for a newspaper, with thirteen questions, ranging from the obvious one, about experimenting with faxes, to one asking whether it would ever be possible for me to paint again and whether I thought it was fun being David Hockney. I said in my reply that I had first been attracted to the fax when I realized it was a telephone for the deaf, but that it also seemed to me to be an aspect of high technology that brought back intimacy which, to me, is the only reality. And, as I have said before, the fax machine was part of the spread of printing, the first victim of which was the totalitarian world — a fact that appealed deeply to my anarchistic heart. I also pointed out that as an artist I saw all my work — theatre, photography, faxes, etc. — as *one*. And that I used whatever technique I thought best for a situation, as each was a means to an end, regardless of market requirements, which do not influence me. I was also asked whether I might ever make a movie, and replied that what's wrong with movies is visual, that those who make them have forgotten that the screen is flat, and ask us to deny surfaces, to look *through* them, not on them, so denying the reality in front of our nose.

235 Untitled fax showing one image inside another, 1989

236 Untitled fax showing how the machine can tilt the image, 1989

237 Untitled, 1989

FROM THE HOLLYWOOD SEA
PICTURE SUPPLY CO.
EST. 1988

238 *Overleaf: Hotel by the Sea*, July 6, 1989

The following si

make this

much l

teen pages
picture.

vé - variant

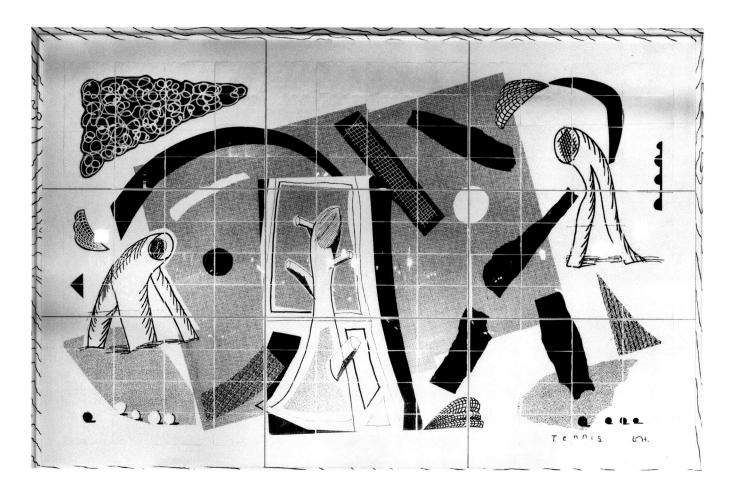

239, 240 *Above and opposite left*
(detail): *Tennis*, 1989

241–244 *Opposite right:* The Bradford
fax show. *Top to bottom:* Sending the
fax from LA; discussing progress with
Jonathan Silver; the last fax sheet is
slotted in; *Tennis* completed.

The fax show in Brazil caused quite a stir. But many people saw the philosophical side, the interesting side, the use of printing to make original works. I assume that even though people think my work is very popular, it often takes them time to see what I am really doing, to see what it is I am exploring, that it is not just a wild thing, but something that grows out of something else, and will grow into something else again.

I sent a few faxes to Japan too and they were very impressed and started sending some back. Somebody in Tokyo had a rubber stamp made – 'Fans of Hockney Fax'. Then Jonathan Silver – an old friend who ran the Art and Furniture Gallery in Manchester from 1979 to 1981 and, since 1987, the 1853 Gallery at Salts Mill in Bradford – came to LA and saw the big faxes just done for Brazil. I explained it had taken an hour and a half to send a big picture on the telephone. My phone bills were enormous. I even urged people at the other end to preserve them by making a black and white copy on ordinary photocopier archival paper which is still quite cheap and does not fade, as thermal fax paper does. Jonathan Silver, showman that he is, said, Ah, will you send one to Bradford? I said, I'll send one tomorrow, if you want. He said, Oh no, hold it, hold it, wait a minute, let *me* tell you when to send it;

I'll fix a time. Because he was planning at the other end to make the arrival of the fax an event. This was an evening event, which meant that in Los Angeles it was morning. We decided to send *Tennis* made up of 144 sheets. We used two fax machines to halve the transmission period, so that the whole picture would arrive at the other end in 45 minutes. In fact he got two plain paper fax laser printers on loan from a Japanese company, Ricoh, in England, which print on high quality paper. Yorkshire Television were going to film the occasion. I said, Alright, do what you want at your end, but it'll just be quiet at our end. But they also sent a cameraman to LA because they made a programme about it and it showed just four of us, Richard Schmidt, Jimmy Swinea and my brother Paul, who happened to be there, sending it off rather quietly in LA, feeding the machines. Jonathan Silver rings up to say it's coming through fine.

In the film I'm complaining about too many people around, making it all too noisy for me. What I didn't know was that at the other end there were more than four hundred drunk people and ten cameras. As the faxes arrived in Bradford, to the accompaniment of the *Walküre*, they'd pin them up so that everyone saw it being assembled and when they finally got the whole thing, the audience applauded. I advised Jonathan to hang it so you could look at it from a long way away, as we had done in my studio. I said, You'll see it's quite spatial. He had it mounted on acid-free rag board, enclosed in nine perspex boxes and he made an enormous frame for it. Then we also sent one to Japan and they too did an event which was on Japanese television. The contrast there was quite amusing. Whereas in Bradford the kind of

people in the audience were slightly drunk, running around and singing, in Japan it was a whole little team of young people, probably art students, all with white gloves, running and putting it up. We then made an even bigger fax of the sea, the last one, I think, which was made of 288 pages. That was sent to Japan as well as to Hawaii and a few other places. With that, I finished with the faxes. The fax period had lasted about six months.

THE IMAGE ON THE SURFACE

In the summer of 1990, Richard Schmidt and I got an invitation to go up to a firm in Silicon Valley where there was going to be a three-day conference about computers and printing. I found out that my Canon printing machine could be plugged up to a computer, so that you could draw on the computer and print immediately. This was very interesting to me. And at this conference somebody showed us a still video camera that could also, with another bit of small equipment, print immediately through your laser printer. It took photographs on a disk, not on film, and I thought that might be exciting, so I bought one. It was rather expensive, I thought, £2,000 for what essentially looked rather a simple camera. It turned out that the reason it cost that much was that they only made 400! I realized later that you could do the same thing from a video movie: you can, with similar equipment, take a still. Nevertheless, I bought the camera, used it, and at first thought the result was a bit fuzzy, that there was something not that good about it, until I explored it more and understood the way it recorded colour. I first made a group called *40 Snaps of My House*. I realized colour was coming out in a different way, no film was being used, the camera was seeing and putting digits on to a disk. I then put the disk into a little machine tied to the printer and you could print the photographs practically any size. If you printed four on a page, they were more sharply focused and the colour seemed rather rich and rather unphotographic. The photographic colour process uses dyes, but here was colour 'photography' without dyes. In fact, the only chemicals used in this 'photography' were the four process colour powders that you put into the laser printing machine: yellow, magenta, blue and black. I was struck by the strong quality of the colour and people realized it was a different way of doing colour photography, a way which is, in fact, not photography at all in the original sense.

I then put the camera down and went to Alaska with Henry Geldzahler. I didn't take a camera at all; I thought I ought to do a little bit of drawing. However, when I got on the ship I realized it was foolish to be surrounded by icebergs and amazing scenery and not have a camera, so I bought a very cheap one on the boat, the kind where all you can do is look through and press the button, with only two choices, framing and timing. I took what Henry regarded as some of my best photographs

262 Spectators in Alaska, June 1990

This photograph was taken on a trip to Alaska with Henry Geldzahler. It was nine o'clock at night, but because we were so far north it was still light. The umbrellas seemed to me like 19th-century ladies dressed in crinolines. In fact, the whole scene had a 19th-century feel to it – it reminded me of one of those pictures of tourists reverently viewing Nature.

on that ship. We had them processed on the spot. Henry took the rolls in and the Austrian boy who did the developing – he was a photographer – kept saying to Henry, What very good photographs your friend has taken – especially when he realized what camera I had used. One evening, Henry and I were in the dining room, and I looked out the window and saw that we were sailing past massive walls of ice, about 200 foot high. We went up on the deck and although it was about nine o'clock it was still light because we were so far north. I was amused by the shapes of the umbrellas on the deck that seemed to be ladies in crinolines, like nineteenth-century tourists looking at awesome Nature. It was a great photographic idea in the nineteenth century: small people standing looking down into the Grand Canyon, the Yosemite. It had that nineteenth-century feel. I remember standing on the deck, and a lady began to walk across it. I waited until she was right in the middle to press the button. It looks at first glance like a nineteenth-century picture of tourists who have just gone to view Nature at its most awe-inspiring, and are standing on a platform, looking straight into the glacier.

With the $2,000 camera, all I'd taken were those pictures of the house; I wasn't using it much. I started to do portraits with it. I had begun to paint *Pacific Coast Highway and Santa Monica* (1990) and this appears in the background of several of the portraits I did with that camera. When *Pacific Coast Highway* went off to an exhibition, I realized I wanted to go on with these portraits, so I painted another painting just to use as background, matching it. I realized that having a common background set up a kind of *gestalt* that made a link. The portraits are of various people, done over a period of about two or three months. Anybody who came to my house or to the studio was photographed – workmen, delivery boys, anybody.

219

263–296

263–296 From *112 L.A. Visitors*, 1990–91

This page

Top row, left to right: Mark Berger; Mary Thompson; Michael Brown; Betty Asher; Ruth Fine; Johanna Neurath; Gregory Evans; Richard Wofford

Bottom row: Michael Roberts; Asti Clarke; Rose Tarlow; David Christian; Dennis Hopper; Geordie Greg; Maryte Kavaliauskas; Joan Quinn

Opposite page

Top row, left to right: Karen Kuhlman; Jason; Alfred Young; Jungeum Lim; Armistead Maupin; Peter and Oliver Goulds; David Morales, Jr; Tony Bennett

Bottom row: Roger Fenby; Kimberly Davis; Ken Tyler; Ardis Krainik; Paul Hockney; Jimmy Swinea; Colin Ford; Jack Hardy I

Elsa Duarte

The pictures shown here, of visitors to my studio, were taken with my new video stills camera, which uses no film. The pictures are stored digitally and can be fed into a video player and TV. In fact, I feed the digital information straight into my computer, which is connected to a Canon colour laser copier CLC500.

These pictures all come straight out of the xerox machine. The photocopier spits out lots of A4 bits of paper which I then stick together.

I took the pictures by moving down the figure; each one is composed of five segments, which has the effect of bringing the full-length figure close to the viewer.

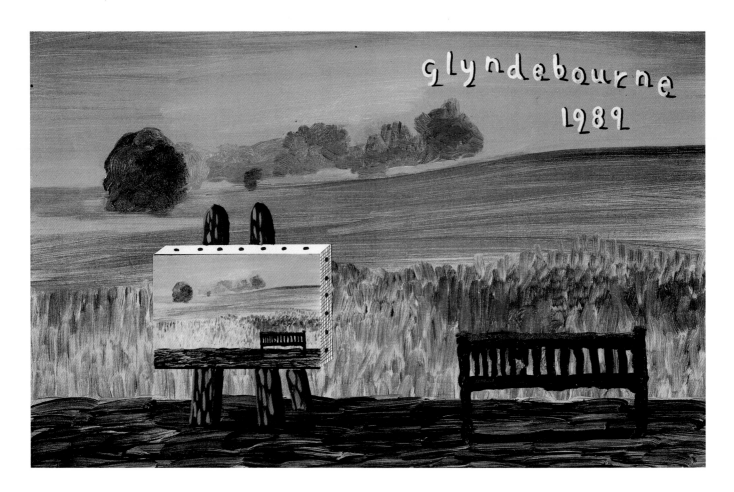

glyndebourne 1989

297 Cover and Back Cover of 1989
Glyndebourne Festival Opera
Programme

When the Glyndebourne Opera
Company revived *The Rake's Progress*
in 1989, they asked me to design the
programme. I used the laser copier for
this. After I had done the paintings I
made reproductions, which I then drew
on. The Glyndebourne people
reproduced by laser from the xerox
sheet; so the whole thing was done
without photography, which pleased
me.

In 1989 I had been asked to do a cover for the Glyndebourne programme –
they were reviving *The Rake's Progress* – and had decided to use the laser copier.
First I made little paintings from memory of Glyndebourne, the hills and seats in
the grounds, just to show the greenery of Sussex. Then I put one of these on to the
copying machine and made reproductions and then I drew on the reproductions,
Glyndebourne 1989. The drawing was done on the top with shadows on, so you had
two heavy illusions. One was that the painting seemed to be right there on the card
and the other that there was something on top of it, breaking into it. Technical
people and designers were curious to know how it was done. For the programme,
they reproduced from the xerox sheet. We sent the xerox sheet and they put it on
their cylinder, because they printed by laser. They made it direct from that sheet –
they did not photograph it. The whole cover, therefore, was done without
photography even though it was based on a painting. I was keen on that, making a
reproduction without photography, and I think the Glyndebourne programme
cover was the best I'd done in that way.

I then bought a Macintosh computer and made drawings on the screen which I
then printed out. The most complicated of these – *Beach House Inside* – took about
nine hours to draw because the reds kept merging together. Drawing on the screen,

300

it looked as though I had many ranges of browns and reds, but it didn't print that way. When I took the printed page and put it next to the screen I realized that I had to be bolder in the contrasts on the screen. Eventually I worked out how I could use the different range. To control it, you need to be constantly printing, you need to look at a proof all the time. I became aware that what the computer was really doing was letting you draw in a printing machine. That's the way I began to see it. Because the computer drawing on the video screen – what is it? It exists only on that piece of glass. It is ephemeral. It needs to be on a piece of paper to be a picture.

I felt I was beginning to know the machine and I was intrigued by being able to draw directly into a printing machine. It raised fascinating issues: What *are* these pictures? These are the originals that come out. They are not, in that sense, reproductions. Eventually, in 1991, I made the poster for *Turandot* entirely on the computer. The disk was sent to Chicago and they sent back proofs saying, This is what the disk produces, but you can have a choice: the disk will produce this red with this adjustment or that red with that adjustment. I made the choices and sent the disk back and that was how the poster was produced, as an original, not as a conventional reproduction of a gouache. The printers were interested too, because, though it cost them a bit more to print, they realized it was something new for them. All they had to work from was the disk with digits, no pre-existing picture to match. I found that aspect exciting because in this work printing and painting seemed at certain moments to be really coming together.

305

298 Untitled, 1991

I created this image on an Apple Mac II FX computer using Oasis software. What really excites me about such a process is that none of the conventional intervening processes of reproduction have been used: this very picture is an 'original'. Before this book was printed you could only look at this image on a computer screen and what you are looking at now is a 99.9 percent accurate reproduction of my 'drawing' on the screen. The printing plates were made directly from my computer disk. The disk contained all the information needed in order for the printer's colour scanning and plate-making machines to print any colour, line, texture and tone that I had specified.

299 *Walking Plant*, 1991

300 *Beach House Inside, 1991*

The interior of the beach house was the
most complicated drawing that I made
on the Macintosh computer. The reds
kept merging together, and though it
looked on screen, when I was drawing
it, as if I had many ranges of browns
and reds, it didn't print out like that –
the contrasts needed to be bolder. It
took me nine hours to get it right.

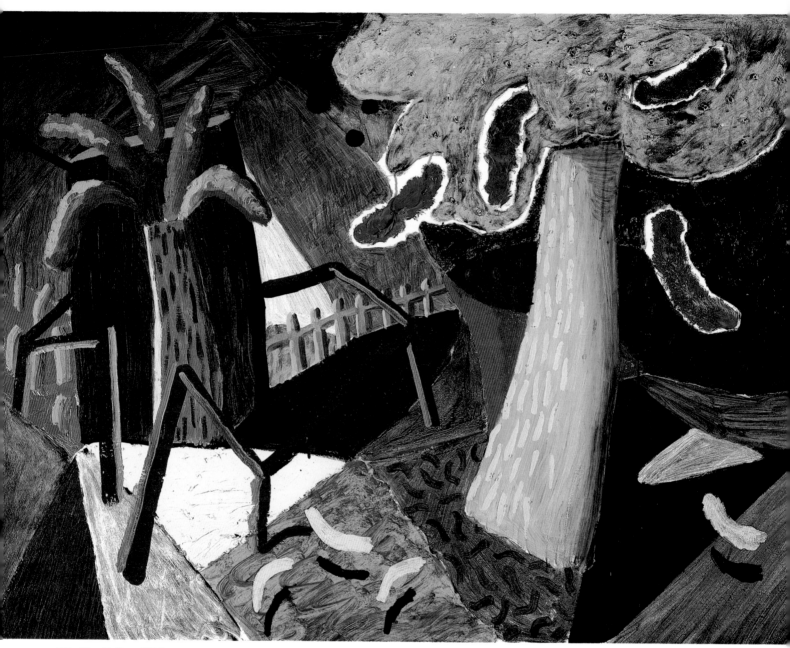

301 *The Railing*, 1990

It is clear from *The Railing* that the
faxes were influencing my paintings.
The different textures produced by the
fax machine were having an effect.

At the same time I was painting. The effect of the faxes was now being felt, I think, in the paintings. *The Railing* (1990) can be related to the fax drawings. I looked at the motifs, the different *textures* that the fax machine produced. I exhibited these paintings in New York in December 1990.

301

For *Turandot* we made the models on a bigger scale – 1½ inches to the foot. With my new system of blinds in the studio, it was dark enough for me to work on lighting the models during the day.

MORE STAGE PAINTING

I had begun work on *Turandot* in September 1990 and we finished it by March 1991. They then made the sets and we lit it in Chicago in July 1991. We made the model for the sets bigger this time – one and a half inches to the foot – because we felt our lighting scale was better for the bigger model. I now had a system of blinds in the studio so we could work during the day in the dark. Richard Schmidt, Ian Falconer and I mainly worked on it. Ian and I designed it together because, for one thing, there are two hundred costumes in *Turandot* and I wanted him to do them.

John Cox, the Production Director of the Royal Opera, Covent Garden, had actually asked me earlier, in 1988, to work with him on *Die Frau ohne Schatten* and I had said I was very interested, it was an opera I'd love to do with him. It is meant to be very grand and exciting theatre, as well as visually challenging. I had seen two or three productions, loved the music, hated most of the productions themselves, though, kitsch things where you never knew what was going on. One production I had seen in San Francisco looked as if it were made with silver foil from cigarette packets. John asked me to do *Die Frau* because we had worked together on *The Magic Flute*. He knew it would have to be a visual extravaganza, because the opera demands it. I began listening to the music again.

The San Francisco Opera had taken both productions that had originated in Glyndebourne and then gone to La Scala, Milan: *The Rake's Progress* and *The Magic Flute*. They had bought those sets and produced those operas in San Francisco and I had helped. So I felt a sense of loyalty. They then said they would love to have an original work made for them and suggested *Turandot*. Then it turned out it would be a joint production with the Lyric Opera of Chicago, opening in Chicago. *Turandot* was the only Puccini opera I would do because it is not *verismo*, there is some fantasy in it, it takes place in mythical China. I had seen many productions, most of them kitsch beyond belief, overdone chinoiserie and too many dragons. In fact, I had previously been asked to do *Turandot* for Covent Garden, in 1984, but I had refused because I had just finished the two triple bills for the Metropolitan and was heavily involved in the photography. When the San Francisco Opera asked me, I thought, I've never done an Italian opera – I'd done eight other operas by then – but I would not do it alone because it is an enormous job. Ian Falconer, Richard Schmidt and I got to work, with Richard, again, setting up the model and doing all the technical work with the lights while aesthetic

302 Production model, Act III, scene i, *Turandot*, 1991

303 Working in my Los Angeles studio on the 1½″ scale model of Act III, scene ii, *Turandot*, Autumn 1990

304 Production model, Act III, scene ii, *Turandot*, 1991

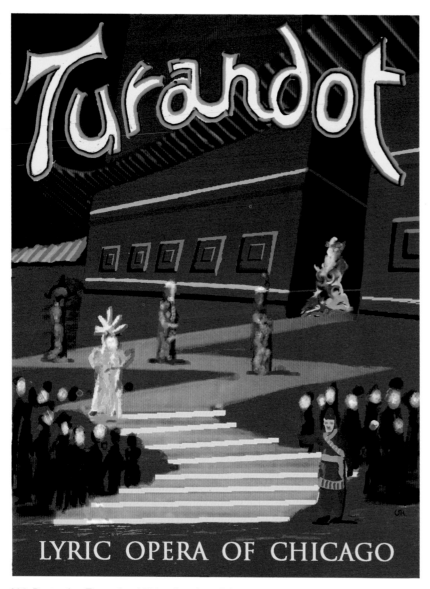

I was attracted to *Turandot* because I love Puccini and I had not done an Italian opera before. I knew it had to be visually extravagant, very grand, very exciting.

When I designed the sets, I was inspired by the Chinese red I had seen on my travels in China in 1981. And I wanted to avoid the 19th-century Chinese look and concentrate instead on the harshness of China – harsh edges, strong diagonals. We started with red walls, and then dressed the chorus in black, to stand out against them. The costumes were boldly abstract, rather than elaborate.

The poster for *Turandot* was done entirely on the computer. I sent the disk to Chicago and they sent back proofs, indicating what the colour possibilities were. I chose what I wanted and that was how the poster was produced – it's an original, not a reproduction of a gouache. The printer had no pre-existing picture to match.

306–308 Production models, Act I, *Turandot*, 1990

The three photographs *below* and *opposite* all show the same model and demonstrate the power of lighting. The model *below* is lit only by a photographic flash, the two *opposite* by the mini lighting rig just visible at the top of the pictures.

305 Poster for *Turandot*, 1991, printed straight from the computer disk

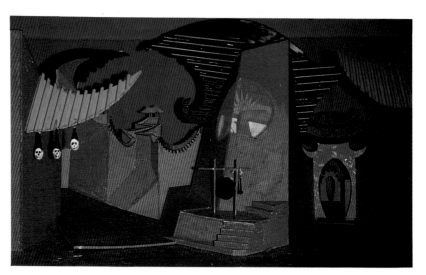

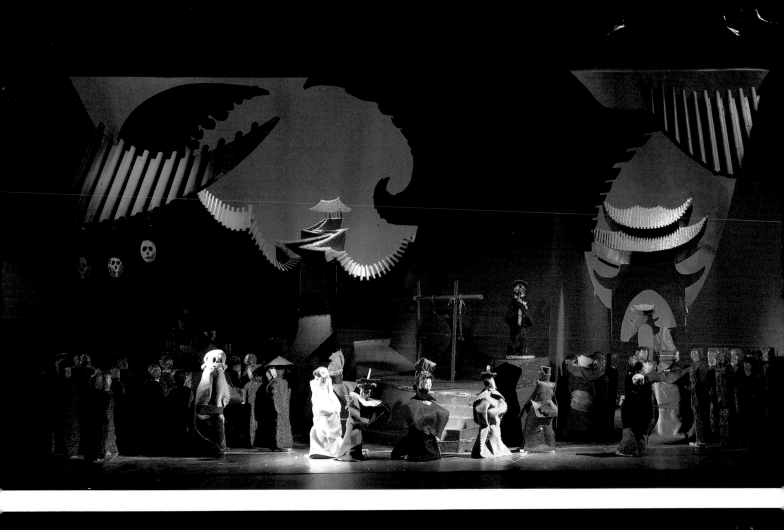
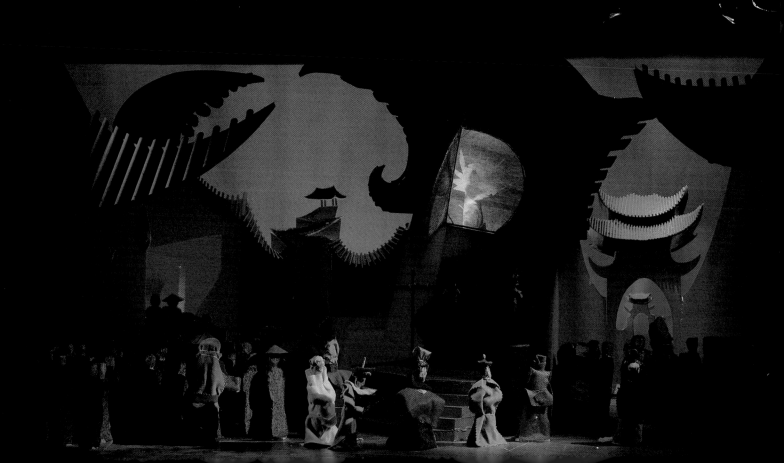

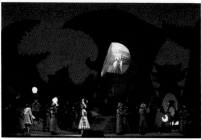

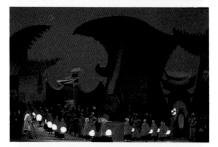

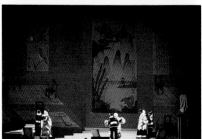

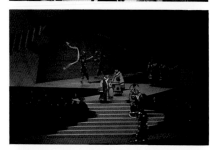

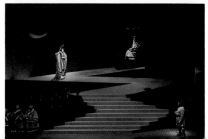

decisions were made by Ian and myself. Straight away I chose the colours, which are predominantly red – the colour of the walls of the Forbidden City in Peking. I also specifically said that we wanted to do away with the excessive nineteenth-century Chinese look, the Victorian look, and use the drama and the music and make forms. It was clear to me – in the first scene in Peking – that *Turandot* was about cruel China, about harsh, sharp edges, axes, not about soft things, certainly not the China of *Le Rossignol*. That was my main theme at the beginning, as well as the red walls. So we began to make harsh edges, strong diagonals, using mad perspectives. We made little models first, just as notes, and then carefully made the big models. For the first scene, the city of Peking, I suggested that we take the dragons away and put them into the roofs, in forms that felt like dragons, without specifically looking like them, thus evoking the grotesqueness of the city.

We used lighting right from the start, keeping in mind how the costumes should look, since Chinese costumes are elaborate. We still didn't know who was going to direct it. San Francisco opera just kept saying, We're keen, we want a show from *you*. But I said I wasn't sure I could direct it as well. In the end, Lotfi Mansouri was asked to direct, but when he realized what we were doing, he decided not to. So the Chicago company replaced him with Bill Farlow. *Turandot* is an opera with a large chorus on the stage for a lot of the time and you have to take into account how they come on, get off and how other characters play against them. We worked it out slowly: when we got the red walls, I suggested that the chorus, the people of Peking, the *popolo*, should be dressed in black against them. Even though the costumes were not in the end elaborate – they were bold abstractions of Chinese costumes – they were marvellous. Ian did a superb job and of course we found marvellous reference books covering 2,000 years of Chinese costume – a very rich area to explore.

Turandot was performed in Chicago in January 1992. We had finished the designs in about March 1991 and the sets and costumes were made in the San Francisco workshops. We kept going to see them, to check on their progress.

In March/April 1991 I began to paint a group of pictures which, in a way, anticipated *Die Frau ohne Schatten*. They were paintings that looked like abstractions, but are concerned with space as subject matter. But at the end of July I had to stop because we had to go to Chicago for a week to light *Turandot*. Myself, Richard Schmidt, and two other friends, Bing McGilvray and John Fitzherbert, drove to Chicago in a recreational vehicle, what in America they call an RV, in which one can sleep, cook, shit and shower. But as I didn't totally trust it, we took the Lexus car as well. Ian Falconer met us in Chicago, because the journey was going to take a week to get there and a week to get back. We drove through the most spectacular parts of the West. Driving, I made sure that I knew where to be when the sun would be behind us, and we planned out the journey quite carefully.

309–315 Scenes from *Turandot*, Lyric Opera of Chicago, 1991–92

316 *Two Small Caverns*, 1991

We took the dogs, John cooked, we never ate in restaurants, we did stay in motels sometimes, we didn't always bother with sleeping in the RV. We had to find Holiday Inns because they allow dogs. The cheaper the motel, usually, the more likely they'd be to have signs saying 'No pets'. From Denver to Chicago it is not as interesting. You drive on a great plain through Nebraska and Iowa and into Illinois, 600 miles of rather flat wheatland, a bit monotonous. Nevertheless, we had a lot of fun driving there. In Chicago we stayed at the grandest hotel because they would take dogs. We were probably the only people who ever arrived in an RV at the front door of that hotel. They were rather amused and loved the dogs. They knew we were coming for the opera; it was the hotel George Solti used to live in when he ran the Chicago Symphony. They have special rooms for guests with dogs, where it doesn't matter if they pee on the floor. We spent every day of the week lighting *Turandot* with a wonderful lighting guy named Duane Schuler, who was very excited by what we had done. He had come through LA a few times, seen our lightboard and seen how to synchronize the lighting with the music. We had worked out a glorious ending, as though you were in a heart. In fact, we thought everything would work very well, however it was directed. It fit the music and was visually exciting together with the music. And we had solved problems that we thought had dominated *Turandot* before.

MOSES SPEAKS IN MONUMENT VALLEY

We then began the drive back to LA. The RV broke down at one point and we did have a bit of a row, crowded as we were, four people sleeping in a tiny room. It broke down just past the continental divide in Colorado, on a marvellous Sunday

afternoon in August. It was absolutely beautiful; you couldn't have broken down in a more spectacular place. We were videoing our journey; we had used video on *Turandot*, with the music, and had made little video versions of it. When the RV broke down and we started rowing, I told Bing to keep the cameras going. Richard, who was the most mechanical of the four of us, had to try and get under the RV to see what had happened. In the end, we had to call the mechanic but even he couldn't deal with it and suggested we leave it there, drive to the next town in the Lexus car, about 60 miles, and have the RV towed in the following day. So we drove into the next town, arriving at about six on a lovely evening.

Next morning, Richard got a tow-truck to tow the RV 60 miles. I wanted to go with him and film it from the car, because we'd been filming the RV going along, and I thought it would be terrific to show it being towed through a spectacular landscape. But Richard just went off on his own, he was so mad, and I was a bit furious that we'd missed putting this on film. It cost $300 to have it towed, and I thought, I don't mind paying the $300 if we can have it on film. I realized that's the artist in me: use it, don't see it as a disaster, just put it on a video; we'll laugh at it then, this marvellous picture of a tow-truck and this big clumsy thing being drawn up the Rocky Mountains. Anyway, we missed it and I was a bit annoyed. Finally, when we were leaving this place in Colorado, Richard said, We're fed up now, it's getting just a bit too much; we should go straight back to LA on the Interstate freeway because if it breaks down again we can always deal with it there. I looked on the map and said, But that's a long way round. What I'd really planned to do was go on these back roads to Monument Valley and the Grand Canyon. So I said to Richard, You drive the Lexus, I'll drive the RV; you go back to LA and we'll go to Monument Valley. I want to see Monument Valley, we want to see the Grand Canyon, we're going to risk it – if we break down, we'll manage, don't worry. And Richard said, All right, I'll follow. That day was one of the most spectacular drives we had. We went on back roads with nothing in front of us, through marvellous gorges, stopped by a lake, ate a lunch, just us, took a swim.

We arrived at Monument Valley just as the sun was going down. It was dark, the two tacky motels there were full, so the four of us had to sleep in the RV. I was determined to see the dawn happen in Monument Valley. But because we'd had the row, I thought I'd better get up and drive out to see it on my own. Bing woke up and asked me where I was going. I said, I'm going to see the dawn, but I daredn't wake the others, they're so annoyed with me. So Bing came with me and we saw the most spectacular dawn I have ever seen in my life. We got quite a bit of it on video. It was the kind of dawn David Lean would have waited six months to film. We drove into the middle of the valley and, even in the dark, we realized there were other people there; they were Swedes and Danes – Europeans. They had also come to watch. As the dawn broke on the eastern sky, on the western sky you saw a great

Left. Monument Valley; the storm breaking as the sun rose

storm, heavy grey clouds moving towards us; as it got lighter you could see it moving. We then drove about as the sun rose and as it rose it hit first the tops of what are the great monuments. It looked like gold, while behind us the storm was coming forward with lightning flashing. And then, as the sun was coming up, appeared a perfect rainbow, with lightning flashing in the middle. What with that, and the sun hitting the tops of the monuments, it was like Moses coming to speak. It was one of the most thrilling, dramatic pieces of nature I had ever stood in. Then we drove to the Grand Canyon, which was crowded in a way that Monument Valley had not been, its southern rim full of people. It's beautiful, anyway, to sit and look at. We left the Grand Canyon at sunset and drove back, a ten-hour drive more or less through the desert, reaching Los Angeles at two or three in the morning.

On my return I started painting intensively. Richard had gone on holiday and I was on my own. When he came back after two or three weeks, he looked at the paintings, looked at the space in them, and saw what the trip had done. In *Iowa Again*, 1991 (which refers to my 1964 painting, *Iowa*), the wood surface at the bottom side on the left might suggest the table in the RV and there are references to windows, corn growing, fields. Richard realized that the space in these pictures had been greatly affected by the trip.

317 *Richard*, 1988

PAINTING NEW SPACES AND THE STAGE

In September I had to stop painting again because between October and December we had to start on *Die Frau ohne Schatten* and then go back to Chicago for all of January to do the staging of *Turandot*. John Cox was with us a great deal, and we blocked in most of the first two acts of *Die Frau* quite well, but it was not until we got back at the end of January 1992 that I began on the last act.

The paintings I had made off and on since March/April and after our drive to Chicago and back were up on the wall in my studio. These were some of the paintings that were shown in Chicago, January through February 1992, at the Richard Gray Gallery. They were around the room as we began *Die Frau* and I realized that *What About the Caves?* was the most complex. Dick Gray had always wanted to do an exhibition so I offered him the recent paintings to exhibit in January, when *Turandot* was on. However, the paintings didn't leave until November so I had them around me while working on *Die Frau*.

Four of us worked on *Die Frau*: Richard Schmidt worked as my technical assistant, making the models with me in the studio; Gregory Evans worked more creatively with me and Ian Falconer was responsible for making the costumes. The first thing I made for *Die Frau*, on a small model, was an abstract representation of a river, like a snake. I put little dots on it which were actually derived from the textures that were appearing in these paintings. *Turandot* is mostly architectural,

318

321

I had these paintings around me on the walls of my studio while I was working on *Die Frau ohne Schatten*. *What About the Caves?* was the most complex, but they all helped me to work out my ideas for *Die Frau* and I found that the textures in these paintings were entering the opera models.

318 *Iowa Again*, 1991

319 *Spring Spirit*, 1991

320 *Light and Dark Getting Together*, 1991

321 *What About the Caves?*, 1991

322 Model, 1½″ scale, for the Dyer's house ('Barak's Hovel'), *Die Frau ohne Schatten*, 1992

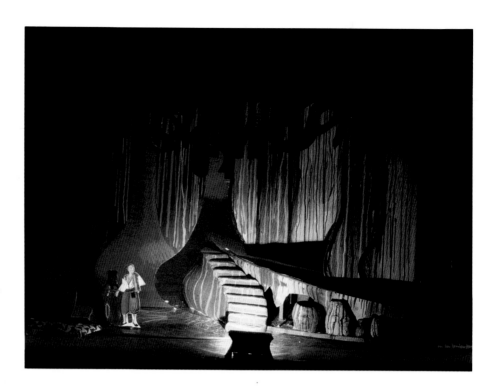

In the collage *opposite*, I was working out how I could make the colour run for the Dyer's house in the first scene of *Die Frau ohne Schatten* (*right*). I wanted to suggest that in the earthly – as opposed to the spiritual – world, gravity was at work – everything was coming downwards.

323 'Emperor', costume design by Ian Falconer for *Die Frau ohne Schatten*, 1992

interiors; even the garden, which is nearest to nature, is a Chinese garden, stylized, formal, not raw nature. In *Die Frau*, on the other hand, we are dealing with nature in the wild – landscapes, forests, etc. – and I knew these paintings were going to influence its design.

I began working with cardboard again, or Styrofoam. I then made some collages. In *Running Construction* I was testing how to make the colours run for the Dyer's house in the opera and what happens when you do that; gravity made these marks. The first scene, a rooftop and landscape in the spirit world, has to change into a hovel where the Dyer lives. It then occurred to me that the Dyer, a user of colour, would have colour running down the walls and this could also suggest that here, on earth, gravity was at work, whereas in the first scene there is no hint of gravity. In the spirit world everything is going upwards while in the Dyer's house everything is coming downwards. Not many commentators noticed that, but it doesn't matter whether you specifically notice it; you feel it; I think the audience felt it. All of this was coming together out of painting that was exciting me. It took about seven months working on *Die Frau*. John Cox came back in February 1992 and we planned the last act. The idea of the golden river at the end came quite quickly. We worked out how you could have the golden river running through a beautiful landscape, just as Strauss suggested, and finished it all by about the end of April. Then everything was sent off to London, where the sets were being made and painted. Ian Falconer had made the costumes, but we had worked together, discussing the characters, what colour should be played against what, and so on.

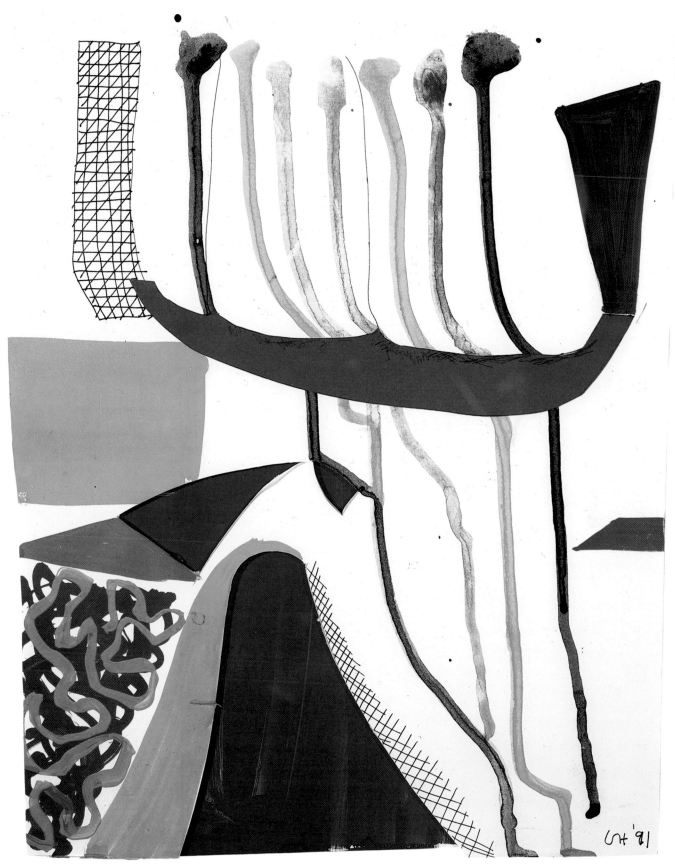

324 *Running Construction*, 1991

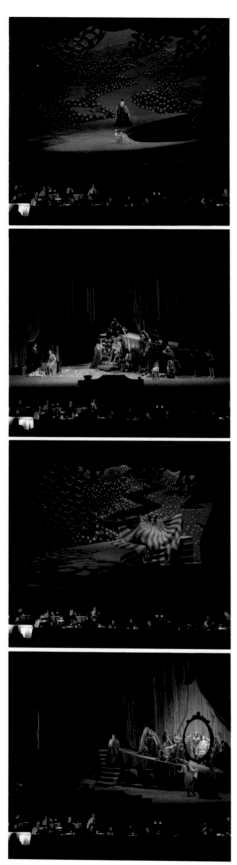

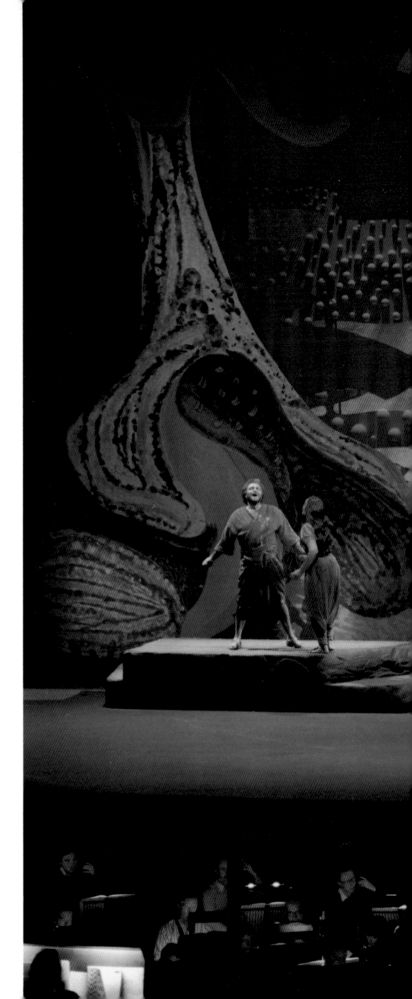

325–329 Production shots from
Die Frau ohne Schatten, Royal
Opera House, Covent Garden,
1992

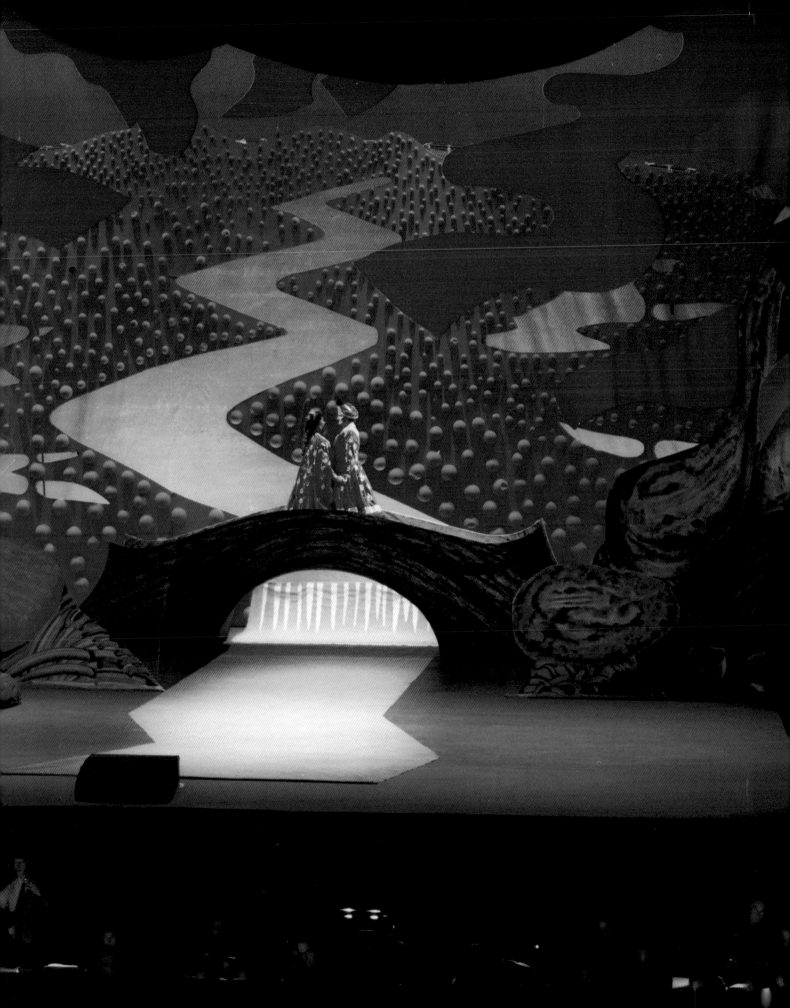

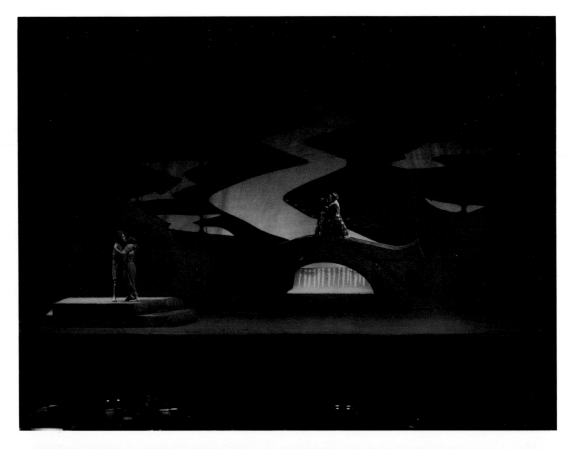

WANDERER THROUGH INTERNAL LANDSCAPES:
A NEW ORDER

I had been working for over two years on operas. My big studio in the hills had that giant model up for two years, taking up a lot of space. The moment we finished the design for *Die Frau*, I told Richard to take the model down, pack it up, and we stored it. At first I thought I'd like to work in the big studio, but I realized I wanted to be absolutely alone. In the theatre you are always working with people. Even in my studio, because of the scale of the models, I needed at least one assistant just to move things – though I would often synchronize the music and the lights on my own. So, the moment the designs had gone off to London, in April, I retreated to Malibu and started painting in my small studio down there in early May. I didn't want anybody around.

I started painting rather quickly. The largest of these paintings are 3 × 4 feet (36 × 48 in., or 91 × 122 cm). The first one, which is untitled, was begun before *Turandot*; it was on the wall during our work on that opera, behind the model, and it is still in my studio. In the end, I didn't want to exhibit it with the new paintings I did in 1992 because I felt that although it was their originator, it was not as dense. In the group called 'Some Very New Paintings' (pp.230–35), I used colours that were more luminous than those I had used in 1991. I experimented, mixed up media myself, stand oil, turpentine, so I could put washes, glazes of colour that make the paintings vibrate: when you are using the white of the canvas with washes, you get a vibration, stronger colour effects. I had started making drawings on pads. When we had paper cut for the printing machines – we had special paper cut – I had all the bits that were left over made up into pads and I kept them by telephones and sometimes, when talking to people, I'd start drawing on them. I realized that the small scale of the paper gave me greater freedom to invent with shapes, that the first painting was too big. So I went to much smaller canvases and I drew with the brush. In a show at the Nishimura Gallery in Tokyo (June 12–July 11, 1992) they showed paintings I had not included in the Chicago show and we added the gouaches like *The Central Rock*, *Stately Edge* and *Running Construction* (p.225) that they loved in Japan. They also showed *Where Now?*, which I didn't want to sell because I thought something new was starting in it.

I was painting in the small room in Malibu and I think at first I was making flowing movements. Down there one is living unbelievably close to the sea, it comes right up to the living-room window, to the kitchen door. When you walk out of the kitchen door, there is a beach and the sea. What is interesting, what seems to dominate, is not the horizon, which is often the dominant thing if you live near the sea, but the *edge* of the sea, which is alive, forever moving. Living there, you begin to feel a bit different. You are in a little intimate house with the infinite outside, the Pacific Ocean, the world's largest ocean. And its rhythms affect you. I

332 *Stately Edge*, 1991

330, 331 *Opposite:* Production shots from *Die Frau ohne Schatten*, Royal Opera House, Covent Garden, 1992

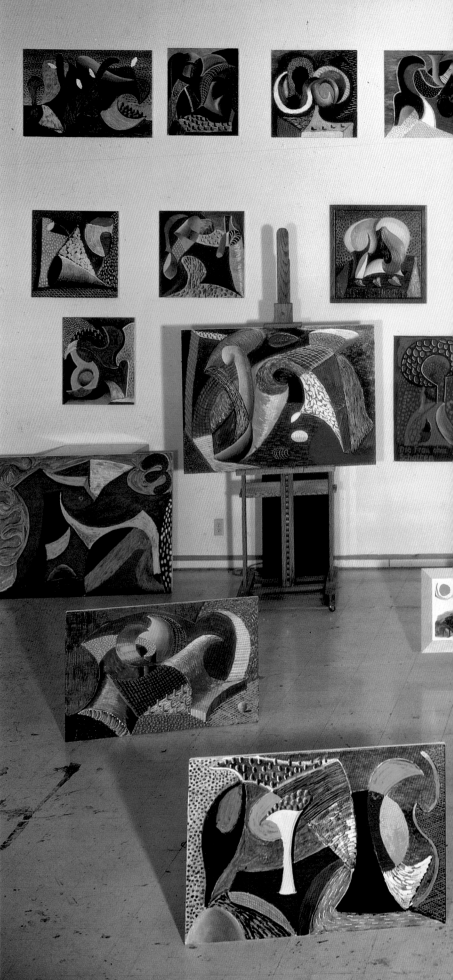

334 In the Los Angeles studio, with 'Some Very New Paintings', October 1992

I was aware that *Where Now?* (*below*) was the beginning of something new and in fact it proved to be a progression towards 'Some Very New Paintings'. These started simply and grew more and more complex. I soon realized that what I was doing was making internal landscapes, using different marks and textures to create space, so that the viewer wanders around.

333 *Where Now?*, 1992

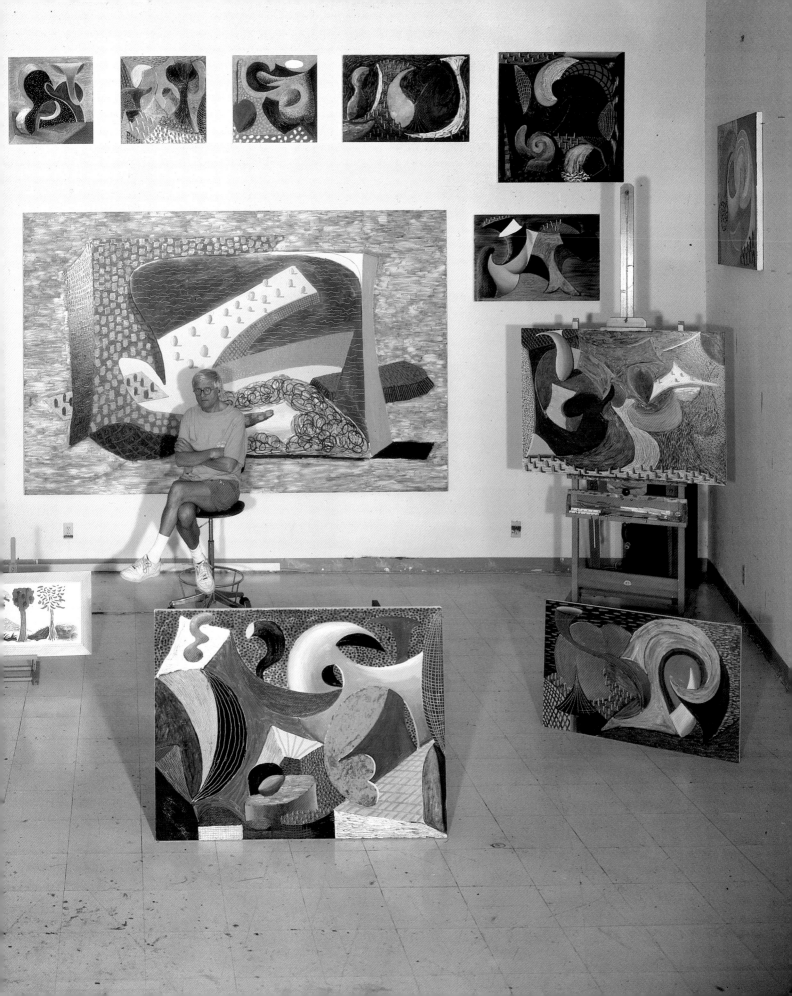

335 *The Thirteenth V.N. Painting*, 1992

336 *Right:The Fourth V.N. Painting*,
1992

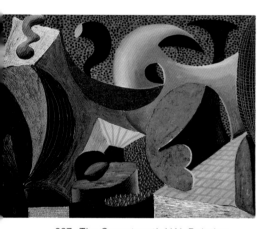

337 *The Seventeenth V.N. Painting*,
1992

336

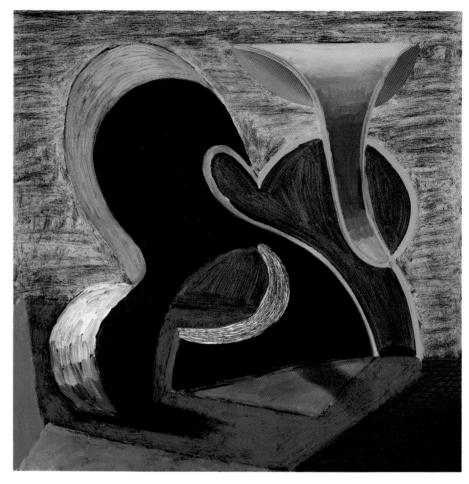

buy tide tables, I learn about the tides, their comings and goings, and it is forever changing, the beach itself, the amount of sand on it. I sit and paint in a little room with my back to the sea, the light is on the window, my back is to what must be a very nice view from anybody's studio. It is probably one of the smallest rooms I have painted in. A painting 3 × 4 feet seems rather large in scale in that small space.

The paintings began to develop themselves. I started using systems of glazes, sometimes working wet on wet, at other times waiting for a colour to dry tacky and then putting other colours on top, or scraping through to get effects. Often, a lot of black was put on first. The pictures in the Richard Gray Gallery in Chicago probably had more black than those in any exhibition I had ever had. The paintings were getting darker, but then got lighter again.

I began to see that I was making internal landscapes. When I had done *The Fourth V.N. Painting*, I called it 'Mother and Child'. The little figure – the blue could be read as positive – with the little hand, the mother's dress suggesting a taller figure, a little hat. I recognized there was a tenderness in the shapes. But all this was after I had painted it and I did not give it that title finally because I thought, Let the viewer do that. This was the first time in a long while that I had not used titles. I

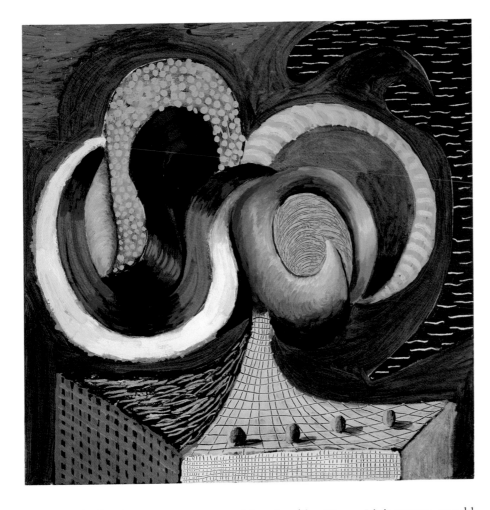

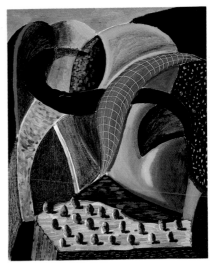

339 *The Fourteenth V.N. Painting,* 1992

338 *Left: The Fifteenth V.N. Painting,*
1992

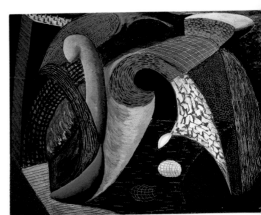

340 *The Sixteenth V.N. Painting,* 1992

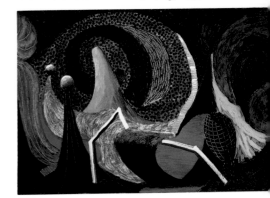

have no doubt that someone, an art historian like Marco Livingstone, would recognize that the group of pictures 'Some Very New Paintings' is almost like doing the same as in 'Demonstrations of Versatility', the title I gave to the group of four pictures exhibited at the 'Young Contemporaries' student show in 1962.

The paintings grew more and more complex and I was sometimes working on two or three at the same time, waiting for a particular colour to dry. By the time I had done about eight, I was beginning to enjoy the little studio where I painted very much. I did these paintings for myself and as I put them up they seemed to grow from one to another. Gregory came down at that time and he thought there were sexual allusions in them. He said, I love this room, sitting in it, and I said, Well, I do too; I come up here at night, sit in here and I love it for an hour.

In June I went to England to see my mother, but was so excited by what I had been doing that I painted three pictures in Bridlington: the *Twelfth, Thirteenth* and *Fourteenth V. N. Paintings.* When I got back to Malibu I carried on painting immediately – I'd left some pictures unfinished, *Sixteenth* and *Seventeenth* were begun before I went away. I went on painting until I had to stop.

335

339

340,337

341 *The Twenty-fourth V.N. Painting,* 1992

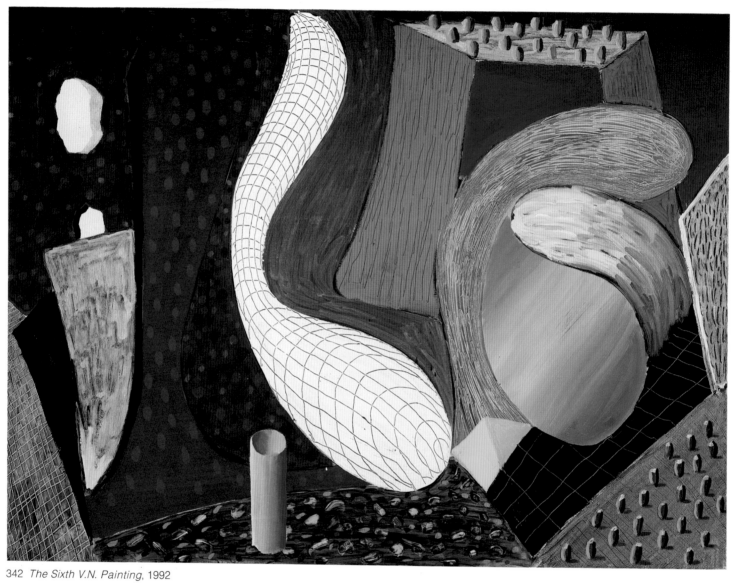

342 *The Sixth V.N. Painting,* 1992

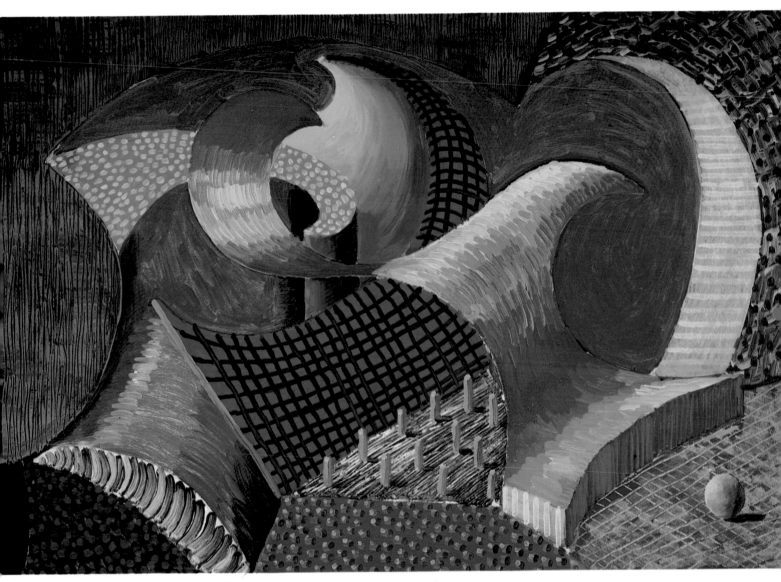

343 *The Eleventh V.N. Painting,* 1992

I had another break in August, when I had to go to London for a few days to attend to some technical problems on *Die Frau*. They were planning their leaflet for it, and I asked them what they normally did. They said they just reproduced paintings, meaning an eighteenth-century painting. And I said, Why not put a new painting in it? So we used some of my paintings that I thought were suggestive of transformations, changes, suggestive of the opera. The music of *Die Frau ohne Schatten* had quite an effect on me; it is just ravishingly beautiful. Some of my friends could not hear it at first, but the moment I started making images, they said they could hear it better. The opera was at the back of my mind when I was doing these paintings, even though it had not been staged yet.

People said that the new paintings had a three-dimensional look. I feel that is true, in the sense that they have two spatial dimensions – vertical and horizontal – and that the third dimension is of course time, the time you give a picture when you look at it and it pulls you in and moves you round and you therefore become aware of taking time. Time does become another dimension and, again, that has to do with the awareness of the surface: only when you *see* the surface can you then play around with it, but you have to see *everything* on the surface, the marks clearly made on it. Then it is quite easy to see what the paint is doing, that it is doing different things, put on in different ways. I have also used linear perspective and played textural perspective games because perspective can be achieved by texture. I tried to do the same with the river in *Die Frau*, using a texture to make a space, to make it look as if it's going a long way back.

Doing all this, a new kind of geometry seemed to me to be emerging in these paintings. At the back of my mind, I also probably had ideas which had recurred to me from the books I had been reading, about fractals and chaos theory, which interested me and appealed to me because according to the theories put forward, if things go towards apparent chaos, beyond that emerges a new order. I am not saying that in doing these paintings I was deliberately trying to illustrate the theories, but that my fascination in them perhaps influenced what I did.

For whatever reason, accepted yet questionable notions of order appeal to me. People often think I am untidy, chaotic, but it doesn't look that way to me, it looks ordered. Maybe I see order where others don't. I said that once to Colin Ford who runs the Photography Museum in Bradford. He was in LA when I was doing the

263–296

video stills portraits; he had come to California to arrange a show of them in Bradford. While he was there, I kept talking to him about the philosophical aspects of photography. He later wrote an essay about the photograph beginning to lose its veracity, something about which I had been talking to him for quite a few years. To me, as I've said before, this is one of the major developments about the implications of perception and not many people are thinking about it at all, because not many people think about pictures. You have to be a maker of pictures to think about

them. Generally, photographers think their perspective is built into the camera, so they don't think about it. I said to Colin Ford that I thought some people can see order where there appears to be none, and, to demonstrate this, I pointed at the table in front of us, which was covered with all kinds of stuff. I took one of the disks for the still video camera and without touching anything on the table, I took sixteen photographs to show order, because *I* could see it. And he was quite impressed. The pictures looked almost as though they had been set up as still lifes, yet nothing on the table had been moved. These pictures are about composition, of course, and edges. My joke used to be, when people said I was untidy, Well, I have a higher sense of order. I then began to think that we all see differently and maybe I can see order where others can't. That is why I am so interested in theories which propose

344–359 *16 Photographs to Show Order*, 1990

I'm often accused of being untidy and disordered. But I always say that I see order where others see chaos. I was discussing this once with Colin Ford, who runs the Photography Museum in Bradford. There was a table in front of us, full of bits and pieces, and, without touching or moving anything at all, I took sixteen photographs to prove to him that though it looked chaotic, I could see order in it. Composition and edges bring order to disorder.

that there is more order in what looks like disorder. For instance, we are discovering that what looks like a disorderly flow of water actually has its own order.

Fractal geometry excited me. I found books for the layman, without too many mathematical equations that would put you off. I don't know enough about mathematics, and yet it did fascinate me. I read that sometime in the nineteenth century, a big conference was held because mathematicians had discovered a flaw in arithmetic. I was delighted by this, as delighted as the little boy in the Ravel opera who shouts, 'Two and two is sixteen!' I thought, maybe it is. I read a kind of history of mathematics, by a mathematician, and it was almost poetic, an abstract, poetic way of looking at the world. These mathematicians were like poets, they were artists, in a way.

Nature is endlessly changing. The Pacific Coast Highway runs at the back of my little house in Malibu, it is a back alley, and the main road is the beach at the front, when the tide is out. That is where I walk. And behind, I look up and don't see the road, I see the beginnings of the Santa Monica Mountains, a whole range of mountains which are empty. So being in that house, in that little studio, I was constantly aware that on one side was nature in its awe-inspiring grandeur, its infinity, looking out at the sea, with its living edge, endlessly moving even when I sleep, endlessly moving for thousands and thousands of years. The mountains behind are not very high, perhaps 2,500 feet, but they are majestic. Some of them have great thrusts. You can see in them the violence of nature that at one time made that thrust and also the calm of nature, now that the thrust has ceased. And you look over the other hill and there is another endless thrust going on, the sea itself. So, living in that little spot, trapped as it were between the mountains and the edge of the water, I was very aware of nature both in its physical forms and in its invisible forces. I have no doubt this had a great effect on my painting and that it provided a new kind of narrative. Ken Tyler said that the new pictures were like abstract pictures with stories.

DEPICTION = ABSTRACTION

These paintings raise again for me the problem of depiction and abstraction, that these are not – cannot be – two different things. Looking at Chinese scrolls, at ancient Chinese paintings, had made me realize that if you were to ask the painters who made them, Are there two different kinds of painting, is there representation and abstraction?, the old Chinese sage painter would have said, No, it's all one; it's either all an abstraction or all representation. And I'm coming to believe that quite strongly, which is why, also, the photograph itself becomes a problem, because it too is of course an abstraction which we read as a record of reality, and a very real

one; and it is the same with television, with all photographic images. I was interested to notice that dogs don't see pictures. My two little dogs never look at the TV screen, even if they're on it in the videos I have made of them. I suppose that all they are seeing are lit up, flat shapes on a piece of glass, which is literally what the TV screen is; they don't read it as we do. However, I notice that in Malibu they sit and peer out at the sea's edge, they watch it, like I do. And you can watch it for a long time because it is always changing, like a fire. Fire and water are never-ending shapes, constantly changing, moving, and the dogs are as interested in that as we are.

What is it we are truly seeing in images? This whole nature of depiction itself, how real is it? And what does it mean to say there is no difference between depiction and abstraction? I read Frank Stella's Charles Eliot Norton lectures that he gave at Harvard in 1983–84, published under the title *Working Space* in 1986. I thought they were interesting but they had a flaw: he does not define what an abstract painting is, though he is making a plea for a narrative abstraction, in a sense. However, in his work since about 1960 and certainly since 1964, and with the most recent reliefs, he doesn't use the flat surface.

The flat surface is interesting to me because that too is a theory – two dimensions is only an idea, it doesn't exist in reality; even a piece of paper is three dimensional. So you realize you are dealing with this theory, this theoretical surface and what can happen on it. Can you make new spaces? We came out of the Renaissance with the invention of the vanishing point and perspective to make a space which, though highly illusionistic, seemed very real. But could this be developed, could it be made more complicated? That was really my question. Should not perspective be more complicated now? Should it not move to a more complicated form? The real painters pull and push in paint and that is why we can sit and look at their pictures for a long time; it is an enjoyable experience, the viewer is pulled into the activities of the paint, it is the viewer who activates the painting; once you look, you activate them.

In 'Some Very New Paintings' I think the viewer is moving in them, so to put a figure there did not seem right. In fact, depicted images or object-like things are included only to give a sense of scale; without those, the pictures would be something different. You may not be sure what those little things are, but they give an illusion and a scale so that the eye roams about, roams and mentally makes space. That gets me excited, because, as people keep telling me, That's what real space is, it is all made mentally. And I must admit I get carried away with these ideas, which surely imply that you can't have the material world without consciousness. So, the viewer roams around in these pictures and once the eye begins to look and see, it is forced to go on a journey and it can come back by a different route, or start somewhere else and make another one. I realized the forms were coming from my

335–343

surroundings, my feelings, and that they had sexual overtones because of my feelings at that time. It all seemed to connect, and I think it made the pictures quite intense and denser, at least to me.

EXPLORATIONS IN SPACE

I then had to break off painting to stage *Die Frau* in London. I didn't mind because I felt that what I was going to be doing was the same thing, only in the theatre, in three dimensions, in space, with characters, with music. Work in the theatre is ephemeral. I do models, but the models are nothing, the sets are nothing, without the music. Putting an opera on stage is not like putting on a Broadway or West End musical. In the theatre they have six weeks or more to stage a show, and once the set is put up it is never taken down. Opera is repertory theatre, one night it's one opera, the next another. You couldn't possibly do *Die Frau* six nights a week. For one thing, the singers couldn't sing it night after night; you'd have to have a different cast to keep doing it. Even for the orchestra it's a long piece, beginning at six and ending at eleven; you'd have to pay more. You get very little time to stage an opera, considering the enormous amount of time you have put into it beforehand. Consequently, you have to compromise, you have to be practical, you have to accept that this is live theatre involving many, many people, not just the musicians, but a vast number of technical people backstage. So you are not in total control. *Die Frau ohne Schatten* was the least time I was ever given to stage an opera and even by the dress rehearsal not everything was lit right. I watched every performance, which meant that I saw the whole thing only six times because the dress rehearsal is the first time you see the performance right through. Therefore, on each of the subsequent five nights, adjustments were made. The last performance was without doubt the best, the only one when all the cues were correct with the music. The singers, too, were at their best because it was being broadcast. I sat there and I don't think there was anybody in that theatre who enjoyed it more than I did. And then it was gone, disappeared. I felt a very deep satisfaction on that last night and I thought, it did work. And that is why I would do it again with another opera; it's worth it for that. It cost me a lot of money, but what does that matter? I did it, on one level, simply for my own pleasure and I got that pleasure in the theatre on that last performance. It was for that one performance that I had worked for about eight months with two collaborators, not to mention John Cox, Bernard Haitink, the singers and all the others who realized so miraculously what before was in my mind only.

Die Frau works on many levels and one of them is that it has to do essentially with creativity, on the level of making children, making ourselves, what we do. The ending with the river becoming the little tree of life, and sperm, seemed to me

perfect with the music. Whether other people thought that, frankly, I don't really care. It worked for me and it was marvellous fun doing it, despite the hard work.

Frank Auerbach was on TV once, being interviewed. He was talking about his way of painting, his struggling way of painting. And he was talking about it very sincerely, and then he looked up and said, I don't want to give the wrong impression, you know. It's hard work, but it's fun in the studio and any artist who tells you he's not having fun in the studio is a bit of a liar. And I thought, oh, yes, that's true; however hard it is, however much you struggle, you do enjoy it. I thought, coming from someone like Frank, who doesn't speak much, it was very touching, very impressive, and I thought, he's a full human being there. So now, once again, I want to be alone in my studio, to paint, to explore.

List of Illustrations and Photographic Acknowledgments

All works by David Hockney are © David Hockney

1 Untitled, 1987. Double spread from the last 24 pages designed for the 1988–89 Retrospective Catalogue, xerographic print, 11 × 17 (27.9 × 43.2). Collection: David Hockney

2 David Hockney's swimming pool, hand painted by him, 1987. Los Angeles, California

3 Celia in a Negligée, Paris, Nov. 1973, 1973, crayon on paper, 25½ × 19½ (64.8 × 49.5). Collection: David Hockney

4 Portrait of Claude Bernard, 1975, red conte crayon on paper, 25½ × 19½ (64.8 × 49.5). Collection: David Hockney

5 George Lawson and Wayne Sleep (unfinished), 1972–75 (detail), acrylic on canvas, 84 × 120 (214 × 305). Private Collection

6 Study of George Lawson, 1974, acrylic on canvas, 40 × 50 (101.6 × 127). Collection: David Hockney

7 Artist and Model, 1974, etching in black, 32 × 24 (81 × 61). Collection: David Hockney

8 Yves Marie, 1974, lithograph in black, 30 × 22¼ (76.2 × 56.5). Collection: David Hockney

9 The Arrival, from A Rake's Progress, 1961–63, hard-ground etching and aquatint, plate 11⅞ × 16 (30.2 × 40.6). Collection: David Hockney

10 Bedlam, from A Rake's Progress, 1961–63, hard-ground etching and aquatint, plate 11⅞ × 15¾ (30.2 × 40). Collection: David Hockney

11 The Morning Room of Rakewell's House in London, Act II, scene i, model for Stravinsky's The Rake's Progress, 1974–75, coloured inks and felt tip on card, 16 × 21 × 12 (41 × 53.3 × 30.5). Collection: David Hockney

12 Set design for the auction scene from Stravinsky's The Rake's Progress (detail), recreated for the exhibition 'Hockney Paints the Stage' at the Walker Art Center, Minneapolis, 1983. Collection: David Hockney

13 Unused pieces for the Brothel scene for Stravinsky's The Rake's Progress, 1975, ink on 7 panels, overall size 18½ × 25 (47 × 63.5). Collection: David Hockney

14 Large-scale painting with separate elements based on the design for Bedlam, for Stravinsky's The Rake's Progress, recreated for the exhibition 'Hockney Paints the Stage' at the Walker Art Center, Minneapolis, 1983, ink on canvas, wood, wool, acrylic on plaster, overall dimensions 120 × 192 × 192 (304.8 × 487.7 × 487.7). Collection: David Hockney

15 Set for Stravinsky's The Rake's Progress (detail), recreated for the exhibition 'Hockney Paints the Stage' at the Walker Art Center, Minneapolis, 1983. Collection: David Hockney

16 Peter and Friend, 1975, crayon. Private Collection

17 Kerby (After Hogarth) Useful Knowledge, 1975, oil on canvas, 72 × 60⅛ (182.9 × 152.7). The Museum of Modern Art, New York. Gift of the artist, J. Kasmin, and the Advisory Committee Fund

18 William Hogarth, frontispiece to Dr Brook Taylor's Methods of Perspective, published by Joshua Kirby, 1754

19 Kerby (After Hogarth) Useful Knowledge, 1975 (detail), oil on canvas, 72 × 60⅛ (182.9 × 152.7). The Museum of Modern Art, New York. Gift of the artist, J. Kasmin, and the Advisory Committee Fund

20 Invented Man Revealing Still Life, 1975, oil on canvas, 36 × 28½ (91 × 72.4). Nelson-Atkins Museum of Art, Kansas City

21 Ils² Ont, 1976, mixed media on canvas, 14 × 18 (35.6 × 45.7). Private Collection

22 'I Say They Are', from The Blue Guitar, 1976–77, etching and aquatint, edition: 200, 18 × 20½ (45.7 × 52). Collection: David Hockney

23 'What Is This Picasso?', from The Blue Guitar, 1976–77, etching and aquatint, edition: 200, 18 × 20½ (45.7 × 52). Collection: David Hockney

24 Self-Portrait with Blue Guitar, 1977, oil on canvas, 60 × 72 (152.4 × 182.9). Private Collection

25 Model with Unfinished Self-Portrait, 1977, oil on canvas, 60 × 60 (152.4 × 152.4). Private Collection

26 My Parents, 1977, oil on canvas, 72 × 72 (183 × 183). Trustees of the Tate Gallery, London

27 In a Chiaroscuro, 1977, oil on canvas, 48 × 60 (121.9 × 152.4). Collection: David Hockney

28 Abuo Shakra Restaurant, Cairo, 1978, ink on paper, 8 × 10 (20.3 × 25.4). Collection: David Hockney

29 Joe MacDonald, 1978, ink on paper, 17 × 14 (43.2 × 35.6). Collection: David Hockney

30 Egyptian Café, 1978, oil on canvas, 36 × 48 (91.4 × 121.9). Private Collection

31 Trial by Fire, model for Mozart's The Magic Flute, 1977, photographs on cardboard, tissue and wire, 16 × 21 × 12 (40.6 × 53.3 × 30.5). Collection: David Hockney

32 Grove with Three Temples, model for Mozart's The Magic Flute, 1977, photographs on cardboard, tissue and wire, 16 × 21 × 12 (40.6 × 53.3 × 30.5). Collection: David Hockney

33, 34 An Avenue of Palms, model for Mozart's The Magic Flute, 1977 (detail), photographs on cardboard, tissue and wire, 16 × 21 × 12 (40.6 × 53.3 × 30.5). Collection: David Hockney

35 The Triumph of Light, model for Mozart's The Magic Flute, 1977 (detail), photographs on cardboard, tissue and wire, 16 × 21 × 12 (40.6 × 53.3 × 30.5). Collection: David Hockney

36 The finale of Mozart's The Magic Flute at Glyndebourne, 1977

37 Ken Tyler, 1978, sepia ink 17 × 14 (43.2 × 35.5). Collection: David Hockney

38, 39 Le Plongeur (Paper Pool 18), 1978, coloured and pressed paper pulp, 72 × 171 (183 × 434). Bradford Metropolitan District Council. © David Hockney/Tyler Graphics Ltd.

40 Untitled, 1978, sepia ink, 11 × 26 (28 × 66). Collection: David Hockney

41 The Conversation, 1980, acrylic on canvas, 60 × 60 (152.4 × 152.4). Private Collection

42 Celia Elegant, 1979, lithograph in black, edition: 100, 40 × 29 (101.6 × 73.7). Collection: David Hockney. © David Hockney/Gemini G.E.L.

43 Ann Combing Her Hair, 1979, lithograph, 23¼ × 31⅛ (59 × 79). Collection: David Hockney. © David Hockney/ Gemini G.E.L.

44 Divine, 1979, acrylic on canvas, 60 × 60 (152.4 × 152.4). The Carnegie Museum of Art, Pittsburgh, gift of Richard M. Scaife

45 Canyon Painting, 1978, acrylic on canvas, 60 × 60 (152.4 × 152.4). Private Collection

46 Untitled, 1979, acrylic on cardboard, 40 × 60 (101.6 × 152.4). Collection: David Hockney

47 Untitled, 1979, acrylic on canvas, 24 × 36 (61 × 91.4). Private Collection

48 Santa Monica Blvd. 1979, acrylic on canvas, 86 × 240 (218.4 × 609.6). Collection: David Hockney

49 Untitled, 1979, acrylic on canvas, 24 × 36 (61 × 91.4). Collection: David Hockney

50 Testing-Testing with Palm Tree, 1979, acrylic on canvas, 24 × 36 (61 × 91.4). Private Collection

51 Bar and Sea from Poulenc's Les Mamelles de Tirésias for the Metropolitan Opera House, 1980, gouache, 14 × 17 (35.6 × 43.2). Private Collection

52 The Orchestra as a French Flag from Poulenc's Les Mamelles de Tirésias for the Metropolitan Opera House, 1980, gouache, 18¾ × 24 (47.6 × 61). Private Collection

53 French Marks Curtains with Airy Garden, 1980, from Ravel's L'Enfant et les sortilèges for the Metropolitan Opera House, 1980, gouache, 18¾ × 24 (47.6 × 61). Private Collection

54 Painted Floor with Garden and French Marks from Ravel's L'Enfant et les sortilèges for the Metropolitan Opera House, 1980, gouache, 19 × 24 (48.3 × 61). Private Collection

55 The Set for Parade, 1980, oil on canvas, 60 × 60 (152.4 × 152.4). Private Collection

56 Untitled, from Ravel's L'Enfant et les sortilèges for the Metropolitan Opera House, 1980, acrylic on blocks, each 1¼ × 4 (3.2 × 10.2). Collection: David Hockney

57 Giovanni Domenico Tiepolo (1727–1804), The Triumph of Punchinello (detail), ink drawing over black chalk, 11¼ × 16¼ (28.5 × 41.3). The Detroit Institute of Arts, Detroit

58 Untitled, 1980, gouache on paper, 19 × 24 (48.3 × 61). Private Collection

59 Zanzibar with Postcard and Kiosk from Poulenc's Les Mamelles de Tirésias, 1980, crayon 18¾ × 24 (47.6 × 61). Private Collection

60 Parade collage, 1980, gouache, ink and crayon on board, 40 × 60 (101.6 × 152.4). Private Collection

61 *Gregory's Painting*, 1980, oil on canvas, 29¼ × 35¼ (74.2 × 89.5). Private Collection
62 *Punchinello with Block*, from Ravel's *L'Enfant et les sortilèges*, 1980, gouache on paper, 14 × 17 (35.6 × 43.2). Private Collection
63 Untitled, 1980, oil, 60 × 72 (152.4 × 182.9). Collection: David Hockney
64 *Horse for Parade I*, 1980, oil on canvas, 18 × 24 (45.7 × 61). Collection: David Hockney
65 *Small Punchinello*, 1980, oil on canvas, 18 × 14 (45.7 × 35.6). Private Collection
66, 67 *Mulholland Drive: The Road to the Studio* (details), 1980, acrylic on canvas, 72 × 240 (182.9 × 609.6). Los Angeles County Museum of Art, purchased with funds provided by the F. Patrick Burns Bequest
68 *Nichols Canyon* (detail), 1980, acrylic on canvas, 84 × 60 (213.4 × 152.4). Private Collection
69 *Nichols Canyon*, 1980, acrylic on canvas, 84 × 60 (213.4 × 152.4). Private Collection
70 *Mulholland Drive: The Road to the Studio*, 1980, acrylic on canvas, 72 × 240 (182.9 × 609.6). Los Angeles County Museum of Art, purchased with funds provided by the F. Patrick Burns Bequest
71 Scene from Ravel's *L'Enfant et les sortilèges*, Metropolitan Opera House, New York, 1981
72 Poster for the Stravinsky Triple Bill at the Metropolitan Opera House, 1981, silk screened on paper, 20 × 7½ (50.8 × 19.3). Collection: David Hockney
73 *10 Dancers*, from Stravinsky's *Le Sacre du printemps*, 1981, gouache on overlay, 19 × 24 (48.3 × 61). Collection: David Hockney
74 *Study for Drop Curtain*, 1981, from the Stravinsky Triple Bill, gouache on paper, 20 × 15½ (50.8 × 39.4). Collection: David Hockney
75–80 Designs for Stravinsky's *Oedipus Rex*, 1981, gouache on paper, 23 × 29 (58.4 × 73.7). Collection: David Hockney
Masks for *Oedipus Rex*, 1981, crayon on paper, each 14 × 17 (35.6 × 43.2). Collection: David Hockney
81 Large-scale painting with separate elements based on designs for Stravinsky's *Le Rossignol*, 1983, recreated for the exhibition 'Hockney Paints the Stage'. Installation photograph at the Rufino Tamayo Museum, Mexico City, 1983, oil on canvas, wood construction, coloured light, wood velour, overall size 144 × 312 × 120 (365.8 × 792.5 × 304.8). Collection: David Hockney
82 Untitled, 1981, photograph, 11 × 14 (27.9 × 35.6). Collection: David Hockney
83 Untitled, 1981, watercolour, 14 × 17 (35.6 × 43.2). Private Collection
84 Untitled, 1981, watercolour, 14 × 17 (35.6 × 43.2). Private Collection
85 Untitled, 1981, watercolour, 7 × 8 (17.8 × 20.3). Collection: David Hockney
86 *Portrait of Ian*, 1981, crayon on paper, 30 × 22½ (76.2 × 57.2). Collection: David Hockney

87 *Hollywood Hills House*, 1981–82, oil, charcoal and collage on canvas, 60 × 120 (152.4 × 304.8). Walker Art Center, Minneapolis (Gift of David Winton)
88 *Terrace Hollywood Hills House with Banana Tree*, 1982, gouache, 51⅛ × 65⅞ (129.8 × 167.3). Private Collection
89 *Gregory Sleeping*, 1984, oil on 5 canvases, 60 × 60 (152.4 × 152.4). Private Collection
90 Untitled, 1983, oil on canvas, 72 × 48 (182.9 × 122). Collection: David Hockney
91 *David Graves, Pembroke Studios, London, Tuesday 27th April 1982* (detail), 1982, composite Polaroid, 51¾ × 26¼ (131.4 × 66.7). Collection: David Hockney
92 *Gregory, Los Angeles, March 31st 1982*, 1982, composite Polaroid, 14½ × 13¼ (36.8 × 33.7). Collection: David Hockney
93 *Looking at Pictures on a Screen*, 1977, cover of 'The Artist's Eye' catalogue, *David Hockney, Looking at Pictures in a Book*, for the exhibition held at the National Gallery, London, 1981. © David Hockney [Original painting, oil, 74 × 74 (188 × 188). Private Collection]
94–105 Twelve double-spread pages from the catalogue of 'The Artist's Eye' exhibition held at the National Gallery, London, 1981. © The National Gallery, London
106 *David, Celia, Stephen, and Ian, London, 1982*, 1982, oil on 8 canvases, 72 × 80 (182.9 × 203.2). Private Collection
107 *Ann & Byron Upton, Pembroke Studios, London, May 6th 1982*, 1982, composite Polaroid, 38¼ × 45½ (97.2 × 115.6). Collection: David Hockney
108 *Grand Canyon Looking North, Sept. 1982*, 1982, photographic collage, edition: 15, 45 × 99½ (114.3 × 252.7). Collection: David Hockney
109 *The Scrabble Game, Jan. 1, 1983*, 1983, photographic collage, edition: 20, 39 × 58 (99.1 × 147.3). Collection: David Hockney
110 *Walking in the Zen Garden at the Ryoanji Temple, Kyoto, Feb. 21, 1983*, 1983, photographic collage, edition: 20, 40 × 62½ (101.6 × 158.8). Collection: David Hockney
111 Jean-Antoine Watteau, *The Intimate Toilet*, c.1715, oil on canvas, 13⅝ × 10⅜ (34.6 × 26.5 with a 5 mm strip added each side). Private Collection
112 Pablo Picasso, *Femme couchée*, 1932, oil on canvas, 15 × 18 (38 × 46). Centre Georges Pompidou, Musée de l'Art Moderne, Paris
113 Cover of French *Vogue* magazine, Christmas 1985, 12½ × 9½ (31.8 × 24.1)
114 *Place Fürstenberg, Paris, August 7, 8, 9, 1985*, 1985, photographic collage, edition: 1, 43½ × 63 (110.5 × 160). Collection: David Hockney
115 *Chair, Jardin de Luxembourg, Paris, 10th August 1985*, 1985, photographic collage, edition: 3, 43½ × 31½ (110.5 × 80). Collection: David Hockney
116 Untitled from 'Vogue par David Hockney', French *Vogue* magazine, Christmas 1985, ink on paper, 12¼ × 9½ (31.1 × 24.1). Collection: David Hockney
117 *Jardin de Luxembourg, Paris, 10th*

August 1985, 1985, photographic collage, edition: 1, 35 × 32½ (88.9 × 82.5). Collection: David Hockney
118 *The Desk, July 1st, 1984*, 1984, photographic collage, edition: 20, 48½ × 46½ (122.4 × 118.1). Collection: David Hockney
119 *Pearblossom Hwy., 11–18th April 1986 #2*, 1986, photographic collage, edition: 2, 78 × 111 (198.1 × 281.9). Collection: David Hockney
120 Ken Tyler and David Hockney, 1985
121 Working in Ken Tyler's studio in Bedford Village on the Pembroke Studio Interior lithographs, 1985
122 *Two Pembroke Studio Chairs*, 1985, lithograph, edition: 98, 18½ × 22 (47 × 55.9). © David Hockney/Tyler Graphics Ltd.
123 *Pembroke Studio with Blue Chairs and Lamp*, 1985, lithograph, edition: 98, 18½ × 22 (47 × 55.9). © David Hockney/Tyler Graphics Ltd.
124 Untitled, 1985, crayon, 13 × 19½ (33 × 49.5). Collection: David Hockney
125 *Tyler Dining Room*, 1985, lithograph, edition: 98, 32 × 40 (81.3 × 101.6). © David Hockney/Tyler Graphics Ltd.
126 *Flowers Apple & Pear on a Table, July, 1986*, home made print on four panels executed on colour office copy machines, edition: 59, 22 × 17 (55.9 × 43.2). Collection: David Hockney
127 *Mulholland Drive, June 1986*, home made print executed on colour office copy machines, edition: 50, 11 × 17 (27.9 × 43.2). Collection: David Hockney
128 *Red Blue & Wicker, July 1986*, home made print executed on colour office copy machines, edition: 39, 11 × 8½ (27.9 × 21.6). Collection: David Hockney
129 *The Round Plate, April 1986*, home made print executed on colour office copy machines, edition: 46, 8½ × 11 (21.6 × 27.9). Collection: David Hockney
130 *The Juggler, September 1986*, home made print executed on colour office copy machines, edition: 31, 14 × 8½ (35.6 × 21.6). Collection: David Hockney
131 *The Drooping Plant, June 1986*, home made print executed on colour office copy machines, edition: 46, 11 × 8½ (27.9 × 21.6). Collection: David Hockney
132 *The Red Chair, April 1986*, home made print executed on colour office copy machines, edition: 44, 11 × 8½ (27.9 × 21.6). Collection: David Hockney
133 *Dancing Flowers, May 1986*, home made print on four panels executed on colour office copy machines, edition: 60, 22 × 25½ (55.9 × 64.8). Collection: David Hockney
134 *Mother, Bradford 19th Feb.*, 1978, sepia ink on paper, 14 × 11 (35.6 × 27.9). Collection: David Hockney
135 Set design for Poulenc's *Les Mamelles de Tirésias* (detail), recreated for the exhibition 'Hockney Paints the Stage' at the Walker Art Center, Minneapolis, 1983, oil on canvas, 134 × 288 × 120 (340.4 × 731.5 × 304.8). Walker Art Center, Minneapolis

136 Large-scale painting with separate elements based on a design for Mozart's *The Magic Flute* (detail) recreated for the exhibition 'Hockney Paints the Stage' at the Walker Art Center, Minneapolis, 1983, acrylic on canvas and laminated foamboard, 120 × 262 × 120 (304.8 × 665.5 × 304.8). Collection: David Hockney

137 David Hockney working in his studio on *Les Mamelles de Tirésias* for the exhibition 'Hockney Paints the Stage' at the Walker Art Center, Minneapolis, 1983

138, 139 Large-scale painted environment based on a design for a garden in Sarastro's kingdom, from Mozart's *The Magic Flute* (two details) recreated for the exhibition 'Hockney Paints the Stage' at the Walker Art Center, Minneapolis, 1983, acrylic on canvas, acrylic on laminated foamboard, 120 × 120 × 262 (304.8 × 304.8 × 665.5). Collection: David Hockney

140 The Shepherds and Shepherdesses appearing out of the wallpaper, detail of a large-scale painted environment based on a design for the room and the garden in Ravel's *L'Enfant et les sortilèges* for the exhibition 'Hockney Paints the Stage' at the Walker Art Center, Minneapolis, 1983, acrylic on canvas, acrylic on wood, wool velour, carpeting, coloured light, overall size 132 × 453 × 332 (335.3 × 1150.6 × 843.3). The Contemporary Museum, Honolulu, Hawaii

141 The Little Princess coming out of the book of fairytales, detail of a large-scale painted environment based on a design for the room and the garden in Ravel's *L'Enfant et les sortilèges* for the exhibition 'Hockney Paints the Stage' at the Walker Art Center, Minneapolis, 1983, acrylic on canvas, acrylic on wood, wool velour, carpeting, coloured light, overall size 132 × 453 × 332 (335.3 × 1150.6 × 843.3). The Contemporary Museum, Honolulu, Hawaii

142 *Hotel Acatlan: Second Day*, 1984, lithograph in 28 colours on 2 panels, edition: 98, 28¾ × 76 (73 × 193). Collection: David Hockney. © David Hockney/Tyler Graphics Ltd.

143 *A Walk around the Hotel Courtyard, Acatlan*, 1985, oil on canvas (2 canvases), 72 × 240 (183 × 609.6). Naoshima Contemporary Art Museum, Japan

144 *Views of Hotel Well, I*, 1984–85, lithograph in 16 colours, edition: 75, 31¼ × 41½ (79.4 × 105.4). Collection: David Hockney. © David Hockney/Tyler Graphics Ltd.

145 *Little Stanley Sleeping*, 1987, oil on canvas, 12 × 18 (30.5 × 45.7). Collection: David Hockney

146 Untitled, 1983, charcoal on paper, 30 × 22½ (76.2 × 57.2). Collection: David Hockney

147 Untitled, 1983, charcoal on canvas, 36 × 60 (91.4 × 152.4). Collection: David Hockney

148 *Self-Portrait, 26th Sept. 1983*, 1983, charcoal on paper, 30 × 22½ (76.2 × 57.2). Collection: David Hockney

149 *Self-Portrait, 12th Sept. 1983*, 1983, charcoal on paper, 22½ × 19 (57.2 × 48.3). Collection: David Hockney

150 *Self-Portrait, 28th Sept. 1983*, 1983, charcoal on paper, 30 × 22½ (76.2 × 57.2). Collection: David Hockney

151 *Self-Portrait with Striped Shirt*, 1983, charcoal on paper, 30 × 22½ (76.2 × 57.2). Collection: David Hockney

152 David Hockney's studio showing *A Walk around the Hotel Courtyard, Acatlan*, Los Angeles, June 1985

153, 154 Images from Quantel Paintbox, 1987

155–57 Scenes from Act I of Wagner's *Tristan and Isolde* at the Los Angeles Music Center Opera, 1987

158 Model of the ship for Act I of Wagner's *Tristan and Isolde* at the Los Angeles Music Center Opera, 1987, gouache, acrylic, foamcore, plaster, xerox, velvet, paper and wood, 50 × 45 × 57 (127 × 114.3 × 144.8). Collection: David Hockney

159–160 Scenes from Wagner's *Tristan and Isolde* at the Los Angeles Music Center Opera, 1987

161 Model for Act III of Wagner's *Tristan and Isolde* at the Los Angeles Music Center Opera, 1987, gouache, acrylic, foamcore, plaster, wood, modelling clay, sand and plastic, 62 × 43 × 38 (157.5 × 109.2 × 96.5). Collection: David Hockney

162 *Tristan in the Light*, 1987, acrylic on canvas, 36 × 48 (91.4 × 121.9). Private Collection

163 *Tristan und Isolde II*, 1987, acrylic on canvas, 10⅝ × 13¾ (27 × 34.9). Collection: David Hockney

164 *Tristan Looking for Shade*, 1987, acrylic on canvas, 24 × 24 (61 × 61). Private Collection

165 *The Love Potion*, 1987, acrylic on canvas, 36 × 48 (91.4 × 121.9). Private Collection

166 *Tristan und Isolde VII*, 1987, acrylic on canvas, 24 × 36 (61 × 91.4). Collection: David Hockney

167 *Large Little Stanley*, 1987, acrylic on canvas, 36 × 36 (91.4 × 91.4). Collection: David Hockney

168 *Green & Blue Plant*, 1987, acrylic on canvas, 24 × 36 (61 × 91.4). Private Collection

169 *Golden Still Life*, 1987, acrylic on canvas, 36 × 48 (91.4 × 121.9). Private Collection

170 *Still Life with Magenta Curtain*, 1987, acrylic on canvas, 36 × 24 (91.4 × 61). Private Collection

171 *Still Life with Flowers*, 1987, acrylic on canvas, 36 × 36 (91.4 × 91.4). Private Collection

172 *Van Gogh Chair*, 1988, acrylic on canvas, 48 × 36 (121.9 × 91.4). Private Collection

173 *Gauguin's Chair*, 1988, acrylic on canvas, 48 × 36 (121.9 × 91.4). Private Collection

174 David Hockney in his studio with the chair paintings, Los Angeles, May 1988

175 *Big Landscape (Medium Size)*, 1988, acrylic on two canvases, 48 × 36 (121.9 × 91.4). Private Collection

176 *Small Interior, Los Angeles, July 1988*, 1988, oil on canvas, 36 × 48 (91.4 × 121.9). Private Collection

177 *Interior with Sun & Dog*, 1988, oil on canvas, 60 × 72 (152.4 × 182.9). Private Collection

178 *Large Interior, Los Angeles*, 1988, oil, paper and ink on canvas, 72 × 120 (182.9 × 304.8). The Metropolitan Museum of Art, New York, purchase, Natasha Gelman gift, in honour of William F. Lieberman, 1989

179 *The Road to Malibu*, 1988, oil on three canvases, 24 × 96 (61 × 243.8). Private Collection

180 *Mum*, 1988–89, oil on canvas, 16½ × 10½ (41.9 × 26.7). Collection: David Hockney

181–215 Installation of the Los Angeles Studio, 1989, portraits, all oil on canvas, 16½ × 10½ (41.9 × 26.7) except where noted below. Collection: David Hockney

Top row, left to right: Ray Charles White, 1988, 36 × 24 (91.4 × 61); Paul Hockney, 1988, 24 × 24 (61 × 61); Albert (Clark) in Black Shirt, 1988, 24 × 24 (61 × 61); Untitled (Albert Clark), 1988, 24 × 24 (61 × 61); Gregory Evans, 1989, 36 × 24 (91.4 × 61); Sully Bonnelly, 1989, 36 × 24 (91.4 × 61)

Second row: Carla Rajnus, 1989; Ken Wathey, 1988; Maurice Payne II, 1989; John Hockney, 1988; Stephanie Barron, 1989; Margaret Hockney, 1988; Richard Buckle, 1989; Brian Baggott, 1989; Mum, 1988–89; Ian (Falconer), 1988, 20¹¹⁄₁₆ × 13 (52.4 × 33); Henry (Geldzahler), 1988, 24 × 24 (61 × 61)

Third row: Bing (McGilvray) II, 1988; Bing (McGilvray) I, 1988; Karen S. Kuhlman, 1989; Bob Littman, 1989; Peter Duarte, 1989; Armistead Maupin, 1989; Maurice Payne I, 1989; David Morales, 1989; Philip (Haas), 1988, 24 × 12 (61 × 30.5); Johnny Reinhold II, 1989; Neil (Hartley), 1988, 24 × 12 (61 × 30.5); Richard (Schmidt), 1988, 24 × 12 (61 × 30.5); Peter Goulds, 1989, 24 × 12 (61 × 30.5); John (Cox), 1988, 24 × 12 (61 × 30.5); Don (Cribb), 1988, 24 × 12 (61 × 30.5)

Bottom three: Helmut Newton, 1989; David Plante, 1989; Nikos Stangos, 1989

216 *Big Waves*, 1989, gouache, ink, marker, crayon, xerox, collage, 8½ × 11 (21.6 × 27.9). Collection: David Hockney

217 *Even Another*, 1989, xerox, marker, ink, 8½ × 11 (21.6 × 27.9). Collection: David Hockney

218 Untitled, 1989, xerox, crayon, felt tip pen, 11 × 8½ (27.9 × 21.6). Collection: David Hockney

219 *Pacific Coast Highway and Santa Monica*, 1990, oil on canvas, 78 × 120 (198.1 × 304.8). Private Collection

220 *The Valley*, 1990, oil on canvas, 36 × 48 (91.4 × 121.9). Private Collection

221 *Mountain Waves*, 1988, oil on canvas, 10½ × 16½ (26.7 × 41.9). Collection: David Hockney

222 *Mountain from Stunt Road*, 1990, oil on canvas, 36 × 48 (91.4 × 121.9). Kansas City Art Institute, Kansas City

223 *The Cutting*, 1990, oil on canvas, 36 × 48 (91.4 × 121.9). Private Collection

224 *Bridlington Blue Flowers*, 1989, oil on canvas, 18 × 12 (45.7 × 30.5). Collection: David Hockney

225 *Looking Down*, 1989, oil on canvas, 24 × 24 (61 × 61). Private Collection

226 *Two Pink Flowers*, 1989, oil on canvas, 16½ × 10½ (41.9 × 26.7). Collection: David Hockney

227 *Malibu House*, 1988, oil on canvas, 24 × 36 (61 × 91.4). Collection: David Hockney

228 *Beach House by Day*, 1990, oil on canvas, 24 × 36 (61 × 91.4). Private Collection

229 *Beach House by Night*, 1990, oil on canvas, 24 × 36 (61 × 91.4). Collection: David Hockney

230 *A Bigger Wave*, 1989, oil on four canvases, overall 60¼ × 72¼ (153 × 183.5). Private Collection

231 *Breakfast at Malibu, Sunday, 1989*, oil on canvas, 24 × 36 (61 × 91.4). Private Collection

232 *Green Tide*, 1989, oil on two canvases, overall 24 × 72½ (61 × 184.1). Private Collection

233 *The Sea at Malibu*, 1988, oil on canvas, 36 × 48 (91.4 × 121.9). Private Collection

234 *Breakfast with Stanley in Malibu, August 23, 1989*, 24-page fax. Black and white laser copy, collage, marker, and gouache, each page 8½ × 14 (21.6 × 35.5). Collection: David Hockney

235 Untitled fax showing one image inside another, 1989, black and white laser copy, gouache, crayon, uni-paint marker, 11 × 8½ (28 × 21.6). Collection: David Hockney

236 Untitled, 1989, fax drawing. Black and white laser copy, ink and brush, uni-ball pen, rubber stamp, uni-paint marker, 8½ × 14 (21.6 × 35.5). Collection: David Hockney

237 Untitled, 1989, fax drawing. Black and white laser copy and uni-paint marker, 8½ × 17 (21.6 × 43.2). Collection: David Hockney

238 *Hotel by the Sea*, July 6, 1989, 16-page fax. Black and white laser copy, collage, felt marker, each page 8½ × 14 (21.6 × 35.5). Collection: David Hockney

239, 240(detail) *Tennis*, 1989, 144-page fax. Black and white laser copy, collage, construction paper, felt marker, each page 8½ × 14 (21.6 × 35.5). Collection: David Hockney

241–44 Stills from the Bradford Fax Show, produced by Nick Gray for Yorkshire Television, 1989

245–61 From *40 Snaps of My House, August, 1990*, Canon still video camera, Canon colour laser printer, each page 8½ × 11 (21.6 × 27.9), four images per page. Collection: David Hockney

262 *Spectators in Alaska, June 1990*, colour laser printed photograph (9 panels), 28 × 41 (71.1 × 104.1). Collection: David Hockney

263–96 Two pages from *112 L.A. Visitors*, 1990–91, a seven-page portfolio, edition: 20, colour laser printed still video portraits, each

c. 22½ × 30 (57.2 × 76.2), framed 25¼ × 35¾. Collection: David Hockney

297 Cover and Back Cover of 1989 Glyndebourne Festival Opera Programme, 1989, collage, uni-ball pen, uni-paint marker and colour laser copy, 11 × 17 (27.9 × 43.2). Collection: David Hockney

298 Untitled, 1991, computer image created on a MacIntosh II, FX using Oasis software, printed on a Canon colour laser copier, 8½ × 11 (21.6 × 27.9)

299 *Walking Plant*, 1991, computer drawing, 8½ × 11 (21.6 × 27.9). Collection: David Hockney

300 *Beach House Inside*, 1991, computer drawing, 8½ × 11 (21.6 × 27.9). Collection: David Hockney

301 *The Railing*, 1990, oil on canvas, 36 × 48 (91.4 × 121.9). Private Collection

302 Act III, scene i, 1½″ scale model for Puccini's *Turandot*, 1990, for the Lyric Opera of Chicago, gouache, foamcore, colour laser copy, plaster cloth, plasticine and papier mâché, 48 × 96 × 82 (121.9 × 243.8 × 208.3). Collection: David Hockney

303 David Hockney working in his Los Angeles studio on the 1½″ scale model of Act III, scene ii, from Puccini's *Turandot*, Autumn 1990, for the Lyric Opera of Chicago

304 Act III, scene ii, 1½″ model for Puccini's *Turandot*, 1990, for the Lyric Opera of Chicago, gouache, foamcore, colour laser copy, plaster cloth, plasticine, papier mâché and styrafoam, 48 × 96 × 82 (121.9 × 243.8 × 208.3). Collection: David Hockney

305 Poster for Puccini's *Turandot*, 1991, for the Lyric Opera of Chicago, computer drawing printed from computer disk. Collection: David Hockney

306–8 1½″ scale model for Act I of Puccini's *Turandot*, 1990, for the Lyric Opera of Chicago, 1990, showing the effects of different lighting

309–15 Scenes from *Turandot* by the Lyric Opera of Chicago, 1991–92

316 *Two Small Caverns*, 1991, oil on canvas, 10½ × 16½ (26.7 × 41.9). Collection: David Hockney

317 *Richard*, 1988, oil on canvas, 24 × 12 (61 × 30.5). Collection: David Hockney

318 *Iowa Again*, 1991, oil on canvas, 24 × 36 (61 × 91.4). Collection: David Hockney

319 *Spring Spirit*, 1991, oil on canvas, 10½ × 16½ (26.7 × 41.9). Collection: David Hockney

320 *Light and Dark Getting Together*, 1991, oil on canvas, 10½ × 16½ (26.7 × 41.9). Collection: David Hockney

321 *What About the Caves?*, 1991, oil on canvas, 36 × 48 (91.4 × 121.9). Collection: David Hockney

322 Model, 1½″ scale, for the Dyer's House (Barak's Hovel) for Strauss's *Die Frau ohne Schatten*, 1992, at the Royal Opera House, Covent Garden, foamcore, velvet paper, gouache, plaster cloth, canvas, colour laser copies, wire screen, 85 × 90½ × 48

(215.9 × 229.9 × 121.9). Collection: David Hockney

323 Ian Falconer, costume design for the 'Emperor', for Strauss's *Die Frau ohne Schatten* at the Royal Opera House, Covent Garden, 1992, gouache on paper, 17 × 11 (43.2 × 27.9). Collection: Ian Falconer. © Ian Falconer

324 *Running Construction*, 1991, uni-ball pen, collage and gouache on foamcore, 15¼ × 12 (38.8 × 30.5). Collection: David Hockney

325–31 Production shots from Strauss's *Die Frau ohne Schatten* at the Royal Opera House, Covent Garden, 1992

332 *Stately Edge*, 1991, uni-ball pen, collage and gouache on foamcore, 22 × 12½ (55.9 × 31.8). Collection: David Hockney

333 *Where Now?*, 1992, oil on canvas, 24 × 36 (61 × 91.4). Collection: David Hockney

334 Oil paintings in the Los Angeles studio, October 1992

335 *The Thirteenth V.N. Painting*, 1992, oil on canvas, 24 × 20 (61 × 50.8). Collection: David Hockney

336 *The Fourth V.N. Painting*, 1992, oil on canvas, 24 × 24 (61 × 61). Collection: David Hockney

337 *The Seventeenth V.N. Painting*, 1992, 36 × 48 (91.4 × 121.9). Private Collection

338 *The Fifteenth V.N. Painting*, 1992, oil on canvas, 24 × 24 (61 × 61). Collection: David Hockney

339 *The Fourteenth V.N. Painting*, 1992, oil on canvas, 24 × 20 (61 × 50.8). Collection: David Hockney

340 *The Sixteenth V.N. Painting*, 1992, oil on canvas, 36 × 48 (91.4 × 121.9). Private Collection

341 *The Twenty-fourth V.N. Painting*, 1992, oil on canvas, 24 × 36 (61 × 91.4). Collection: David Hockney

342 *The Sixth V.N. Painting*, 1992, oil on canvas, 36 × 48 (91.4 × 121.9). Collection: David Hockney

343 *The Eleventh V.N. Painting*, 1992, oil on canvas, 24 × 36 (61 × 91.4). Collection: David Hockney

344–59 *16 Photographs to Show Order*, 1990, Canon still video camera, Canon colour laser printer, 8½ × 11 (21.6 × 27.9), 16 images on one page. Collection: David Hockney

p.220 The Monument Valley photos were shot with a Sony Hi-8mm Handycam camera, and printed on a Canon Color Laser Copy machine

Illustrations provided by The David Hockney Studio and Tradhart Ltd. Further photographic acknowledgments are as follows:
Mojgan Azimi **218**; James Franklin **12, 14**; Guy Gravett of Picture Index **36**; Jim McHugh **120, 121, 303**; Steve Oliver **42, 46, 48, 49, 91, 92, 116, 134, 158, 219, 220, 222, 223, 228, 229, 301, 316, 318–21, 335, 338, 339**; Dan Rest **309–15**; Richard Schmidt **1, 2, 13, 56, 74, 107, 113, 127–33, 148, 152, 162, 163, 173, 174, 181–215, 263–97, 323, 324, 332, 334, 336, 337, 340, 343**; Seven Hills Production, Inc. **325–31**

Index